D1198903

Assemblage

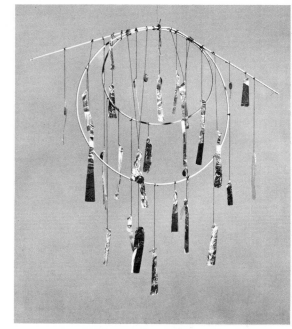

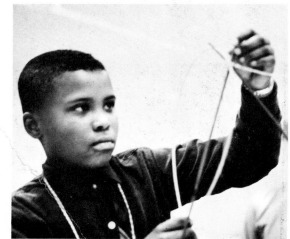

78 projects using the new arts of
collage and construction
for children and young people
from 4 to 14

Assemblage

A new dimension in creative teaching in action

Victor D'Amico and Arlette Buchman

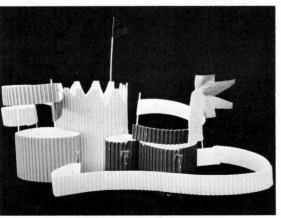

THE MUSEUM OF MODERN ART, NEW YORK

Distributed by New York Graphic Society Ltd., Greenwich, Connecticut

PHOTOGRAPH CREDITS

Cathryn Abbe, 115; *Ferdinand Boesch,* 192; *Arlette Buchman,* 3, 8, 12, 13, 15, 16, 19, 20, 21, 23, 24, 25, 32, 33, 35, 55 bottom, 61, 83, 103, 109, 113, 115, 125 right, 135 center and right, 141, 143 left, 163 top, 165 bottom left, 167 bottom center, 172, 173, 186, 195, 199, 206, 207, 218 top, 221, 228 right; *Diane Buchman,* 89, 111 bottom; *Rudolph Burckhardt,* 110 top; *Geoffrey Clements,* 128; *G. D. Hackett,* 116 bottom; *Wallace Heaton,* 116 right; *John Hedgecoe,* 150 top; *H. Mardyks,* 150 bottom left; *James Mathews,* 11, 37, 39, 41, 43, 45, 47, 49, 51, 53, 55 top, 57, 59, 63, 65, 67, 69, 71, 73, 75, 77, 79, 80, 81, 85, 87, 91, 93, 95, 97, 99, 101, 105, 107, 111 top, 119, 121, 123, 125 left and center, 127, 129, 131, 133, 135, 137, 139, 143 right, 145, 147, 149, 151, 153, 155, 157, 159, 161, 163 bottom, 165 top and bottom right, 166 top and bottom left and bottom right, 169, 175, 177, 179, 181, 183, 184, 185, 187, 189, 191, 193, 196, 197, 201, 202, 203, 209, 210, 211, 213, 215, 218 bottom, 219, 223, 225, 227, 228 left; *Metropolitan Museum of Art,* 82; *Solomon R. Guggenheim Museum,* 120 right; *Adolph Studly,* 50 bottom; *Soichi Sunami,* 50 top, 52, 84, 108, 112, 116 top, 120 left, 142, 152, 194 bottom; *Taylor and Dull,* 110 bottom; *Charles Uht, courtesy Museum of Primitive Art,* 122; *John Webb,* 150 bottom right.

Library of Congress Catalog Card Number 76-86412
ISBN 0-87070-223-8

THE MUSEUM OF MODERN ART
11 West 53 Street, New York, N.Y. 10019

Designed by Betty Binns

PRINTED IN THE UNITED STATES OF AMERICA

Contents

Acknowledgments

We are deeply indebted to those who have contributed their wisdom, enthusiasm, and energy to the realization of this book. Dorothy Knowles has seen it through from its first stages, doing the preliminary editing, a considerable amount of the necessary research, and the final editing, typing, and organization. This work might never have been produced without her devotion and efficient cooperation. Helen Franc did the monumental task of reorganization of the sections, re-editing the text for greater clarity and interest to the reader, and made numerous suggestions that enhanced the book. James Mathews and his staff, particularly Marjorie Wood, photographed most of the examples of the children's work, took action shots of children at work and processed photographs over a period of one year, devoting their time and skill generously and cheerfully. Harriet Schoenholz Bee has worked on the book through its labyrinthine history, from its inception to the final steps of production. She made the first reading of the manuscript, appraising it constructively and suggesting changes and improvements, and she proofread the text and saw to its many details. We are grateful to the designer, Betty Binns, who visualized the layout creatively and worked to make the book both aesthetically satisfying and easily used by teachers and parents.

Richard Oldenburg inherited this undertaking when he succeeded to the directorship of the Department of Publications. We are grateful to him for his cooperation in promoting the progress of the book, his encouragement, and his able direction of the members of his staff and the specialists who worked on the book.

And finally, special gratitude is given to Mabel D'Amico and Alex Buchman for their encouragement and patience.

Arlette Buchman and Victor D'Amico

Introduction

This book is a guide to art teaching in action. It presents a contemporary approach to teaching art based on the new art of assemblage, which is integrated with the more familiar means of creative expression of drawing, painting, and modeling. The projects described were created especially for this volume by Arlette Buchman, my co-author, and were taught in her classes for children from four to fourteen years old at the Art Center of The Museum of Modern Art. Each project is therefore the report of an actual teaching experience, and the accompanying illustrations show either work in progress or finished products. The projects re-create the teaching situation, describe the motivation techniques and the procedures adopted by Mrs. Buchman, and whenever possible record the children's reactions and comments.

The volume is planned to give the teacher an understanding of the philosophy underlying the projects, to expand and enrich his knowledge of the creative behavior of children, and to present teaching methods that relate the philosophy to practice. The introduction to each group of projects for a particular age level contains a description of the general creative characteristics at that age level. These descriptions are sometimes repeated within the projects, either for emphasis or because they may be applicable to particular situations.

Although the seventy-eight projects presented here provide an extensive program for teaching, the authors hope that the projects will be used as the basis for further experimentation, serving as examples to teachers for the creation and development of projects of their own. In this way, the teaching experiences will become more personal, and the possibilities for new projects will be unlimited.

The book is intended for art teachers in enriching their own programs, for other classroom teachers in developing creative art programs of their own, for art supervisors and directors in guiding teachers under their direction, and for teachers' colleges and universities in the training of new teachers. It can also be useful to parents, who can introduce the projects to their children and work with them in the same way as the teachers do in the classroom; but the parents should also study the general philosophy and methods described in the introduction to each age level, so that each experience may become an educational adventure as well as a challenging technical accomplishment.

The book is dedicated to teachers and children everywhere.

Victor D'Amico

Introduction to assemblage

New dimensions in creative teaching

JUST AS MODERN SCIENCE has discovered and developed new ideas and techniques to enable us to live better, so modern art education has discovered and developed new concepts and methods for creative growth. The introduction of assemblage has vastly enriched the art experience by bringing to art education new insights, a tremendous potential for stimulating creative activities, a variety of mediums and materials, and innumerable ways of appealing to the senses.

As used in this volume, the word "assemblage" applies generally to works put together from a variety of elements; it includes both the two-dimensional medium of collage and three-dimensional constructions. The more specific words "collage," "construction," and "mobile" are used in instances where they seem more clearly to define or describe a particular work or activity.

This volume presents three significant approaches to assemblage: first, as an independent form of expression which, by offering new concepts, mediums, and experiences in the use of materials, can develop a wide range of possibilities for creativeness; second, as a means of revitalizing, rather than substituting for, the basic expressive means—drawing, painting, and sculpture; third, as a force for integrating all the visual and plastic arts. A few projects in drawing, painting, and clay work are therefore included, which both enhance and are enhanced by experiences in assemblage. It is the interaction between these established kinds of expression and the newer ones that sharpen the child's aesthetic awareness and enrich his total creative growth.

In his catalogue for the exhibition *The Art of Assemblage,* shown at The Museum of Modern Art in 1961, Dr. William C. Seitz has pointed out a significant difference between assemblage as a means of personal expression and a new aesthetic concept, and assem-

blage as merely the application of new mediums and materials. He says: "Every work of art is an incarnation: an investment of matter with spirit. The term 'assemblage' has been singled out, with this duality in mind, to denote not only a specific technical procedure and form used in the literary and musical, as well as in the plastic arts, but also a complex of attitudes and ideas." It is precisely this emphasis on attitudes and ideas, and on the investment of matter with spirit, that distinguishes this art as a vital teaching method and forms the basis for the philosophy and practice presented in this book.

Background of assemblage

Assemblage is in tune with our time. It was pioneered and originated by some of the leading masters of modern art. Collage, as a Cubist invention of Pablo Picasso and Georges Braque and as further developed by Kurt Schwitters during the Dada period, entailed the pasting of newspaper clippings, theater tickets, wallpaper, and other printed "found" materials onto their paintings. Like a painting, collage is conceived on a flat plane and is seen from one point of view.

Construction, in large part the discovery of the Russians, Kasimir Malevich and the brothers Naum Gabo and Antoine Pevsner, departed from the conventional sculptural techniques of carving and modeling by creating works formed by the joining together of parts. Constructions are three-dimensional, freestanding or hanging in space, and meant to be seen from several points of view. They include both static or stationary works and those that move and have moving parts. So closely associated are they with the work of Alexander Calder that many of them are called by two terms first applied to his sculpture—"stabiles" and "mobiles." The

motion in a mobile may be caused by natural forces, such as gravity, wind, and water; or by built-in mechanical means, such as springs, balances, or electrical motors.

More recently, the movement called "kinetic art" has become increasingly widespread, enriching three-dimensional works still further by the addition of light and sound as well as motion. Turntables, motors, lights, recording tapes, bells, and a variety of electronic equipment now enrich our experience of plastic art.

All these new forms of expression are distinguished by their use of materials and techniques not previously applied to the creation of works of art. Further, this mixture of mediums is tending to break down the old categorical distinctions between "painting" and "sculpture." To describe some of these new works, new terms have had to be invented, such as "shaped canvases," "combines," and so forth.

Unless art teachers are aware of these developments and consciously make them a functioning part of their programs, art education will become obsolescent and out of step with the times.

The pioneers of the art of assemblage did not invent these new forms and techniques for the sake of art education, and comparatively few of them had either children or older students in mind. The one notable exception was among the masters of the Bauhaus, the world-famous art school where many of the great artists and innovators of our century developed new teaching methods and put their ideas and techniques into practice. Founded by Walter Gropius in Weimar, Germany, in 1919, the Bauhaus was transplanted as a greatly enlarged institution to Dessau, where it remained until 1928, and then moved to Berlin where, in 1933, its doors were closed by the Nazis.

The Bauhaus was intended for the education of professionals—artists, architects, designers, photographers,

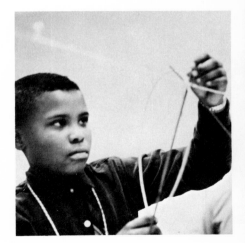

weavers, typographers, and those in the theater arts. Besides its director, Gropius, its masters included such distinguished men as László Moholy-Nagy, Josef Albers, Oskar Schlemmer, and Paul Klee. It had tremendous impact on all the arts, but its effect on art education—particularly at the college and art-school levels—was truly revolutionary. The foundation courses at the Bauhaus introduced new concepts of design and technique based on tactile, visual, and kinesthetic exercises, studies of space and motion, and experiments with new materials. The closing of the Bauhaus by no means put an end to its influence, which in fact became widely disseminated as its masters emigrated elsewhere—many of them to the United States. Their ideas revolutionized American art education, from preschool through the college levels, as well as in schools of art, architecture, and design.

The new assemblage techniques of collage and construction emerged at the same time that the philosophy of creative teaching in general was being developed. Creative education began as self-expression, which at first was conceived merely as freeing the child from adult and academic indoctrination. At the outset, it represented more of an escape for what education should *not* be than any clear concept of what it *should* be. In short, we were more certain of what we should not do to the child than what we could do for him. This was an idealistic conception of freedom without practical application.

Art educators are to be commended for recognizing the values inherent in collage and construction and introducing these mediums into their teaching of children from the preschool level through elementary grades. Gradually, as they have developed both educational concepts and methods for teaching, they have found in assemblage one means for structuring a basic program of creative expression.

The materials approach

In one form or another, collage and construction have been included in the curriculum of art education for over a quarter of a century. Often, however, the emphasis has been more on the addition of new materials and technical procedures, than on the contribution these can make to new concepts and ways of learning. In fact, so much attention has been focused on the materials used in collage and construction that their inclusion in art education has gained the title of "the materials approach." This implies a point of view that regards materials as having the power to teach by themselves, without the guidance of an art teacher or a teaching plan. In fact, many teachers are satisfied to set out a variety of materials and turn the children loose on them, in the hope or belief that the children will thus be able to inspire and instruct themselves. Yet, no matter how attractive a material may be, it cannot per se insure a creative experience. Left without guidance, a child is apt to imitate his neighbors or fall back on clichés. Of course, clichés can be produced as readily with new materials as with old, and by artists and children alike if there is no awareness of aesthetic values and personal expression.

Many of the exponents of "the materials approach" have written articles and books extolling the virtues of collage and construction simply because they use waste materials or junk. This indeed may be an attractive asset for the teacher with a limited budget (and who doesn't have to live with one!) or the school administrator who welcomes any opportunity to cut costs. But this is an economic advantage only and does not take into consideration the still greater advantages that assemblage can offer by stimulating and enriching personal creative expression. It is certainly an economic benefit to be able to use waste materials, but the sig-

nificant factor in their use is that through creative insight and the inventive power of the individual, such materials can be given a new meaning.

The searching eye, the imaginative mind, and the skill of the human hand can invest all dormant material—old or new, costly or free—with a new life and form. For example, a piece of string or wool can describe the shape of an object or a free form; newspaper can become an interesting pattern in a mural or, mixed with glue, can make a paper sculpture; used radio or television tubes, clockworks, springs, and similar small parts can be used to motivate projects on computers, flying machines, or abstract constructions. A ten-year-old boy created a construction that he called *Outer Space*. Choosing glossy, silvery Christmas-tree balls of several sizes, he suspended them on a silver cord that had been used to tie a gift package. He stretched the cord between posts made of dowels anchored in a plywood base, creating a tensional design, and hung the silver balls at strategic intervals to suggest planets. He used silver wrapping paper from the same gift box to construct space ships, which he hung on black thread so that they seemed to be flying in space. The result was interesting both as an abstract design as well as an interpretation of a three-dimensional subject, space.

Awareness of the aesthetic quality of materials not only increases the possibilities for individual creativeness in using them but also enlarges one's horizon by leading to a greater appreciation of one's environment. Every material has two basic values: its intrinsic aesthetic value and its potential for creative use. When these values are abused, ignored, or left to chance, the material—any material—is wasted; and, still more regrettably, the child's interest and creativity are wasted.

The sensitive teacher is aware of all factors in the creative process. The presentation of raw materials for creating is as important as the stimulation or the process itself. Frequently, teachers put collage and construction materials before the class in a conglomerate heap, which makes them appear like so much rubbish, whether they were purchased or acquired without cost. Children are often expected to find objects or materials. The more the material becomes used, the more the mass appears shopworn and unappealing.

Materials should be presented in an attractive manner, so that visually they stimulate the creative appetite just as attractively presented food starts the digestive juices flowing. We can learn a lesson from the way in which the Italian fruiterer displays his goods, or from the exquisite care with which the French pastry cook decorates his pastries and arranges them on variously shaped trays. The materials for the development of creative youth deserve at least as much attention.

The talent myth

Besides the overemphasis on "the materials approach," there is another fallacy in art education that recent developments have tended to expose. This is the talent myth—the belief that some children are talented, while others are not. Many studies are underway, attempting to identify and measure talent, but as yet there have been no conclusive results. Often children are regarded as talented by their art teachers, parents, and peers if they can draw well—the quality of the drawing being evaluated by its likeness to the object or to reality. Unfortunately, this point of view overlooks such important factors as the individual's perceptiveness, inventiveness, originality, uniqueness, and personal expression, which are the essential values of a creative artist.

Assemblage has provided new ways to discover and develop creative ability without reliance on skill in

drawing or the ability to ape reality. In collage and construction, children can demonstrate their sensitivity to color, pattern, and organization. Freed from the fear of having to draw or represent objects accurately, many children find courage to express themselves in new ways through means with which they can feel a positive identification. There are as yet no set criteria either for making or evaluating collages and constructions, and therefore children do not feel themselves in competition with traditional values, as in drawing or painting, or with their classmates who have been identified as "good" in those mediums. Assemblage is not hampered by academic rules of perspective or anatomical proportions, which some teachers believe must be mastered before children can begin to create. Like most other forms of modern art, assemblage has its own fundamentals, based on aesthetic principles and emotional responses.

It is true that skills and techniques are required, but they are new skills and techniques. It requires skill to select materials for a certain objective, whether it be a tactile collage made to delight through the sense of touch or a construction that is a metaphor for space. There is skill in planning and organizing a collage or construction, and technique in putting it together.

We do not wish to imply that drawing is outmoded and that assemblage has taken its place; rather, we are comparing the advantage of assemblage with the disadvantageous limitations imposed upon art education and the child by those who adhere to academic "rules." There are concepts and techniques in the teaching of drawing and painting that are as new and fresh as those in assemblage—contour and intuitive drawing and expressive painting, for example; but many of those who still believe in the talent myth are making their evaluations on the basis of academic rather than creative values.

Aesthetic responses through assemblage

Assemblage is employed at its best when the child can use it as an emotional, aesthetic, or symbolic expression rather than as a means of imitating nature and realistic objects or of interpreting subjects. The four-year-old who makes a collage of his favorite color may choose blue because he likes it, not because he is representing the sky. The ten-year-old who made the *Outer Space* construction described above did not use the Christmas-tree balls because they resembled stars or planets but because they glittered and symbolized for him the feeling of vastness. These are aesthetic and not realistic criteria. When a child uses such a collage material as green carpeting, for example, to represent grass, or red beads for apples on a tree, he is merely imitating nature, just as if he were painting a landscape or still life by copying nature without putting into his work any of his own feelings and imagination.

There are psychological as well as aesthetic arguments in the case against imitation. When a child copies, he knows that he is a middleman, so to speak, between his realistic subject and the work he produces; he is not in command, so he feels no identity with the end result because he is not applying his own feelings or aesthetic values to it. The wise teacher, therefore, avoids projects that induce copying of a thing, a place, or a person. Instead, he motivates and stimulates the child's awareness of his feelings, for example by suggesting the making of a collage that expresses roughness or smoothness, or a mobile that expresses flying or a happy mood.

Spontaneity through assemblage

Spontaneity is an important factor in the creative process, valuable because it releases the child's visual

and emotional responses. Painting directly with brush and pigment is ideal for encouraging spontaneity; and collage offers similar advantages, but in a different way. The child places the materials spontaneously, directly on a background or in conjunction with each other. If he doesn't like a particular piece of material, he changes it for another; or if his first arrangement doesn't suit him, he may change the position or relationship of the pieces. He is governed by his own aesthetic and emotional responses, without dependence on preconceived notions of skill (as in drawing) and with no association with accuracy of representation. There is no erasing, because the child merely replaces one material with another; therefore, he feels more free to experiment. He is his own authority, because his observations and feelings tell him whether his work is right or wrong.

Three-dimensional expression through assemblage

One of the greatest advantages of introducing assemblage into the art experience is that it provides a wide range of opportunities for three-dimensional expression. Most art work on the elementary- and secondary-school level limits the experiences to crayons, paint, and clay; of these, clay alone is a three-dimensional material. There are two reasons for this situation. First, teachers are seldom as experienced in the use of three-dimensional materials as they are in two-dimensional ones (a condition which this book seeks to correct); second, it is easier to teach the two-dimensional mediums. Even clay, which in many schools is the only three-dimensional material used, is often avoided because it is "messy"—the children soil their hands and leave fingerprints on the furniture and footprints on the floor.

The values to be gained in the child's development through the use of assemblage, however, far outweigh the drawbacks. From the experience of the authors, and from extensive studies and research made over a period of more than thirty years at the Art Center of The Museum of Modern Art, it has been learned that children of all ages have interests and abilities that necessitate three-dimensional expression. Certain individuals, in fact, are more three- than two-dimensional in their perception and expression, and their creative development depends on the inclusion of appropriate outlets. Of course, this is hardly a revelation, and it should not come as a surprise to anyone either parent or teacher. For generations, children have manifested their interest in three dimensions through their fascination with building blocks or by making sand structures on the beach. The only startling fact is that it has taken so long for these interests to gain recognition in the classroom and become an integral part of the art curriculum.

Assemblage for all age levels

Assemblage is suited to any and all age levels, from the preschool child to the mature adult. The young child is apt to work more instinctively and emotionally, choosing materials that please him because of their texture or color. The older child or adolescent will probably work more intellectually, choosing his materials on a rational basis. Both, however, use emotion and intellect in their creative expressions. For example, in the project "My Favorite Color" (page 42), three- and four-year-olds make a collage of materials of one preferred color. Their selection of the color and its variations is based on emotion, because they choose the one they like; but the size and shape of the materials and their placement are at least in part rationally

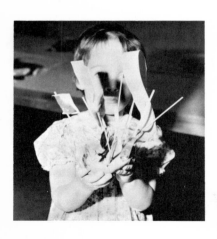

determined. The mature artist no less than the layman combines in his work the twin faculties of emotion and thought; where the former predominates, the art tends to be expressionistic, and where the latter is dominant, the art is often regarded as "classic." Individual temperament, rather than age or experience, is the decisive factor; the particular advantage of assemblage is that it is flexible enough to accommodate both feeling and thought.

Motivation—the open sesame of creative teaching

In creative art education, the most vital part of the teaching process is providing the motivation. The teacher can stimulate the child by involving him in the creative act, by stirring him both emotionally and mentally, by making him aware of the aesthetic qualities of the materials he will use and of their appeal to his visual, tactile, and kinesthetic responses—in certain instances, to his senses of hearing and smell as well. Even though the aim is to have the child work spontaneously or intuitively, the teacher still must provide the open sesame, motivating through a planned verbal and visual presentation to elicit the child's optimum creative response to a specific process and medium.

Motivation should not be confused with the traditional assignment. The teacher who uses traditional methods steers the child toward a predetermined product, accepting no ideas or procedures that do not conform to the set path. Those who conform are "right," those who do not are "wrong." The final result is also measured by a preconceived image, and whether the teacher judges it as "good" or "bad" depends on how nearly it resembles the standard he has set up in his mind's eye.

The teacher who uses the motivational approach, on the other hand, provides the spark that kindles the individual's own thoughts and feelings. The problem presented for solution is offered as a challenge, not a directive. Although the teacher may indicate a general procedure to follow, this is fluid and offers many possibilities, allowing each individual to proceed in his own way, according to his own ability, preferences, and maturity, toward the objective, which he reaches through his own direction and procedure. There is no predetermined end result. Neither the child nor the teacher knows in advance exactly what the final result will be, or precisely how it will look. Before it can be seen, it must be born of the child's own creativity. The problem motivationally presented, therefore, is open-ended, and its consummation is in the child's experience as he proceeds.

Assemblage, with its variety of materials and the fluidity of its procedure, is ideally suited to this kind of creative teaching in action. Motivation is the vital core of such teaching and of the projects described in this book. These projects, derived from actual experience, offer motivations and procedures structured according to the age level and creative development of the child. Even though a certain kind of experience may appeal to a variety of age levels, it must nevertheless be adapted so that it is custom-tailored for the particular age that is being taught.

In order to make the book as useful as possible, the authors have tried to be specific in their suggestions and recommendations. As is made clear in the section on "The Art Teacher" (page 18), however, in the last analysis it is the individual teacher on whom the effectiveness of these projects will ultimately depend.

The new world of materials

THE MATERIALS of the contemporary artist, especially the assemblage artist, can be found almost anywhere—in the home, the neighborhood, at the seashore or in the country, perhaps even in outer space. As long as art was confined mainly to the traditional mediums of painting and sculpture, the artist could go to the art-supply store and secure enough materials to last him a year or more, or even order all his tools and materials by mail from a catalogue, where everything could be found under its appropriate classification.

Today, any place the artist looks and whatever he sees may yield material for his creative effort. Sometimes he may look for a particular object or material with which to carry out an idea he already has in mind; at other times, he ventures forth with an open mind, without any preconceived idea or image, letting the material he encounters suggest ideas to him. Often without his conscious searching some material will unexpectedly provide him with an inspiration and germinate a new piece of work.

Materials and mediums are more than the stuff of which works of art are made. What we select is indicative of our manner of looking at the world and the myriad things it contains, and this way of looking either expands or limits our range of appreciation and creativity. The exploring, expectant eye sees and enjoys more than the eye that is inhibited by convention or prejudice. We must see both with the freshness of innocence and with the knowledge of experience. An idea may originate in the mind or the heart, but it is only through craftsmanship and material that it can be made into a work of art.

Because a diversity of materials is so vital a part of assemblage, the teacher must acquaint himself with as varied a selection as possible. Sources for materials are everywhere, but he must discover, learn, and master them. For the assemblage artist, there are two major

kinds of materials: those that are provided by nature and those manufactured by man.

Natural materials

Nature yields numerous things that the artist discovers ready-made in their form, shape, color, and texture and prizes just as they are; these are discussed in the section on "Found Art" (page 22). Nature is also prodigal in offering other materials that the artist transforms from their natural state, incorporating them into a work of art in accordance with his idea.

GIFTS FROM THE SEA

There is first of all the variety and richness of treasures to be found on the beach or in the shallow waters offshore. Today, with the growing popular interest in scuba diving, these can be amplified by less familiar and even more fascinating treasures to be found in the deeper waters. The assemblage artist of any age is confronted with a wealth of materials from the sea in widely varying shapes, colors, and textures. Purposeful searching and experience will reward the seeker and satisfy his most optimistic expectations.

Sand is the most common and available of the materials, but there are many kinds of sand—fine, white, and powdery, or granular and grayish, as well as the thin layers of red, gray, and black sand found at the high-tide mark, which must be scooped up gently. Shells too are bountiful, differing according to climate and location. Clam, mussel, slipper, scallop, razor, oyster, and conch sheels vary in shape and color; they can be used whole, in fragments, or crushed to make textured surfaces. Pebbles at the water's edge range from pure white to black, and vary in color, shape, and size. It is advisable to carry a number of bottles or boxes when collecting these materials, to facilitate sorting and storing them.

The dried skeletons of fish and birds form excellent bases for original constructions. Feathers may be dispersed over a wide area along the shore, but with patience one can acquire a considerable number. Driftwood almost constitutes an art unto itself. From the smallest chip only a few inches long to the large, gnarled root or branch, there is an extensive choice of sizes, shapes, and textures.

Just by taking walks along the beach, one can acquire quite a collection of such materials; with the aid of a "beach buggy," exploration can reach the dunes and areas beyond the shoreline, where storms and high tides often deposit their rarest gifts. Collecting and examining these found materials can afford much pleasure and information; but still greater satisfaction comes from converting them into collages, constructions, and mobiles of one's own design.

THE WOODS AND FORESTS

The natural materials to be found in the woods and forests are also familiar to the average person and especially to the nature lover; but the assemblage artist looks upon them in a new and personal way. Here nature is as bountiful as on the beaches. Trees offer delicate, lacy twigs as well as twisted branches large enough to be transformed into sculpture with a minimum of carving. Bark varies from smooth, silky surfaces to those that are rough and heavily textured. Wood knots and pieces of wood with knotholes provide interesting examples of positive and negative shapes in nature. Leaves seem limitless in color and shape; as is commonly known, they can be made to last by being pressed in a book. Leaves that have been perforated

by insects are worth seeking out for their fine filigree patterns. Grasses, thick and thin, short and long, can also be pressed in books for permanence. Plants can be preserved by hanging them in a dry place; after they are dried, they can be used singly or in large bouquets.

Man-made materials

The man-made or manufactured materials used in making assemblages fall into two categories: those ordinarily produced for art work, such as paint, canvas, or clay, and those produced for other purposes, such as chemical glassware, machine parts, cast-off wrappings, molded forms used to transport or market foodstuffs—in fact, any manufactured object that the artist can adapt and convert for his creative endeavors. The first group may be purchased from an art supplier or manufacturer. The latter, which must be sought for and which must be acquired from disparate sources, we shall discuss first.

THE HOME

Our search for materials can begin at home, because that is the most familiar place for the child to find available materials to gather for his playtime activities and for his collection at school. In addition, searching for materials in the home develops the child's sensitivity to his immediate environment as well as his sense of discrimination in selecting materials. The child can use a shoe box to house his personal collection, or he can accumulate his contributions toward any collection at school in a shopping bag, which can be used to carry them to class. The parent's cooperation will not only help to enrich the child's collection but also provide a common interest and shared activity; for parent and

child to work together constitutes a valuable and necessary experience in the child's growth.

Look for and save canceled stamps on letters and postcards; postcards picturing scenes or with reproductions of painting and sculpture; gift wrappings in solid colors and patterns; metallic and fluorescent papers; envelope linings; greeting cards. Save boxes of all kinds, particularly flat boxes such as glove, handkerchief, or tie boxes, small containers for jewelry, drugs, and cosmetics—round, oval, or any odd shape, made of cardboard or plastic; cylindrical cereal boxes, long spaghetti boxes. Save cardboard shirt backings, corrugated board and paper; bottlecaps and corks; string and ribbons; buttons, beads, and discarded costume jewelry. Dismantle old toys for their wheels, gears, springs, and worn-out dolls for their heads and limbs; save alphabet and building blocks, playing cards, and game counters.

THE SCHOOL OR CLASSROOM

Like the parent at home, the teacher at school can encourage the child in the habit of looking for and saving materials. The children can be asked to bring contributions for the school or classroom supply. Instead of just having them dumped into the general collection of materials, spend time discussing each item and its potential use in creative work. This will reward their efforts and develop a greater sensitivity to the visual and tactile qualities of the materials. The general classroom or school supply can be stored in paper cartons or shoe boxes, properly labeled; but a portion of each kind of material might be put into clear plastic boxes for everyday use, which will both make it easier to see the materials and make them appear more glamorous. If necessary, the plastic boxes can be carried from room to room on a tray or rolling cart.

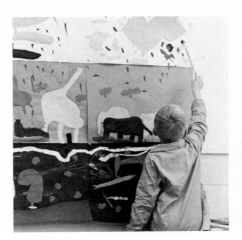

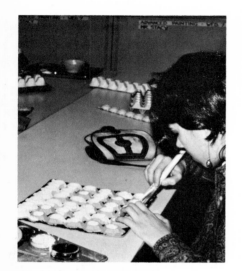

Within the school itself, there are sources that can greatly augment the supply of materials. From the woodworking shop, one can acquire wood scraps, sawdust, and odd nails and screws. Many junior high schools have physics and chemistry laboratories which can be asked to contribute glass tubing, watch glasses, beakers, bottles, glass stoppers, and rubber corks. (If these materials are not available at the school, they can be obtained from sources suggested on the following pages.)

NEIGHBORHOOD STORES

We are apt to overlook the so closest to us, such as the neigh and drug stores, because we believe that the treasures we lie undetected. Yet, if we know to look for, the neighborhood v variety and quantity of materi to The Museum of Modern Ar find the unique materials used with children, which they se exhibitions and publications. T answer: most of these materials were acquired and solicited from stores in the neighborhoods where the children and teachers live, and can be found in the inquirers' neighborhoods, too.

From the local grocery store or supermarket one may acquire net sacks for oranges and onions; burlap sacks; clear plastic bags; cardboard molds used to pack eggs, vegetables, and fruit; colored tissue wrappers for fruit; shredded paper and plastic; corrugated boards used as dividers in egg and fruit cartons; paper cartons of all sizes; wooden crates that can be taken apart for their slats; baling wire, string and twine. Most of these have been used in the projects described in this book and

can be identified easily by examining the illustrations or reading the lists of materials accompanying the projects. Most store owners and managers will be glad to part with these materials, which they discard as waste. Many will cooperate by telling you when they expect new shipments and when they are unpacking, so that you can be on hand to select and carry off the materials you desire; some local merchants will even save them for you, if you ask.

From the local paint and wallpaper store one may acquire sample color folders for both glossy and mat paints. These are useful in making collages, and even more valuable for this purpose are the large sample books of wallpapers containing sheets with figured patterns, textured surfaces, and sometimes even embossed designs. Usually the books are discarded when a new line of wallpapers is issued. They may also be acquired by writing or visiting large wallpaper manufacturers.

Hardware stores usually accumulate a variety of items which are too mixed up or off-size to keep and which they dispose of when taking inventory. These include nails, screws, washers, nuts and bolts, cup hooks, staples, screw eyes, wire of different gauges, ends of screening, wire mesh, sheet metal, metal moldings, and tubing. Many hardware stores carry plumbing and electrical supplies; if they don't, you can find them at a plumbing and electrical shop. Plumbing supplies—fittings such as elbows, nipples, washers, and tubing—are useful in making constructions, and electrical supplies such as leftover wire (bare and insulated), used fuses, wire connectors, sockets, and junction boxes provide ample stimulus for imaginative conversion into creative projects.

The local drugstore can provide unusual materials seldom seen by the average customer. These include containers holding packages of a dozen or a gross of

Supply ideas →

merchandise that is usually sold in one or two packages at a time. The containers are discarded as soon as they are empty; in fact, the druggist often fills his shelves with the merchandise as soon as it arrives and disposes of the containers at once. There are also cosmetic containers of various sizes and shapes—round, oval, rectangular, and lozenge-shaped; glass and plastic bottles from drugs and perfumes; cardboard or plastic pill boxes with fascinating inserts die-cut with round, oval, or odd-shaped holes. Here, too, may be found shredded cellophane in various colors, and boxes with egg-crate dividers. A talk with your druggist will reveal a host of other materials.

YOUR FAMILY DOCTOR

Many of the materials for assemblage that you can obtain from your family doctor may be similar to those to be found in the drugstore, but they are often of a wider and more interesting variety. Most doctors receive a large number of samples from pharmaceutical firms, handsomely designed and packaged to attract the doctors' attention to the products. These include containers, bottles, and molded or perforated inserts in styrofoam or plastic. The doctor, like the druggist, dispenses the drugs in one package at a time or in measured quantities and disposes of the containers when they are empty. A word to your doctor about their usefulness should make them available to you.

OTHER SOURCES OF WASTE OR SCRAP MATERIALS

The lumber yard or mill will probably not occur to a teacher as a source for assemblage materials, and since such establishments deal for the most part with builders and carpenters, few teachers have occasion to visit them. They nevertheless contain rich resources for collage and construction. Scrap "cut offs" from long-grain boards, plywood boards of various thicknesses and widths, and fir joists are excellent for making constructions and bases for wire or wood sculpture. Dowels, clothes poles, balusters, spindles, and fence palings—whole or broken, or left over as "odds" after an inventory—may be purchased for a small fee or obtained for nothing. If the lumber yard does jigsaw or scrollwork, the discarded negative shapes make excellent pieces for creative work. Fine, medium, or coarse sawdust is available from the saw table free of charge, as are wood chips from the plane. These can be used to make textured surfaces on a collage or construction, by coating the surface with glue or paint and then applying a coat of sawdust or wood chips. These materials can also be mixed with glue or plaster, poured into a negative mold or empty milk container, allowed to dry, and then carved into a sculptural form. Short and long curls of shavings are useful in assemblage. Odds and ends of moldings of all shapes and sizes are valuable in a variety of ways, as are leftovers of plain and molded frames, if the yard does framing; if not, look up your local framer to secure such scraps.

At construction sites of houses and other buildings, ceiling and wall tiles of fireproof or acoustical materials may often be found as waste. They make excellent backgrounds or bases for constructions and collages. The builder or foreman will usually be willing to let them be removed at no charge.

Workshops or studios that design and construct window displays for department stores and local shops yield a wealth of materials. Leftovers from the cutting of plywood, masonite, or other boards include interesting shapes that can be used in assemblage projects. Bits of fabric, plastic, plexiglass, and colored or figured boards and papers can also be used effectively. Small

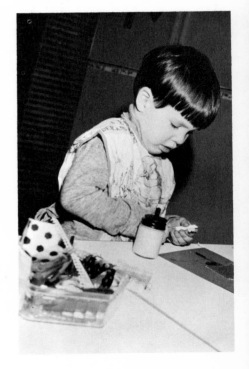

constructions such as stands, tables, and shelving units made for display lend themselves to three-dimensional constructions. As these materials are usually relegated to the junk heap when a display is dismantled, the owner or manager of the store will usually welcome having them put to some useful purpose.

Die-cutting establishments that mass-produce containers, inserts, and other goods for foodstuffs, druggists' supplies, toys, handbags, and wallets are veritable gold mines of materials. Literally tons of such stuff are carted off to the city dump periodically. A teacher could fill a station wagon with discards or arrange to have them picked up in some other way. Materials include cutout shapes in cardboard, metal, fabric, and leather, and molded forms in *papier mâché,* metal, and plastic.

Photography is seldom thought of, even today, as an art by many teachers, and advertising and typography are regarded as "commercial." These nevertheless pervade our environment, and experience with them is essential in the child's creative work and developing appreciation of contemporary forms of expression. Teachers therefore should not overlook materials and sources such as the following.

From the local photography shop one can acquire old negatives, color slides, and prints, especially those used for display, which can be cut up for collage. Empty film cans and boxes are also available. These materials may also be solicited from children who take photographs, or from their parents.

Typography is an art in itself and can play a significant part in creative teaching of painting, assemblage, and design. Individual letters, type faces, words, and patterns made by whole pages of type can be used, and selecting tear sheets and cutouts from newspapers and magazines can constitute a valuable exercise for both teacher and child as well as providing elements for the collage supply. Advertisements from all kinds of periodicals provide a particularly fruitful source of printed and pictorial materials.

THE FIVE-AND-TEN-CENT STORE

So far, the materials discussed have been waste or discarded items that can be gathered free of charge. Teachers should, however, include in their budgets funds for materials that are not customarily thought of as art supplies. School lists for materials are often conventional and out-of-date, including only items that relate directly to art teaching in the most academic sense. The enterprising teacher can add new materials and sources and discuss the need for a wider selection with those who administer the budget, as well as requesting a cash allocation to be used for purchasing items needed for special projects.

The five-and-ten-cent store (a misnomer today) carries many quite inexpensive items useful for work in assemblage. Cellophane, colored paper—especially the kind with a glossy surface, often called "pinwheel paper"; bags of marbles; crushed glass; beads; wooden balls and blocks; coils of iron, copper, and brass wire; steel-wool or other kinds of scrubbing pads; sandpaper; chains; gears; wheels; these all come neatly packaged and can be bought for classroom use. A study of your local variety store will reveal an even wider selection of usable materials.

The basic materials

Up to now, we have discussed materials that until recently were neither regarded as artists' supplies nor included in the production of works of art. Now we shall discuss those materials that may be considered

the basic staples of an art program and that can be purchased either at art-supply stores or from large manufacturers. They are classified below according to the particular expression or medium involved—whether the traditional modes, such as painting or modeling, or the newer ones, such as collage, construction, etc.

MATERIALS FOR PAINTING

The materials for painting include water-based paints, paper, brushes, sponges, and containers for using and storing them. At the Art Center of The Museum of Modern Art, it was found most efficient and economical to equip each child with his own set of materials: a tray to serve as a palette for mixing paints, furniture coasters (one to hold each color), brushes, an acetate sponge used for drying brushes and often as a painting tool, and a water dish. Whenever the materials listed for projects in this book specify "paint," this is the equipment intended:

From an art-supply store:

Moist tempera or poster paints (also called showcard colors): red, yellow, blue, green, black, white. For economy, buy at least a pint of each color, and a quart of white; buy the best quality you can afford.

Bristle brushes, short bristles (called "brights"), 1″ and ½″ widths

Camel's hair watercolor brushes, pointed, about ⅛″ stroke

Drawing paper, 18″ x 24″

Newsprint, 18″ x 24″ (Larger sizes of these papers can be bought in rolls and cut to any desired size.)

From the five-and-ten, department, or hardware store:

Glass furniture coasters, for spoonfuls of paint

Plastic bowls with flat bottoms, for water

Cookie pans, about 10″ x 14″ x ½″, preferably aluminum which does not rust, for use as a tray and palette

Acetate sponges

Syrup dispensers with metal tongues and no fine springs, which may become clogged with paint, in the handles; excellent for pouring paint without waste.

MATERIALS FOR WORK IN CLAY

Moist clay is the most effective material for modeling, ceramic sculpture, and general use in assemblage. Two kinds are available: a nonfiring clay which is suitable for very young children, if the work is not to be fired, and for general use in assemblage work; and a firing clay, for work which is to be fired or fired and glazed. Nonfiring clay may be used for all projects in this book that require clay.

Moist clay, which may be purchased from a dealer in art or ceramic supplies, is usually packed in a plastic bag within an outer burlap sack or cardboard carton. The 50- or 100-pound sizes are most economical for school use. The other materials required for working in clay are:

From a building-supply store:

Rubber or asphalt tiles, linoleum in 9″ squares, or tempered masonite of the same size or larger, for use as bases while working.

From the drugstore:

Tongue depressors, cut to a point at one end. (These will be adequate for all the projects requiring clay described in this book, though they may be supplemented by simple wood and wire tools for shaping and cutting clay.)

From the grocery or supermarket:

Sheet plastic, cut into pieces, for keeping clay moist between working periods. (Large tin cans placed over the objects will also help to keep the clay moist.)

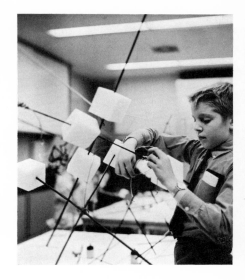



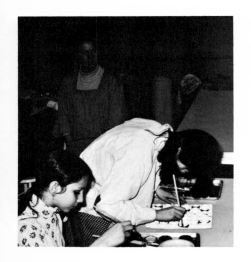

MATERIALS FOR COLLAGES, CONSTRUCTIONS, AND MOBILES

The materials described above are suitable for general use in art programs; those that follow are regarded as the staples for assemblage work. They should be available for general use, as well as for a foundation for whatever unique materials may be supplied by individual teachers or contributed by the students.

Materials	Source
Colored construction paper in sheets 6″ x 9″, 9″ x 12″, 12″ x 18″, 18″ x 24″. The following basic colors are recommended: red, orange, yellow, green, blue, purple, pink, brown, gray, black	Art-supply store
Cloth, plain and patterned	Remnants from sewing or bought at yard-goods or department store
Tarlatan or theatrical gauze	Department or theatrical supply store
Netting, in various meshes, colors, and textures, some with stiffening	Department or theatrical supply store
Burlap, various colors	Yard-goods or department store
Colored gelatins, in a wide variety of colors	Theatrical lighting store
Wallpaper, sample books or in rolls	Department store, wallpaper, or paint store
Feathers	Loose feathers of all kinds can be bought in special stores; they can also be found, or taken from old ornaments or those bought in the five-and-ten
Sequins	Five-and-ten or department store
Rickrack, buttons, beads	Five-and-ten or department store, or saved from sewing
Wooden beads, natural and colored, all sizes	Five-and-ten or toy store
Confetti	Five-and-ten
Gummed stars, arrows, and other shapes	Five-and-ten or stationery store
Gummed paper letters	Stationery or sign store
Metal paper fasteners	Stationery store
Pipe cleaners, 100 of a color in a box	Florists' supply store; assorted colors in a box are sometimes available at five-and-ten or department stores
Florist's wire, 16, 20, and 23 gauge, in pieces 18″ long	Florists' supply store, sold by the box; wire of various gauges can also be found in coils, often sold by the pound, at hardware stores
Tongue depressors and applicator sticks	Drugstores
Wooden coffee stirrers and spoons	Five-and-ten
Paper and cellophane straws	Five-and-ten

In addition, collect scrap of any kind, such as fur, wood, sponge rubber, box fittings from pill and medicine boxes, punched cards or tape from office machines.

COLLAGE BOXES

For many projects, it is convenient to have assorted small bits of collage materials in boxes, each of which can be shared by two children. Boxes about the size of a shoe box are suitable. They should contain colored and patterned paper and cloth (scraps are excellent), short pieces of yarn and string, gelatins, feathers, beads,

lace-paper doilies. Whenever the lists of materials for projects in this book specify "collage boxes" this is what is intended.

General materials and tools for most projects

Materials	*Quantities*
Office staplers, all metal, with 4″ or 7″ throats (the latter give a better reach); any light stapler will not stand up under classroom use	One for every two or three children to share
Paper punches with ¼″ holes	Six can be shared by a class of about twenty children
Scissors: 4″ or 5″ long, with rounded ends, for children six years old or younger; 6″ long, with pointed tips, for older children	One per child
Pliers, two kinds, for wire sculpture, constructions, and general use: blunt, needle-nose, with side cutters; and cutting pliers	Six of each will serve a class of twenty or more children
Metal snips, 8″ long, for cutting metals	Six for a class of twenty or more children
Adhesives: White library paste, in bottle dispensers with brush applicators (jars of one gallon or less can be bought for refilling them); rubber cement (also called paper cement), in cans with brush applicators (one-gallon cans can be bought for refilling them); Elmer's Glue, in plastic dispenser bottles, the medium-sized bottle being most practical	One bottle or can for each child
Thinner, for thinning rubber cement and cleaning brushes (can be bought in cans of one gallon or less)	To be shared
Masking tape, 1″ wide, in 60-yard rolls	To be shared
For display board and general use: steel or plastic-headed pushpins, ½″ points, and thumbtacks, ⅜″ and ½″ points, in boxes of 100	

The art teacher

THE MOST VITAL FACTOR in the learning process is the teacher working directly with the child. Teaching machines, electronic devices, and visual aids can greatly improve the effectiveness of teaching, but they cannot replace the teacher. There is no substitute for the teacher, in general, and for the art teacher, in particular. His role is as catalyst, prime motivator and tender of creative growth.

The authors here offer some suggestions and recommendations that may re-enforce the teacher's own creativity and increase his effectiveness in teaching the projects described in this book.

Practice what you teach

It is absolutely essential for the teacher to do any project before presenting it to the children. This will help him to identify with the project and give him the authority of firsthand experience. Teachers often work by theory or formula, applying a process they have observed or read about without trying it out themselves. Many teachers admit that they have taught the making of collages or mobiles for years without ever having undertaken the problem of designing and executing one themselves. Know-how in art means more than mastering processes and techniques. It requires one to be inspired by an idea one can identify as one's own and carrying it out in material form. Collages or constructions may have been done a thousand times by others, but the one a particular artist conceives will be entirely new to him and to the world. This applies to the art teacher and the creative child as well. Therefore, do the various projects that are presented here yourself—not as an obligation or a chore, but as an opportunity for increasing your enjoyment and satisfaction.

Invent new projects

It is equally important that the projects presented in this book be regarded as examples only, and not as a series of recipes. The seventy-eight projects described have all been worked out and found to be successful with the respective age levels for which they are recommended, and could keep children interested and occupied for a considerable time. But if they are used merely as recipes, the effect of this volume will be limited, and the aim of the authors will be defeated.

We hope, therefore, that each teacher will invent new motivations and projects. This can be a test of the teacher's creativeness; and unless a teacher is creative himself, he can hardly develop creativeness in others. The authors are more interested in the new ideas that may be born through the creative use of this volume than in the literal execution of the separate projects. If these are used as wellsprings for new projects, they can be an inexhaustible source. The real test of creative teaching is in the contagious effect it has on those who are exposed to it, and the desire it induces in others to try the activity for themselves and identify themselves with the works of art they produce. Similarly, the test of a good creative project is that it serves to stimulate many other variations and developments; and this is the standard by which the authors hope the projects presented in this book will be judged.

What makes a creative teacher?

This is a universal and persistent question, asked again and again at teachers' conferences and meetings, and repeatedly addressed by each art teacher to himself. Like the question "What is art?" it has no definitive answer. With the growth of one's own philosophy and with the changes in concepts and attitudes that are occurring so rapidly in art today, the answer will of necessity vary from time to time. There are, nevertheless, certain fundamental and relatively constant values, which can help the teacher answer the question to his own satisfaction in determining whether he is progressing, retrogressing, or standing still.

The question "What makes a creative teacher?" is related to such questions as "How does the art teacher compare with the artist?" and "What is an art teacher?" There are certain basic characteristics that the artist and the art teacher have in common, and there are others that are distinctive to each. The artist might be defined as someone who is primarily interested in his own capabilities and development and with his role as an artist, and who has made becoming an artist his life's ambition. The art teacher, like the artist, must develop his own creative talents, discover and evolve his own individual character, know what techniques and processes are required to produce works of art, and he must be a craftsman. But from this point on, the aims and roles of the art teacher and the artist differ. The art teacher must be interested in the creative characteristics and development of others, rather than of his own alone. He needs to know how creativity grows—beginning with the preschool child through all the stages of development to mature adults. Even if he does not teach young children, he should know the stages out of which the creativity of older ones emerged. Knowing these stages, he will be able to interpret, motivate, and guide an experience in terms of the needs, interests, and capacities of each age level.

The artist can be selfish in keeping his knowledge and techniques to himself for his private use. The creative art teacher must give freely and generously, without regret or sense of sacrifice. The artist can be prejudiced in terms of the kind of expression he prefers

and reject all others. The art teacher must be catholic in his tastes and opinions, presenting all forms of expression as impartially and objectively as possible. Of course, this does not imply that the artist-teacher should have no standards of his own, or that he should regard all artists and movements with equal liking and respect. It does mean, however, that he should present the concepts of, and facts about, an artist or work of art in a way that will allow students to make their own value judgments.

Transmitting the art heritage

Although the teacher must be progressive and familiar with all current expressions and movements, he must also have a knowledge of the art heritage. Many modern expressions are completely new and indigenous to our time, and many techniques and materials now in use did not exist in the past. It is also true, however, that many of the new modes of expression have their roots in past concepts and practices. "The more things change, the more they remain the same."

Knowledge of the art heritage has two functions. On the one hand, it exposes the child to the great works that artists of all eras have handed down to us; on the other, it establishes faith in man as the eternal creator, and in the act of creating as an essential factor in human development. For these reasons, many of the examples and illustrations used in motivations for the projects in this book are drawn from the past. Our art heritage should not be ignored or regarded as obsolete. Teachers should never create the impression that only contemporary art is valid, or that our own age is superior to all others in its concepts, aesthetics, or achievements. The most important conviction is a belief that art is man's personal and spiritual expression, and that

art is most vital when it most vitally stimulates and serves mankind in its time.

Developing a sense of quality

Children should learn to recognize and respect a sense of quality or excellence in art. Nothing can achieve this goal more effectively than presenting to them the works of master artists of both past and present. Many projects in this book introduce works by outstanding artists, which set up a frame of reference, a goal, or an example of ultimate achievement. The purpose is not to have the child idolize or imitate the examples but to provide them with a recognition of the artist's authority and, even better, to establish a *simpatico* relation with the artist. Many children are reassured when they find that an artist has an imagination similar to theirs or uses a comparable aesthetic expression. Miró and Calder, for example, re-enforce the child's creativeness. Often, children find themselves in conflict with adults whose tastes have become too sophisticated or conventional, and they are inclined to distrust their own achievements. Artists who speak their language confirm their faith in themselves.

Evaluating creative progress

How do you evaluate creative progress? How do you know that an experience is creative, or that the child is creating? These questions concern every art teacher. Evaluation is a two-way street that involves both the teacher and the child. A child may seem uncreative because the art experience is uncreative, or the teaching is so overstructured that it allows the individual no opportunity to find the character of his own crea-

tivity or interpret a project in his own way. By contrast, the teaching may be so loose or unguided that the child finds no challenge or goal in it.

Let us first consider the evaluation of the teacher or the teaching. If the project is presented without enthusiasm, or as something to be done by rote, it is unlikely that the children will respond enthusiastically. If it is presented as an obligation or a test of the child's interest, it is apt to engender fear, uncertainty, or a feeling of opposition. The teacher must be interested in the experience he offers the child and enthusiastic about it. "We are going to try something new today." "Here are some materials that I think you can make into a very unusual design." "You have three colors on your tray, as well as black and white. They can be made into any color, or any number of colors. You have the magic in your hands to make your own. There is no limit; try to invent new colors; invent as many as you can." "Close your eyes and feel the materials with your fingers. Put all the materials that your fingers like in one pile, and the others in another. Make a feeling collage out of the materials your fingers like."

The object of saying such things as these is to stimulate the child to action, to make him want to do something, to make his fingers itch to get underway. That is the object of motivation—to move a child to action. If the project succeeds in producing action, a desire to do, then it may be regarded as valid.

Evaluation, then, begins at the beginning. The teacher should be on the alert for verbal responses to the motivation. If the children ask questions or offer suggestions, if they start with enthusiasm and continue with absorption, if they embrace the idea and form from it unique designs of their own, the teaching may be considered effective.

The important steps in the creative process are the initial motivation and the working process. The product remains a culmination of the experience. It is evidence of what has taken place, and perhaps of what has been learned and achieved. It should not be evaluated separately. Unfortunately, evaluation is often confused with grading or marking the individual or estimating the end product. The success of the product should be measured by the amount of interest engendered, the behavior of the child in the course of its production, and his attitude toward its completion. A creative experience is successful if the child has gained a new interest in art, overcome a restricting habit, or discarded a cliché, even though the result of his work may be crude.

Motivation and evaluation are continuous processes. The teacher may find it necessary to remotivate at various times throughout the experience; he may interrupt an individual or a group while they are working, to call attention to the objective or to redirect the procedure. Motivation, therefore, does not start only at the beginning, nor evaluation take place only at the end. They are concomitant and simultaneous.

How do you evaluate the child? How do you know that he is learning and growing? The most important value in the child's creative growth is the uniqueness in his behavior and work. If he responds in his own way, expressing ideas that are particular to him, and if his work has a character all its own, then it can be assumed that he is growing. If he is becoming more sensitive to aesthetic values in his own work and that of others then art is making an essential contribution to his development. If he is becoming more aware of his environment, more selective and discriminating in his tastes, more receptive to others, then art is a humanizing influence, a vital aid to living.

The object of art in education is not to produce artists nor prepare the child for a profession. It is to make life richer and more meaningful for the individual and for society as a whole.

The art heritage and
the daily environment

INVOLVING THE CHILD with a variety of techniques and mediums and developing his ability in working with them is not enough for his full and well-rounded creative growth. The creative experience should extend beyond making and enjoying things for and by oneself. It should include a heightened awareness and respect for the expressions of the artists of one's own time and of times past, and also for the natural and man-made environment that one lives in day by day or visits and explores anywhere on this planet and beyond, as far as his aesthetic eye can reach. In short, it should engage the individual in an ever widening and deepening spiral of aesthetic response.

The vast treasures of our environment offer almost unlimited sources of personal enjoyment, besides providing the means for motivating creative activity and helping to establish standards of aesthetic excellence. The art teacher can provide the child with experiences and resources for this necessary enrichment in a number of ways.

Found art*

Every modern artistic discipline or educational theory, from Arthur Dow to John Dewey, from academic to avant-garde art, has stated as a primary aim the development of the power of observation of the individual, whether child, youth, or adult. But does observation mean only to see facts, to notice the obvious—such as that a temple has eight or twelve Doric columns, or that one man is fat while another is thin? Or does observation not really involve the power to perceive,

*This section is abridged and adapted from Victor D'Amico, "Found Objects—an Educational Discovery," in Oscar Bailey and Charles Swerdlund, *Found Objects—Mid-Century Genre*, catalogue of an exhibition at the Upton Gallery, State University College at Buffalo, New York, February 28–March 21, 1965, pp. 31–32.

to sense, to feel the essential qualities of things, to develop an ever deepening awareness of the elements of one's environment—the country, the sea, the city or village one lives in, the house one inhabits, the surrounding objects, the clothes one wears, the insect crawling on a blade of grass, the subtle cracks in a piece of old china?

"Found art" has to do with the discovery of an aesthetic component in natural or man-made things that were not intended to be works of art: the tortuous grain of a tree stump in browns or silvery grays, the concentric pattern of a cobweb glistening with raindrops, the weathered stains on a stucco wall, the cracked sidewalk with a child's drawing scrawled upon it, the mat brilliance of a spun aluminum or copper bowl shimmering with coldness or warmth. Once these qualities have been revealed, the secret is out. Only the first one who discovered the object can really be credited with having recognized and felt the aesthetic value contained within it; but everyone can discover other objects or combinations that have aesthetic value.

Learning to "find" art involves some basic disciplines. It involves curiosity in seeing, it involves courage to look for the unexpected and familiar, it involves sensitive choice, it involves conviction in making the judgment that the found thing has aesthetic value. These aesthetic disciplines can operate at any age level. The young child may select a particular shell out of hundreds lying on the beach for its shape, texture, subtlety of color and pattern. The older child may choose a particular stone for its form, luminous structure, or tactile surface. The adult, whether layman or artist, can recognize aesthetic values in a rust-encrusted machine part or smashed automobile body. Experience in found art both develops a source for one's personal creation and expands one's creative sensibilities to creativity— accidental or deliberate—outside himself.

Found art thus not only adds a new dimension to the creative act but, to make a play on the word, it has probably "found" what art educators have been seeking ever since the art of teaching began: proof or evidence that aesthetic values have been experienced. How can one verify that an individual has acquired the ability to know and judge aesthetic values for himself? Oral or written examinations are not only unreliable methods but also degrade the creative experience and rob it of its spiritual triumph. Found art, however, solves the problem in a joyous manner and is proof-positive that the individual has exercised independent judgment and given evidence that he is sensitive to aesthetic values (providing, of course, that the teacher possesses at least the same aesthetic ability and sensitivity himself).

We of the twentieth century have become particularly interested in the character of things. Science has opened up new worlds of vision that were hidden to people of the past. The microscope has revealed vast quantities of forms that constitute new realms of found art; even diseased cells have an exciting beauty. The telescope and the cameras borne by astronauts have penetrated outer space, expanding our visual horizons and suggesting still further explorations in centuries to come. The probing spirit of the scientist has been contagious in the arts and is probably, at least in part, responsible for the spirit of seeking underlying found art. Collage and other kinds of assemblage are among the kinds of expression stemming from the modern artist's spirit of curiosity and invention.

Field trips

Insofar as possible, depending on different localities and on the age level of the group, the art teacher should

arrange field trips. Visits to the woods and seashore, or to parks, will provide opportunities to "find" art and to gather materials for incorporating into assemblages (see "The New World of Materials," page 9). Learning to assess the aesthetic qualities of one's own neighborhood—houses, factories, industrial buildings, stores, store windows, street signs, public buildings—or trips farther afield to see outstanding examples of architecture and engineering are all important in making the student aware of the environment by which his own way of seeing is largely conditioned. Such trips provide an excellent way of fostering the appreciation of objects not originally intended as art but nevertheless possessing aesthetic quality, such as machine forms (coils, springs, gears, refrigerators, gas pumps) and engineering structures (bridges, dams, highways).

Original works of art

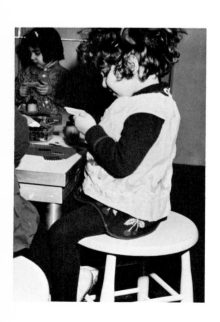

First and foremost, as a means of developing an awareness of their art heritage, children should be exposed to original works of art. Visiting museums and galleries, and perhaps artists' studios, is of prime importance. The child should be made aware both of his heritage from the past and of contemporary forms, including the most avant-garde and experimental. He should be exposed not only to painting, sculpture, drawings, prints, and architecture—traditionally called the "fine arts," but also to photography, film, and the many forms of mixed mediums.

Visual materials

While there can be no substitute for the valuable experience of exposure to natural or man-made objects in the environment, and to original works of art, the art

teacher will have to supplement them or perhaps depend largely on indirect sources—slides, photographs, and reproductions—for aesthetic enrichment and for motivational use in presenting projects. Today both children and adults are bombarded with visual images through television, motion pictures, magazines, newspapers, and billboards, but most of these lack any positive aesthetic qualities. It is therefore up to the art teacher to prepare a wide variety of resources.

The visual materials should be further supplemented by a reading library for reference and research, including magazines, books, catalogues, and monographs on artists and art movements; works on aesthetics and the philosophy of art; information on mediums, processes, materials, and techniques; and critical reviews.

Some teachers are opposed to the use of any visual materials, because they fear that children may imitate or copy them. Imitation is a learned habit, however, and is more likely to be the result of a faulty method of teaching than of the child's own inclinations. If originality and uniqueness of personal expression are encouraged, there will be no temptation to imitate. Depriving the child of enhanced responsiveness to his environment or of his art heritage is too great a price to pay for a presumed gain in creative effectiveness; it also reveals a weakness in the teacher's own confidence and teaching. Originality does not always manifest itself in a startlingly new and different procedure or result; a new arrangement or a different use of color or texture may also signify originality.

Visual materials may be used in a variety of ways, depending on the age level being taught and the purpose of the teacher. They can be used at the beginning of a project to set a goal or illustrate an idea, or else at the end as a kind of summary of the experience. It is better to show several appropriate examples rather than one, because this enables the child to become

acquainted with a wider range of expression and makes him less inclined to be too influenced by any single one. There are times, however, when an isolated example may be more effective, particularly if it is striking and unique, and if it is presented in a thorough and interesting manner. It may be a challenge to the child's ability to be inventive or resist being imitative.

For a class of young children, the teacher may tack reproductions or photographs to the display board and leave them there without comment, allowing the images to be recorded unconsciously in the child's mind; or he may specifically point out certain features of color, pattern, or texture that relate to the activity about to be undertaken. Occasionally, the teacher may call attention to the exhibits after the children have begun their projects, or display them at a strategic moment in the lesson to accentuate the aims of the project or clarify ideas brought up in the motivational discussion.

Assembling a collection of visual materials

Every school or art class should have an interesting and diversified collection of materials that can be used for purposes of inspiration and motivation. This may include a wide assortment of things found, begged, or borrowed, which have aesthetic value. Among the items might be bric-a-brac, costume jewelry, artificial flowers, stuffed birds, skeletons of animals, birds, or fish, weathered wood, corroded hardware, bits of colored broken glass, feathers, fur, old watches and clocks, musical instruments, keys, chains, masks—the list is endless. Formerly, such items were used principally as still-life objects in the teaching of drawing or painting, and were intended as models for copying. In the modern classroom, however, they serve rather to titillate the imagination and stimulate the senses.

Projected images—slides, filmstrips, motion pictures, and opaque projections

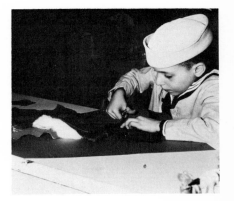

Slides and filmstrips of good quality on almost any subject may be purchased or rented from museums or commercial outlets; school systems often have audio-visual materials available for circulation; and many universities have extension services that provide materials for rental within their own states. Many public libraries can assist in locating audio-visual materials.

For equipment, it is desirable to be able to own or rent slide projectors, motion-picture projectors, and a screen. With an opaque projector, illustrations in magazines or books, as well as postcards and small photographs, can also be projected on the screen.

In the summer of 1967, the Department of Photography of The Museum of Modern Art presented an exhibition called "Once Invisible," which featured wonders of nature that have long been invisible but have now been revealed through the microscope and telescope and recorded through the eye of the camera. A whole microcosm of fascinating forms, from bacteria to the minute structure of stems and leaves as seen in cross section, has now become visible. The vast array of patterns and shapes provides superb materials for motivational use in various projects. The teacher can borrow slides of such subjects from natural history museums or find examples in scientific publications. Medical journals* are excellent sources and can be acquired from your family doctor or direct from the publisher. A single copy is apt to yield enough images to provide motivations for a number of projects.

At the opposite extreme from these microscopic images are the once invisible images from outer space, such as comets and nebulae. Photographs taken of the

*In particular, *M.D.*, published by M.D. Publications, Inc., 30 East 60 Street, New York, New York 10022.

moon's surface and of other planets, and those still to be made as the space program progresses, offer a timely gamut of inspiration. Newspapers and magazines abound in reproductions, both in black-and-white and color, of such photographs. (In conjunction with these images of the natural space environment, pictures of such relevant man-made objects as rockets, capsules, and jets also constitute motivational stimulation.)

Still another category of once invisible forms now made accessible to us through the aid of the camera is the variety of marine flora and fauna recorded by underwater photography in the course of oceanographic expeditions and research. Slides and photographs of these subjects, too, can be borrowed or purchased from natural history and marine museums, and reproductions can be found in either scientific or popular publications.

Slides and filmstrips on various kinds of art can be supplemented by motion pictures, either dealing with subjects, movements, or individual artists. Such superb examples as *The Works of Calder** or *Fiddle-de-dee,*** can furnish children with delight and inspiration for a considerable time. Although they involve the investment of money for purchase or allocations for rental fees, they are worth the investment, for they can be used in a number of classes or for an assembly of the entire school body. (It is useful to remember that the sound track can be turned off if it does not seem appropriate for a particular group, and the teacher can provide his own commentary.)

*Produced and narrated by Burgess Meredith; photographed and directed by Herbert Matter; narration by John Latouche; music by John Cage. 20 minutes, color, 16 mm. Available from The Museum of Modern Art Film Library.

**Produced by Norman McLaren for the National Film Board of Canada. 3 minutes 22 seconds, color, 16 mm. Available from Contemporary/McGraw Hill, 330 West 42 Street, New York, New York 10036.

Color reproductions, prints, and posters

Color reproductions (which come in a variety of sizes), prints, posters, photographs, and postcards are the most versatile tools for use in the classroom or studio. They have the advantage over slides in that they can be shown in a lighted room; also, several can be displayed at one time for contrast or comparison. Large reproductions and posters can be viewed simultaneously by an entire class, while smaller ones can be passed around from one child to another.

Any of these visual materials that are valuable and intended for frequent use by the teacher and children should be well mounted and protected. They can be mounted on some kind of a board backing, matted or trimmed, covered with plastic, and bound with tape or passe-partout. For displaying, they should be provided with hangers on the back or grommets (metal eyelets) in the corners. To hang the print and at the same time protect the edges, pushpins can be used against the edges without piercing the print itself.

Photography and typography

From the local photography shop, one can acquire old negatives, color slides, empty film cans and boxes, and color prints—especially those used for advertising and display—that can be cut up for collage. Most of these materials can also be solicited from children who take photographs, or from their parents.

Teachers who possess cameras (and every art teacher should) can make their own slides and photographs of interesting places and objects, of textures and patterns in nature, of manufactured objects, and of buildings. A closeup lens is particularly useful for photographing details, textures, and patterns that can be used to en-

hance art appreciation and to motivate students in their creative projects. At the junior high-school level, camera clubs can be formed with the purpose of discovering shapes and patterns for use in art projects.

In addition, teachers should build up a file of good photographs selected for their subject matter and composition as well as for their illustration of shapes and patterns. Henri Cartier-Bresson, Margaret Bourke-White, Edward Steichen, Paul Strand, Edward Weston, Walker Evans, and Jerry Uelsmann are a few among the many outstanding photographers whose work can inspire children and young people.

Typography is another art that can play a significant part in developing appreciation and motivating creative work in painting and assemblage. Individual letters, type faces, and patterns formed by pages of type are important for the teaching of design. Selecting tear sheets and cutouts from newspapers and magazines can constitute a valuable exercise for both teacher and child, besides providing materials for the collage supply. Children can also design their own type faces and carry them out in a variety of mediums—linoleum blocks, drawn lettering, collage using torn letters and words, and sculpture in clay, wood, or other materials. There should, however, be no attempt to have students design an entire alphabet or memorize the names of type faces. The study and designing of letters are important concepts and should be learned as techniques; they also provide the basis for interesting and challenging projects for students in junior and senior high school.

Advertisements seen on television, in newspapers and magazines, and on car cards and billboards are part of the child's everyday visual world. It is therefore desirable for the child to learn to evaluate their quality, as well as to design posters and advertisements of his own. A collection of well-designed advertisements and posters is as essential for the teaching of art as a file of good reproductions of paintings and sculpture. Slides may be purchased from museums or such commercial companies as Sandak in New York; copies of original posters are obtainable free of charge, or for a small fee, from advertising firms, travel agencies, airlines, and shipping companies. Advertisements can be cut from popular magazines, art magazines, and daily newspapers and used in collages and collage paintings.

Building up an informal library of visual materials

The most versatile and economical source of visual materials, and one that can be extended indefinitely, is a file that can be assembled by the teacher through collecting clippings and tear sheets from popular magazines, art publications, and newspapers (including advertisements), as well as travel folders. They can be placed in legal-size manila folders, which are inexpensive and practical because they will accommodate large-size pages from such magazines as *Life* or *Fortune*. Each folder should be marked with a subject or title and placed in alphabetical order in a steel file, where it will be easily available to the teacher and the children for their research.

The folders might be classified in categories that would include individual artists and art movements, specific subjects, different mediums and techniques, etc. The related arts—dance, music, motion pictures, theater—should also be included, as well as reproductions of works illustrating their relationship (e.g., painting or sculpture inspired by the dance, or by music, and so forth). Provision can be allowed for cross-reference, for example from the name of an individual artist or movement to a specific subject.

The following list includes some suggestions for headings (other than the names of individual artists) according to which such a visual file might be classified:

A

Abstract art
Aerial views
African art
Airplanes
Animals
 Domestic: Cats, Dogs, Horses, etc.
 Wild: Lions, Tigers, etc.; *see also* Fantastic art
Architecture
 Capitals and columns
 Castles
 Churches
 Houses
 Skyscrapers
Arms and armor
Automobiles

B

Birds
Boats
Bridges

C

Ceramics
Circus
Cityscapes
Collage
Color
Constructions
 Mobiles
 Stabiles
Costumes
Crafts; *see also* Ceramics; Folk art; Glass; Metalwork
Cubism

D

Dada
Dance

E

Electrical equipment
Engineering; *see also* Bridges; Roads
Expressionism

F

Fantastic art
Fish
Flags
Flowers
Foliage
Folk art
Frescoes; *see also* Murals
Fruit and vegetables
Furniture
Futurism

G

Games; *see also* Sports; Toys
Geometric forms
Glass
Graphic art
 Advertisements
 Book design and typography
 Posters
 Prints

H

Household equipment
Houses; *see* Architecture

I

Imaginary beasts; *see* Fantastic art
Impressionism
Insects
Interior design

K

Kinetic art; *see also* Constructions—Mobiles

L

Landscapes
Letters and lettering, *see* Graphic art—Book design and typography
Light
Looking down; *see also* Aerial views
Looking up; *see also* Telescopic views

M

Machines and machine parts; *see also* Electrical equipment; Household equipment; Tools and utensils
Marine flora and fauna
Masks
Metalwork
Microscopic views
Minimal art
Mobiles; *see* Constructions
Monuments; *see also* Sculpture
Mood
Motion
Multi-media
Murals
Music

N

Nature, miscellaneous; *see also* Animals; Birds; Fish; Foliage; Insects; Landscapes; Ocean; Reptiles; Rocks and pebbles; Seashore; Seasons; Shells; Trees and woods
Numbers

O

Ocean; *see also* Marine flora and fauna; Seashore
Op art

P

Painting—techniques
Patterns
People
 In action
 In crowds
Photography
Pop art
Portraits
Primitive art; *see also* African art; Folk art

R

Reptiles
Roads
Rocks and pebbles

S

Sculpture
 Reliefs
 In the round
Seashore
Seasons
Shells
Shields; *see* Arms and armor
Spears; *see* Arms and armor
Sports
Stars and planets
Still life
Surrealism

T

Telescopic views; *see also*
Stars and planets

Textiles

Texture

Theater

Tools and utensils

Toys

Transformed objects

Transportation; *see also* Air-
planes; Automobiles; Boats;
Bridges; Roads

Trees and woods; *see also*
Foliage

U

Uniforms

Utensils; *see* Tools and uten-
sils

W

Ways of seeing

World's Fairs

X

X-rays

Projects for developing creativeness

in children and young people

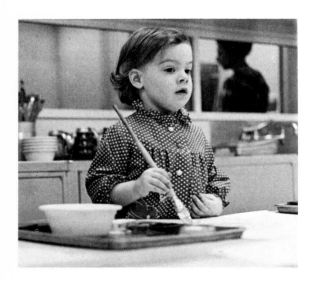

The following five sections are devoted to projects that range from those for preschool children of four to five to those for seventh- and eighth-graders—no longer small children, but young adults of thirteen or fourteen. Each section is introduced by a description of the characteristics of the general behavior and creative development of the age level for which the projects are intended. These descriptions serve to orient the new teacher and to recapitulate for the experienced one the behavior, interests, and needs of each group. There are, of course, no hard-and-fast characteristics pertaining to any one group: there is divergence in the group as well as in the individual. A six-year-old boy may have the characteristics and growth of a four-year-old, while a class of seven-year-olds may have, as a group, the characteristics of five-year-olds. Nevertheless, a knowledge of the general behavior and creative growth that may be expected for a group will provide the teacher with some guidelines for judging and working with it. Such knowledge enables the teacher to prepare a suitable approach, should a group turn out to be more or less mature or developed creatively than its chronological age would lead one to expect. Only by comparison with an earlier or an older level can we determine the stage of development of those who are new to us. It is therefore important for the teacher to be knowledgeable about all levels of growth, so that he can adjust his teaching to a lower or higher level as the situation may demand.

Considered abstractly or theoretically, a survey of these developmental stages may not seem very interesting. When they are illuminated, however, by actual situations

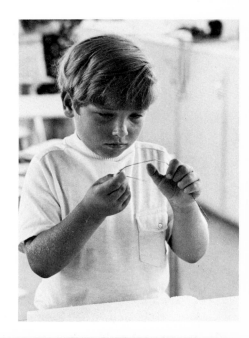

in which children are engaged in creative experience, and by fascinating examples of their work, they prove dramatic and exciting.

The projects are designed to integrate idea, aesthetic concept, tools, and materials with the creative interests and abilities of the respective age levels. The motivation for each project has been planned with a particular objective in mind, and the procedures described are tailored to the age level involved. It is important to realize, however, that all children do not conceive their ideas or execute them in the same way. Each child will start at his own time and proceed at his own pace, often backtracking if necessary, to reassure himself or to repeat a stage because he enjoys it. Some see their idea clearly at the outset and proceed to carry it out with only minor variations, whereas others start out with only a vague idea, which they develop in stages or steps as they go along. Still others do not conceive of the structure of the project or know how to proceed until the materials are placed in front of them. It is therefore advisable for a teacher confronted with a child who complains about not having an idea to say, "Take the materials and look at them a while, arrange them in different ways, and an idea may occur to you"; and it usually does. That is the very point when teaching in depth begins. Teaching does not cease or relax at the end of the motivational discussion. The teacher watches each child to see whether he is working on his own, and to discover any problems or confusion. He proceeds from group motivation to individual teaching. The activity of the child is more revealing than his spoken word. It is motivation that sets creative energies flowing.

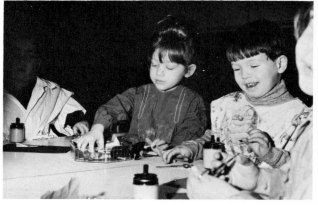

Projects for children four and five years old

FOUR AND FIVE are fruitful creative ages, full of wonder and adventure. The preschool child wonders about the world and the things in it; he adventures in creative experiences. The adult—especially the layman—wonders that so small and young a being can do so many things that seem impossible for tiny hands and fingers. The artist wonders at the directness of the child's approach to his materials, the spontaneity of his expression, the freshness of his vision, the innate sense of design in his selection of materials for a collage or a construction, and the originality of his concept. These are all qualities that the artist himself once possessed as a child, and which he must now strive with great trial and effort to recapture. Even at four or five, a child is already well advanced in his creative growth, especially compared to a three-year-old; and there is also a greater change within the year from four to five than occurs at older levels.

The four-year-old child

The four-year-old is alert, eager to explore, and quite sociable. He is independent and wants to be considered a big boy or girl. He is interested in and aware of forms and is able to make use of his discoveries in independent work. Four-year-olds are egocentric; they see the world only through their own eyes and cannot imagine any other way of seeing it. They become

completely absorbed in whatever they are making. They also regard themselves as much more grown-up than three-year-olds. This is especially true of an "old" four—a term which is appropriate because there is so much change within a single year that the terms "young" and "old" four are quite descriptive.

On the whole, the span of concentration of four-year-olds is longer than that of three-year-olds. The average time is from fifteen to thirty minutes, but some may work an hour or longer. They can manipulate materials and enjoy doing so, because it gives them a sense of mastery to change the colors in their paintings and the shapes in their collages, or the forms in clay, as they work. In painting and collage, they usually use the whole paper for their compositions, often organizing it and filling it completely with shapes and colors.

When working in clay, the four-year-old represents definite things. He builds them by adding parts together rather than by pulling forms out of the lumps of clay. Work in collages and constructions includes cutting out shapes with deliberation, but some may have difficulty in pasting. Although the four-year-old can choose and combine materials easily, he has difficulty in tying or connecting them together.

The five-year-old child

The five-year-old concentrates longer than the four-year-old—about twenty to forty minutes, and a few for more than an hour. Often this concentration may be focused on one piece of work, but it may also be on two or three successive pieces. The child is inclined to plan his paintings ahead of time and to make positive shapes. He exercises greater deliberation and selectivity in mixing colors. Sometimes he may change his work, however, and paint over already painted areas, but this is apt to be more true in the case of a child who is just beginning to paint.

When working in clay, five-year-olds construct and combine forms better than fours. They make more complex pieces and show greater discrimination and purpose in selecting the materials they add to the clay, in contrast to younger children—particularly the "young" four-year-olds—who tend to add materials as instinctive acts, for the fun of sticking things into the clay.

The assemblages of five-year-olds are thoughtfully planned and executed. Children of this age enjoy making collages and constructions, and they are particularly fascinated by mobiles, because their movement is a new discovery within their creative experience. They not only see materials freshly and in new ways but use them as the means to invent things of their own—things that are original and imaginative. In handling their materials, five-year-olds show their advance over four-year-olds by using scissors and other tools more efficiently and with greater assurance.

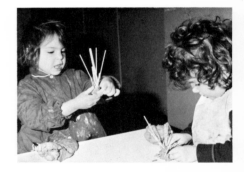

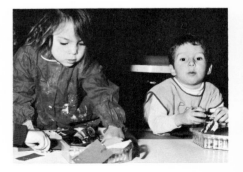

Painting motivated by collage, I: a circular shape

PURPOSE

To use collage as a stimulus for a painting; to make children aware of geometric shapes.

MATERIALS

Different colors of construction paper, 6″ x 9″, cut into circles 5″ in diameter. (The leftover pieces with holes cut out should be saved for the following project.)

White paper, 18″ x 24″, at least one sheet per child

Paint

Before the children entered the room, the teacher laid on the tables sheets of paper, on each of which she had pasted somewhere a circle of colored construction paper. When the children came in, some were attracted by the circles and chose a sheet because they liked the particular color of the circle pasted on it; others sat in their usual places, and a sheet was given to each one.

> *Teacher:* What is the shape on the paper in front of you?
> *Susan:* It's round.
> *John:* It's a circle.
> *Teacher:* What does a circle remind you of?
> *Alice:* A sun.
> *George:* A moon.
> (Several repeated the words "sun" and "moon.")
> *Teacher:* Does it remind you of anything else?
> *Lorrie:* A balloon.
> *Elsie:* A face.

The children were obviously impressed by the circles on their papers, even though many began painting at once without waiting for the discussion. Some used the circle as a focal point and painted around it (fig. 1). A few obliterated or at least de-emphasized it by painting over it (fig. 2). For others, it became part of a face or a figure (fig. 3). The pasted collage, used as the motivation for a painting, provides some children with a definite incentive, and their paintings become richer than when no collage is used.

To make progressive projects, the number of pasted circles can be increased to two or three.

APPLICATION TO OTHER AGE LEVELS

The project can be adapted for use with older children by motivating them to incorporate the shapes into representational paintings.

1

2

3

Painting motivated by collage, II: a negative shape

PURPOSE

To teach basic shapes; to encourage awareness of negative shapes.

MATERIALS

Construction paper of various colors, 6" x 9", each with a 5" hole in it. (These have been saved from the preceding project.)

White paper, 18" x 24", at least one sheet per child

Paint

Before the class, the teacher had pasted a rectangle of colored construction paper with a hole in it on each sheet of 18-by-24-inch white paper and laid one sheet at each place. When the children entered, each one chose a place.

Teacher: Look at the shape on your paper and tell me what it is.
Children: It's a circle.—It's a balloon.
Teacher: Yes, but look at the circle. (Holding up an un-mounted piece of construction paper with a hole in it, she first looked through it, then put her finger in it.) What is it now?
Children: It's a hole.—It's a round hole.
Teacher: What does it remind you of?
Patricia: A box. You can put something in it like candy.
Nancy: It reminds me of my mother's sewing box.
Teacher: Very well, we can begin painting, and if you want to put anything in the box you can paint it in.

Some started painting around the pasted paper; a few painted inside the hole; others painted at the opposite side of the paper, seeming to ignore the pasted piece. The color and shape of the rectangle with its cutout circle nevertheless provided a definite motivation. The children repeated the color or the shapes of the pasted piece, producing color harmonies and rhythms of lines and masses (figs. 1, 2). Some even repeated on other parts of their sheets the textures they had used to suggest objects in the hole (figs. 3, 4).

APPLICATION TO OTHER AGE LEVELS

As with the previous, related project, a similar motivation can be adapted for use with older children.

1

2

3

4

A collage painting: buildings

PURPOSE

To use the child's interest in building in three dimensions as a motivation for two-dimensional expression.

MATERIALS

Several sets of building blocks, including arches, semicircles, and triangles, for the preliminary stage of building. (Children can use the sets in turn if there are not enough to go around.)

White drawing paper, 18" x 24", at least one sheet per child

Construction paper of various colors, cut into rectangles and squares 3" x 6", 6" x 6", and 9" x 9", at least three pieces per child

Scissors

Paste

Paint

The teacher placed several sets of building blocks on a large table and invited the children to use them to build houses. Each child made his own composition, arranging the blocks side by side or piling them on top of one another. After everyone had made several experiments, the teacher said they would try a collage painting. She held up pieces of the colored construction paper, precut into different sizes, and said they could be used for the buildings. The children could cut windows and doors in them, or add these later with paint. The pieces could be pasted down on the 18-by-24-inch white drawing paper in any arrangement the children wished; when they had finished pasting, they would be ready to paint.

Some of the children pasted the pieces of paper for houses on the white background of the drawing paper at random, without cutting them. Others cut out doors and windows, some cutting out the shapes completely to leave holes (fig. 1), while others left flaps like open doors (fig. 2). One boy folded the sides back so that the building stood out from the background, producing an accentuated three-dimensional effect. David scattered the buildings without regard to a ground line. A few used a formal row arrangement. Carolyn piled a number of shapes on top of one another as if they were blocks, with a result suggestive of a complex stepped-back building (fig. 3). The children then painted on the buildings, around them, or both. The finished collages were direct and free, with the pasted paper serving only as starting points or focal areas for the painting.

APPLICATION TO OTHER AGE LEVELS

This project should not be attempted with younger children, but it should appeal to the six- to seven-year-olds.

1

2

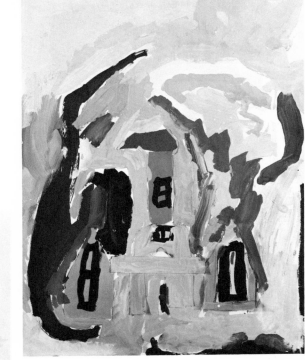

3

A collage using different materials: my favorite color

PURPOSE

To help children learn about colors—their particular identity and their relationships; to help them acquire a simple sense of selection or discrimination.

MATERIALS

Construction paper of various colors, 6″ x 9″, at least three sheets per child

Corrugated paper, patterned and solid-colored paper, cloth and fabrics, cut into small pieces 2″ x 2″, 2″ x 4″, 3″ x 4″ (or irregular scraps from other classes may be used).

Feathers

Yarn in short lengths

Drinking straws

Paste

The teacher told the children that they were going to make collages using their favorite colors. Each child was to choose his own color and pick out different materials, all in that color, to make his collage. She demonstrated the idea by holding up pieces of material from the supply placed on the table: a pink feather, a strand of pink wool, a piece of pink net, a swatch of patterned fabric with pink predominating. She called each piece she chose a little brother, sister, or cousin and put it with the others as part of the same family. She laid these on a piece of pink construction paper as a background, and explained that they would be pasted down to make the collage. The pieces to be pasted were precut to avoid the child's having to interrupt himself to stop and cut a piece, thus breaking his train of concentration. Particular care had been taken to have a good range of colors in each material.

The teacher had the children choose their colored background papers first, so that these would guide them in choosing their collage materials, which she stressed were to be of the same color as the background. As the children worked at picking and rejecting materials, the teacher spurred the hunt by calling out, "Who's looking for a blue? or a green?" Occasionally a child chose a color different from his background. When one picked out a piece of green, after having chosen blue for her collage, the teacher asked, "Is that blue." "No," the child replied, "but it looks so good on the collage." This might have been accidental; on the other hand, the child might have been aware of the relationship between blue and green, for even children as young as four or five sense harmonies between colors, although they may not be able to rationalize the relationships or know the vocabulary. For example, a five-year-old selected a piece of purple paper to go on her all-yellow collage, because she said she liked it; of course, she did not know that she was producing a harmony of complementaries.

APPLICATION TO OTHER AGE LEVELS

This project can be adapted for use by children at older age levels. It is especially appropriate when adapted for six- to ten-year-olds, who should cut the shapes and sizes of the collage materials themselves.

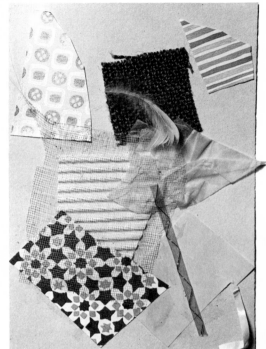

1

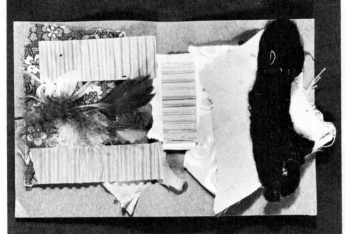

3

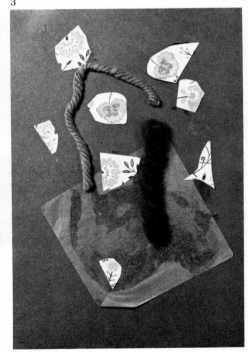

2

A flag collage

PURPOSE

To give an added dimension to a learning experience by adding a surprise element: the changing of a collage into a flag. This involves merely stapling a stick onto a collage.

MATERIALS

Construction papers of various colors, 4½" x 6", at least one sheet per child

Corrugated cardboard, and colored or patterned paper, cut into 2" x 3" pieces

Coffee stirrers or tongue depressors, one per child

Paste

Staplers

This project represents an advance or extension of the children's earlier experiences with collage, by introducing the element of surprise. Children of this age particularly enjoy the idea of a game or surprise element, which heightens their interest and increases their sense of anticipation. Though the mere act of stapling a stick onto a collage to make it into a flag may seem very simple, to children of four or five it represents a great change in their concept and use of the materials.

The teacher said, "Today our collage is going to be a surprise, but you have to make the collage first before there can be a surprise. All of you have made collages, so here are the colored paper and the pieces for you to paste on it to make your collage today."

The children responded by hurrying to make their collages, selecting the precut materials and pasting them onto colored construction paper in the usual way (figs. 1, 2). A few children wanted to alter their pieces by cutting them, as Thomas did (fig. 3). When the first collage was finished, the teacher took it and announced to the entire group, "Look, everybody, I'm going to show you the surprise." She then stapled a coffee stirrer to one of the short edges of the collage, so that it extended a few inches below the bottom of the paper. Holding it by the end, she waved it and said, "Look, it's a flag." As each child finished his collage, he transformed it into a flag; a few needed to have the coffee stirrers tacked on by the teacher, but most could do it themselves.

Because of the wide span in awareness, understanding, and work habits between four- and five-year-olds, comprehension and execution of this project may vary markedly, and the teacher should accordingly adjust her approach both to group and individuals.

APPLICATION TO OTHER AGE LEVELS

The project is especially suited to the age level for which it is intended and is not suitable for older children unless it is made more challenging.

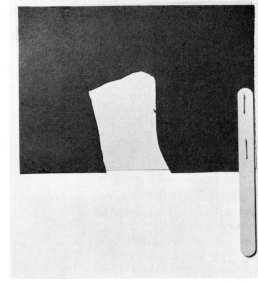

3

1

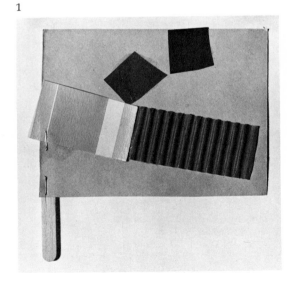

2

An assemblage of paper strips

PURPOSE

To make a collage out of multiple strips; to introduce the concept of open spaces as part of a design by making a collage without a background.

MATERIALS

Construction paper of various colors, cut into strips approximately 1″ x 6″, ten per child. (These can be scraps left over from other projects; it is a good idea to keep a box of such scraps and cut them up as needed.)

Paste

Scissors

The teacher said, "Most of the collages we have made before have been pasted onto pieces of paper. Now we will make a different kind. We'll paste these strips over each other and leave holes so that we can see through it." To demonstrate, she held up a collage made of crisscrossed strips of paper and looked through it at the class. She also showed the children the method of pasting by putting a dab of paste on the spot where two strips were to cross each other and pressing them together to attach them.

The children found the project fascinating and easy to carry out. They used a variety of colors for the strips they pasted over each other. Most crisscrossed the strips at random, but a few held to a more regular pattern of horizontals and verticals. One five-year-old girl wove the strips in and out of each other.

When the collages were finished, a piece of yarn or string was fastened to the top of each one for hanging. When they were all hung on the wall, they seemed similar, but each child was able to identify his without difficulty.

APPLICATION TO OTHER AGE LEVELS

This project can be done by older children as a more complex design problem.

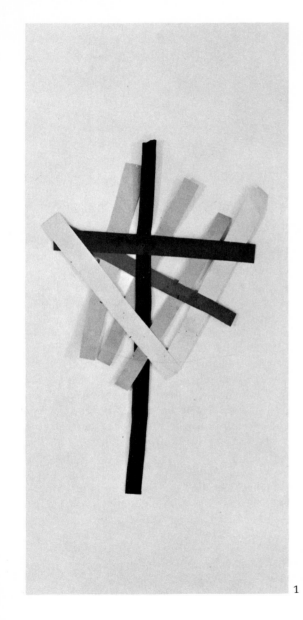

1

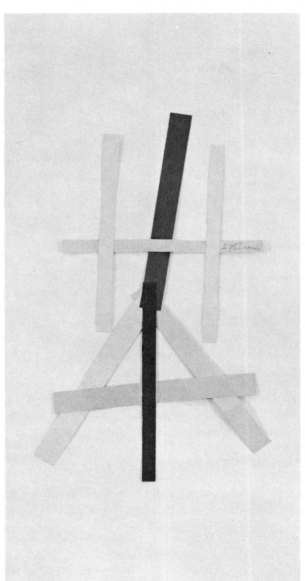

2

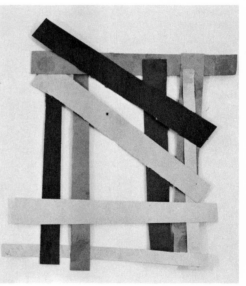

3

A collage greeting card

PURPOSE

To develop a simple idea of three dimensions at an early age level, by bringing concepts of form and space into work with collage.

MATERIALS

Construction paper of various colors, 6" x 9", at least one sheet per child

Collage boxes (see page 16), one for each two children

Scissors

Paste

Paper punches (optional)

This project resulted from the request of some of the children to make something for Mother's Day, but it is equally appropriate for any holiday or for birthdays. A major motivating force is the child's desire to make something for a person he loves.

Before the class began, each 6-by-9-inch piece of colored construction paper had been folded to make two leaves 4½ by 6 inches. The teacher began by saying, "What shall we make? What will you take home?" She introduced the idea of making a collage card by taking one of the folded pieces of paper and standing it on end, calling it a "standing collage." She referred to the earlier collages that the children had made on a background, and demonstrated the difference between a flat collage and one standing in space. She also drew attention to the front and back, and to the inside pages; but she did not mention using a name or a message, and the children did not require it, nor did she suggest a subject.

Stimulated by the idea, the children were ready to make their collages and went to work at once, selecting materials and pasting them down. A collage box was placed between two children for them to share; each box contained approximately the same materials in order to avoid any conflict or competition. Some chil-dren started on the inside pages of their cards, while others began with the back and front; some placed collage on all four sides. They were proud to show the various sides, turning them around and holding them up for the teacher to see. The four-year-olds did little or no cutting, so the process became one of selecting and pasting of materials (fig. 1). Five-year-olds, however, cut pieces and were more deliberate in making their designs. Some children wished to include painted areas in their cards, as Andrew did (fig. 2). The introduction of the paper punch can give added interest to the project by allowing holes to be made as part of the design; in this case, however, no fabric should be included in the collage materials, because the children cannot punch holes through it and become frustrated.

APPLICATION TO OTHER AGE LEVELS

This project can be used effectively with older children by making both the idea and the materials more complex. Older children will want to incorporate names and messages, and this offers some experience in lettering and the use of typography. Words or phrases can be cut out of newspapers and magazines and pasted down as part of the collage.

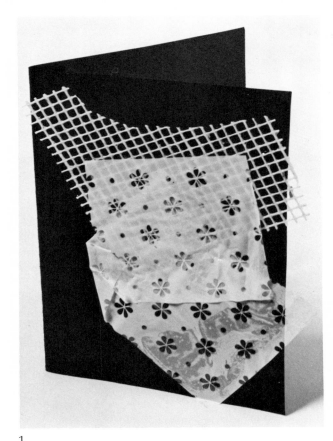

1

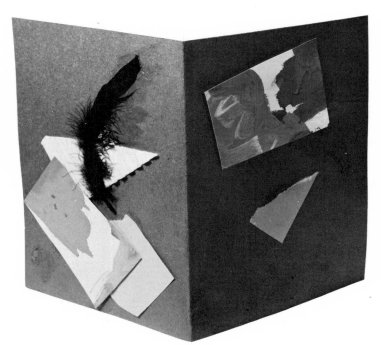

2

Collage construction: making crowns

PURPOSE

To stimulate the sense of fantasy by appealing to the desire for self-adornment; to develop a group spirit.

MATERIALS

Construction paper of various colors, cut into strips 24″ long by widths ranging from 4½″ to 9″, and strips 1″ wide by lengths of up to 9″, at least two per child

Tissue paper and net, cut into 3″ squares

Wool, assorted colors

Pipe cleaners

Straws

Scissors

Staplers

Paste

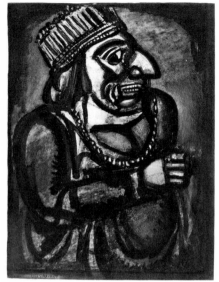

Rouault *We Think of Ourselves as Kings*

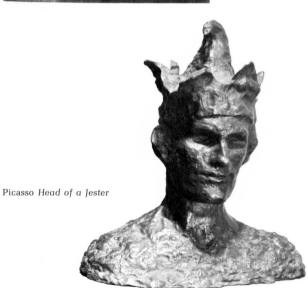

Picasso *Head of a Jester*

The teacher showed reproductions of Georges Rouault's *We Think of Ourselves as Kings* and Pablo Picasso's *Jester*. Taking a band of the precut colored paper 24 by 4½ inches, she put it around her head, overlapping the ends until it fit. Then she showed how the band could be decorated by cutting the edges and by stapling or pasting pieces of collage material around it. She spoke about the regal effect of a crown produced by shapes going up.

The children chose paper strips for the bands, selecting wide strips if they wanted high crowns or narrow ones if they preferred low crowns. First they decorated the strips with collage. One boy used straws all pointing upward; another used only wool (fig. 1). One girl stapled straws and tissue paper to her crown (fig. 2). Children who found the stapler a little difficult to handle pasted their materials on. A few children cut the edges of the band, and others followed their suggestion (figs. 1, 3). As each child finished his strip, the teacher helped by fitting it to his head and stapling the ends together. The children were so pleased with their crowns that they wore them in the class.

APPLICATION TO OTHER AGE LEVELS

This project will appeal to six- and seven-year-olds, and to older children, depending on the sophistication of the group.

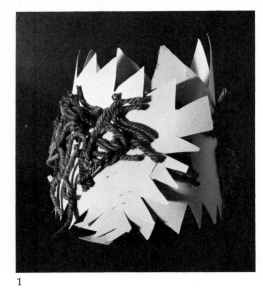

1

2

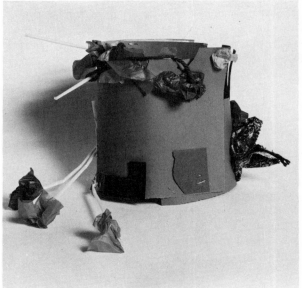

3

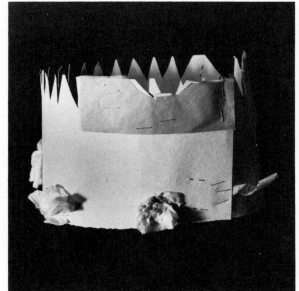

A flower construction

PURPOSE

To make a three-dimensional construction by applying collage methods

MATERIALS

Cardboard strips, 1" x 10" (shirt boards or any available), approximately three per child

Tarlatan and tissue paper, various colors, cut into 3" or 4" squares, approximately ten per child

Pipe cleaners, various colors, at least one per child

Moist clay, rolled into balls approximately 3" in diameter, at least one per child

Paste; staplers

Redon Vase of Flowers

Color reproductions of flower paintings—Odilon Redon's *Vase of Flowers* and Raoul Dufy's *Tulips and Anemones*—were displayed to give the children stimulating visual impressions for the flowers they themselves would make. The teacher asked whether the children had seen flowers like those in the paintings either at home, in the park, in florists' windows, or in the country. "Did you ever blow on a flower to make it move? The wind does." She pointed out that some flowers are slender and delicate, while others are big and strong. She showed them pieces of colored tarlatan and tissue paper and told them that they could make their own flowers by using the pieces as they were or by folding or crushing them. Holding up a white cardboard strip, she demonstrated how petals could be pasted on both sides of it so that the flowers would be interesting to look at from the front or the back.

The four-year-olds pasted paper or tarlatan along the two sides of the strip, some without changing the shape and seemingly aware only of the color. Others, particularly the five-year-olds, folded or creased the materials to suggest the form of petals (fig. 1). Only a few of the children used the colored pipe cleaners included among the materials, bending them around the cardboard strips to give an added touch of color and a lively effect to the design (figs. 2, 3). When the flower strips were finished, the teacher showed the children how to take a ball of clay and flatten its bottom, making a base that would stand without rolling off the table. The children then "planted" the flower strips in the clay balls; several of them made two or three flower strips and stuck them into the clay bases to give the effect of a flowering plant or bush. When the group assembled all the flowers, they made a glorious bouquet.

Note: This project may be done at any time but it is especially good in the spring, when children become aware of flowers and the project appeals to them more readily. City children are more apt to have seen flowers only in vases at home, in window boxes, in florists' windows, or perhaps in the park, whereas country children and suburban children are more apt to have seen them growing in their own or their neighbors' gardens, or in open fields. Both, however, seem to enjoy making their own flowers.

APPLICATION TO OTHER AGE LEVELS

Older children may enjoy a similar project, with more complex flower constructions and a greater emphasis on movement in the finished assemblage.

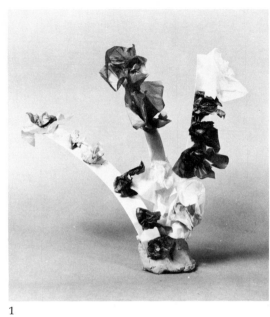

1

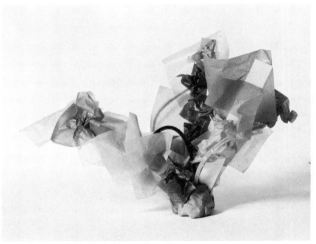

2

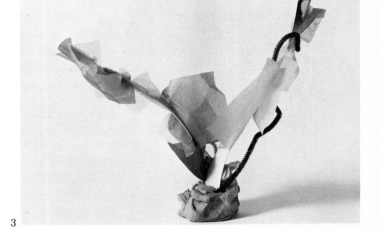

3

Wire construction, I

PURPOSE

*To introduce the child to the experi-
ence of working with wire.*

MATERIALS

*Florist's wire, 22 gauge, 18" long,
about two pieces per child*

*Moist clay rolled into balls 2" in di-
ameter, at least one for each child*

The teacher demonstrated the properties of wire by bending it into various shapes—a right angle, an arc, a zigzag line. She made a curve in it, twisted it around her finger, made funny shapes with it. Then she took a lump of clay, shaped it into a ball, and stuck one end of the wire into the clay ball, flattening its bottom to make a base for the construction.

The children were fascinated with the demonstration and eager to begin making their own wire constructions. Each made a clay ball, then took a wire and shaped it. There was no attempt to imitate or try to remember exactly what the teacher had done (her construction had been destroyed and the clay put back into the supply). The children were content to manipulate the wire and make their own shapes. Some stuck one end of the wire into the clay; others stuck in both ends. Only a few used two balls, or two pieces of wire.

APPLICATION TO OTHER AGE LEVELS

The next project carries this one further, and it could be elaborated still more for older children.

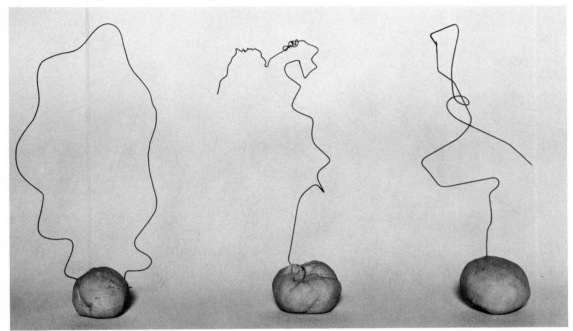

1

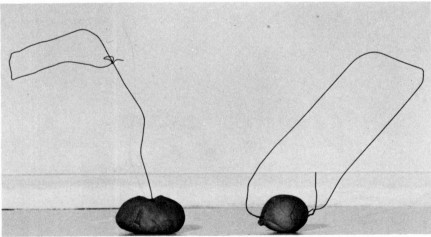

2

Wire construction, II

PURPOSE

To continue the exploration of the special properties of a single material, wire.

MATERIALS

Florist's wire, 22 gauge, 18" long, about three pieces per child

Pipe cleaners, various colors, at least one per child

Colored tissue papers, and various thin or loosely woven fabrics like net or burlap through which wire can be threaded easily, cut into pieces about 2" x 4" and 3" squares, about six pieces per child

Straws

Wooden applicators

Moist clay, rolled into balls about 3" in diameter, one per child

The teacher demonstrated the character of wire by bending it into various shapes—a right angle, an arc, a zigzag line. She threaded one end of the wire through a piece of colored tissue and stuck the other end into a lump of clay. She showed the children how to make a base by pressing the bottom of a clay ball on the table to flatten it.

The children made their clay bases first; some just pressed the ball with both hands, while others flattened it on four sides to form a rough cube. They then wiped their hands to avoid soiling their materials. Each child started with one length of florist's wire, but some eventually used two or three. Some bent the wire to form angles or curves; others twisted it. A few bent two wires together near the middle and spread them apart at the top. Then they threaded tissue paper or fabric on the wire, some using only a single material and others several pieces of different materials. They then stuck their constructions into the clay bases. Next, each child selected one or two pipe cleaners, bent them, and added them to the construction (figs. 1, 2, 3). Some also added the wooden applicators, making straight lines that contrasted with the bent wires.

APPLICATION TO OTHER AGE LEVELS

This project can be used instead of the preceding one to introduce wire construction to older age levels.

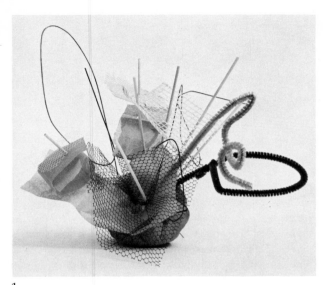

1

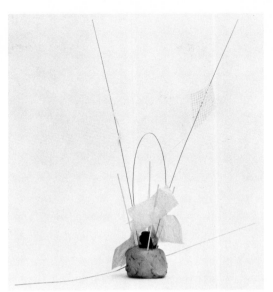

2

3

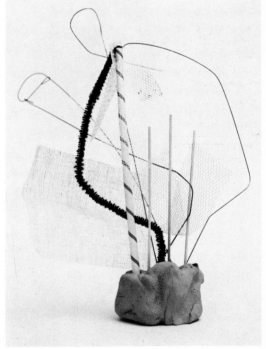

A construction of clay and toothpicks

PURPOSE

To develop skill and balance in the young child's three-dimensional expression by taking advantage of the pleasure children at this age level derive from making little balls of clay and sticking things into them, and from piling things on top of each other as in block building and simple collage.

MATERIALS

Moist clay, rolled into balls at least 4″ in diameter, one for each child

Natural or colored toothpicks, one box for each child

Caution: *The clay and toothpicks can be used again and again, but care must be taken to remove all toothpicks from the clay to avoid causing injury to the hands.*

When the children entered the classroom, they found several piles of clay and boxes of toothpicks on the table. They all sat down around the table, and the teacher, by rolling pieces of clay in her hands, made a small group of clay balls each about ½ inch in diameter. She then flattened a piece of clay into a lump about 1 inch thick and 3 to 4 inches wide. Each child watched and then produced a pile of balls and a flat piece. The teacher then took a toothpick and stuck a ball on the end of it. "I can do that," a four-year-old called out. The teacher answered, "Yes; can you do this too?" She stuck the pointed end of the toothpick into the base, made a second ball and toothpick which she also stuck into the clay, and then bridged the balls with a third toothpick. The children quickly caught on to the idea and began on their own constructions.

Children love to slap and pound clay at this age and often do it without making anything. Actually, in this project, the motivation and procedure go hand in hand, as at this age level children learn more from the visual part of the demonstration than from the verbal description and advice. The children did not follow the demonstration precisely, but they got the idea of supporting and balancing, working in different ways. The teacher suggested the association with building blocks and cautioned that the structures would fall down if they were built too high. When a part collapsed, or a single unit fell off, the children took the structure apart and rebuilt it in a different way. The concept and the process of creating were integrated, because the children worked without a plan in mind, building their structures as they went along. They had no intention of making a finished product, because the activity itself was the object. When the session was over, the constructions were dismantled, and the toothpicks and clay collected separately, as blocks are put away after one has finished playing with them.

APPLICATION TO OTHER AGE LEVELS

Although this project is particularly suitable for this young age, it may be used as a "starter" for six-year-olds who have had no previous experience with three-dimensional construction.

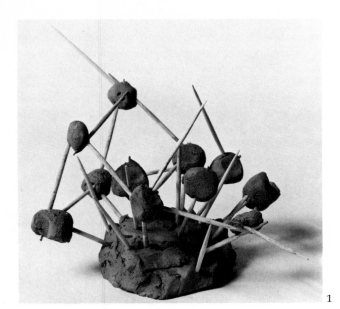

1

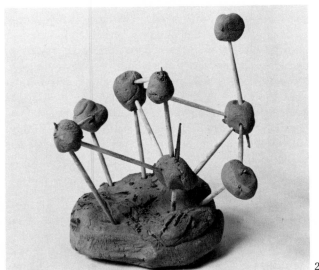

2

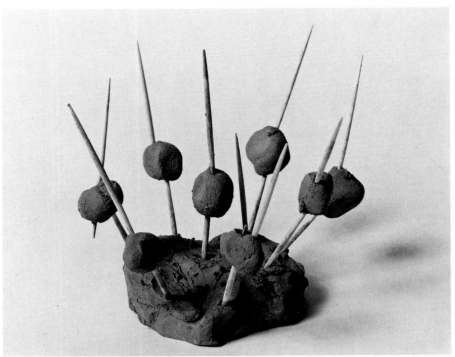

3

Projects for children six and seven years old

THE PROJECTS IN THIS SECTION are designed to integrate idea, aesthetic conception, tools, and materials with the creative interests and abilities of children from six to seven. Children of this age go to school and have established certain routines and habits. They are less egocentric and more sociable than preschool children. They can communicate with each other and with their teachers; they know how to operate in a group and how to work with adults other than their parents. They are playful and often rambunctious—the boys especially. They want to touch everything. They can't wait, and as soon as their tools (brushes, scissors, and staplers) or materials (paint or clay) are put in front of them, they start to touch and manipulate them immediately. It is therefore important that the motivation be directed toward immediate action, that it be brief and challenging, and that whenever possible the materials not be set out until after the motivation.

The teacher should offer the motivation in the form of provocative questions, which call for a give-and-take between her and the children, instead of making a speech while the children wait, champing at the bit to begin. Children of this age can work as long as an hour, but at times after working for only ten minutes they may ask, "What am I going to do next?" The motivation should therefore be based on some absorbing activity, and if there are children with a short attention span, the motivation can be broken up and given at different stages of the project, such as the selection, construction, and painting.

Assemblage is ideally suited to this age level, because it involves the child immediately in an activity—choosing materials and putting them together. They enjoy working in three dimensions, and if asked to choose a material, clay is usually their favorite, at least until they have experienced the making of stabiles and

mobiles. Because they want to appear grown-up, all the motivations must differ from those they associate with younger age levels. Although six- and seven-year-olds enjoy painting, they often associate it with writing and drawing with crayon, which they have learned in their other classes. As a result, they paint by drawing first, and this accounts for the black lines they so often use in their work. They have to rediscover the use of the brush as a painting tool for creating masses and textures as well as for drawing lines.

The degree of maturity varies not only from the six-year-olds to the seven-year-olds, but also among the six-year-olds as well. Some have had no previous experience in art, either at home or in a class. Some are timid, others aggressive; some are verbal, while others talk very little. There is a difference in comprehension as well as in performance. Six-year-olds are apt to regard a white sheet of paper with awe, just as the artist is often terrified when confronting a new canvas. Some start off spontaneously and boldly, while others are deliberate or hesitant. The teacher must take these differences into consideration and make the motivation broad enough to encompass all the differences and stimulate all the children. She should encourage every kind of expression and use subjects or ideas that are generally exciting.

Besides wanting to experiment, children of this age are interested in animals and in stories, but their experience of a particular subject may be limited. For example, the animals that are familiar to them may include only pets, such as cats, dogs, and bunnies, which they repeat again and again, perhaps in clichés. The teacher can capitalize on their interest by showing pictures of other creatures that the children may never have seen, such as fish, insects, or wild animals. This will sharpen their observation, memory, and imagina-

tion. The purpose is not to copy the animal but to use it as the basis for an imaginative object or form.

The teacher may read a story and have the children paint as she reads. They do not have to illustrate the story but can paint whatever they feel like—gay colors, or objects, or things that occur to them because of the story, but which may not necessarily be included in it. The teacher can ask leading questions: "Was it a sad or a happy story? What do you suppose the little boy in the story was thinking? Was the street noisy or quiet?"

A combination of collage and painting appeals to six- and seven-year-olds. Some elements of the picture may be collage, either made first or added to the painting. Collage painting is especially helpful because it provides the child with something more than paint as a starter; a piece of colored paper or a texture can stimulate a beginning, which the painting can enhance.

Through the motivation, collage and construction can lead the child from a realistic concept to an imaginative one. A box can be imagined as many things, and it can be transformed into a house, a spaceship, a treasure chest, or whatever occurs to the child.

Tools and materials have a great appeal to children of this age level and, if permitted, they would try to use all of them at once. The teacher should therefore include tools and materials as part of the motivation and demonstrate their use in a particular project. The stapler, for example, which is rapid and mechanical, fascinates some children, and the teacher should allow them to experiment with it to satisfy their curiosity and pleasure in working with it; but she should also show them how a stapler fastens certain materials together better than paste does. After a little experience with them, the tools cease to be novelties and become useful for their intended purposes.

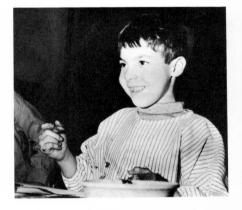

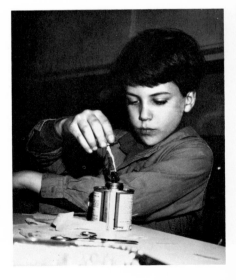

Drawing with yarn: a line collage to motivate painting

PURPOSE

To use collage as an approach to drawing; to encourage the basic experiences of spontaneity and experimentation.

MATERIALS

Yarn of different colors, the thickness of a lead pencil, cut into 2' and 4' lengths, at least two pieces per child. (Shorter pieces can be tied together; if yarn is not available, soft string can be used.)

White paper, 18" x 24", at least one sheet per child

Rubber cement

Paint

A piece of yarn or string is used to introduce line as a concept in art. It is dropped on the paper to produce an accidental line or shape as a starting point; the composition is then built around the line or yarn, which is pasted down and incorporated into the design. The child drops the yarn several times until it makes a shape that pleases him, so that accident is transformed into directed purpose. Children enjoy the experience, and it presents a way of working with line without the necessity of using a tool and erasing the effect if it is not satisfactory.

"We are going to draw before we paint. We shall draw a line. A line can be drawn with pencil, crayon, charcoal, or paint." The teacher demonstrated, first drawing straight and curved lines in charcoal and then making free-form lines. "But we shall not use any of these ways of making lines today, because I am going to show you a new way. We shall draw with a piece of thick yarn." The teacher held a piece of yarn about 2 feet long above a sheet of white paper and let it fall, creating a line. She repeated this several times; each time, the line was different. "Now try it for yourselves. Choose a piece of yarn of any color. If you have an

extra long piece of yarn, put your paper on the floor and drop the yarn onto the paper. After you've dropped the yarn a few times, try another way. Hold it high by one hand and let the other end touch the paper. As you lower the yarn, change the direction of the line with your finger, if you like. You are drawing with yarn!"

Each child selected a piece of yarn and a sheet of white paper. They dropped the yarn onto the paper and had great fun seeing the results, doing it again and again. They tried directing the line as it fell. When they found a line they liked, they pasted the yarn down a little at a time, carefully brushing the rubber cement onto the paper under it, not on the yarn itself. A few used more than one piece of yarn. They had become sensitive to the quality of line in a new and spontaneous way. When they were ready to paint, the teacher suggested that they might paint inside or outside the yarn, and could make either an abstract design or a picture of anything that the line suggested to them. Some began inside the shape or painted along the edges of the yarn. Others painted all the space outside the shape and approached the yarn last. A few repeated

1

the course of the yarn several times, creating a kind of linear rhythm (fig. 1).

Some of the reactions:

Andrew (one of the most articulate members of the class): I just meant it to be really a design. Most of the colors are mixed.

Teacher: How did you like starting with the yarn, Andrew?

Andrew: It gives a good start, I mean a main start.

Donna: This round shape suggested a face to me. I don't think I would have made a face without the yarn.

Sarah: It's an angel. It was easier with the yarn (fig. 2).

Betty: I like to start with the yarn. It was fun dropping it and seeing the shapes that just happened.

Stephen: I liked starting with the yarn, but I don't know why.

APPLICATION TO OTHER AGE LEVELS

This project can be applied not only to older children but even to adolescents and adults. They can direct the yarn or string to use it more purposefully in their drawing; for example, junior-high-school students can draw from the figure, interpreting the contours in yarn or string.

2

Collage painting
with yarn: trees

PURPOSE

To satisfy the child's desire to draw a subject, by using yarn as a new way to draw, replacing the pencil; to conceive of line simply and directly and stimulate the imagination.

MATERIALS

Yarn of various colors, such as purple, red, yellow, orange, ¼″ thick, cut into 15″ to 20″ lengths, at least one or more length per child

White paper, 18″ x 24″, at least two sheets per child

Paint

The teacher displayed several photographs of trees—single ones, trees in groups of three or four, and trees in a forest. She called attention to their shapes and how they differed in this respect just as people do. She pointed out that the shape of a single tree and of a clump of trees differed, too. She asked the children to observe other characteristics. They noticed that some trees looked alert and eager, while some looked droopy and tired. One child saw a large tree with small trees around it and was reminded of a mother with her children. The teacher also called attention to the branches, their thickness, and whether their lines were straight or curved.

Next, the teacher demonstrated the use of the yarn by dangling it and letting it fall. Then she showed how its direction could be changed without losing the accidental quality. She said that the children would make trees by dropping yarn onto a piece of paper in this way, and then adding paint. The children could either choose one piece of yarn for a single tree, or a number of pieces for a group of trees or a whole forest, as many as they wished. The challenge was to use each piece of yarn without cutting it; if it was too long, they could make more curves or double it for thickness.

When, after selecting their pieces of yarn and drop-ping them onto their papers, the children had achieved the tree shapes they desired, they pasted the yarn down with rubber cement. Then they began painting inside and around the yarn in a free manner. They were encouraged to use colors and add more trees with the paint, or anything that suggested itself. The teacher called attention to the fact that several children had used brightly colored yarn—red or purple—for the tree trunks, branches, or foliage, and that since they had used their imagination with the yarn they could do the same in painting, for instance, making red or yellow trees. Some children added painted trees, while others put in flowers; one child made a gigantic flower among the trees. Others painted winter scenes with barren trees, others fall scenes with colorful trees. None were interested in realistic trees or colors, or asked for green or brown paint. They were too involved in ideas from their imaginations. Emily titled her work *God is in the Tree* (fig. 4).

APPLICATION TO OTHER AGE LEVELS

This may be applied to older age levels, especially eight to ten years, to overcome the drawing of trees by clichés and develop sensitivity to line quality.

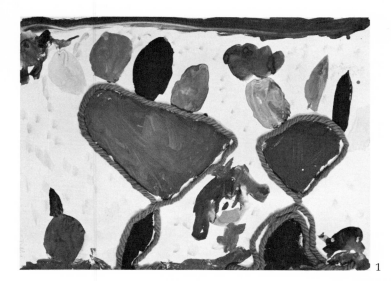

1

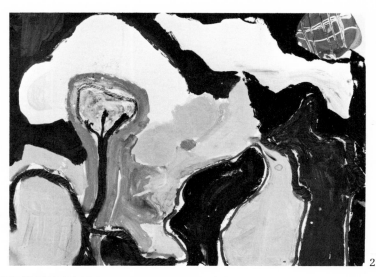

2

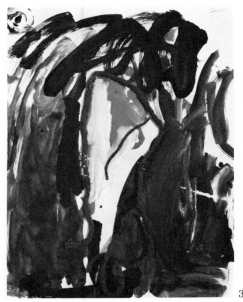

3

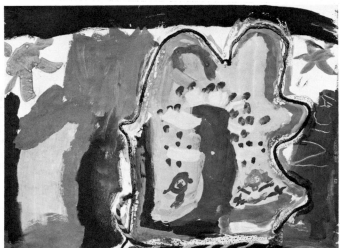

4

A collage painting: the city

The teacher showed a dramatic panoramic view of Manhattan by the photographer Ongi and an intimate scene of a Paris street by the painter Maurice Utrillo. Both examples were presented in terms of their vertical design or the environmental backdrop of buildings, rather than as perspective or aerial views, which are concepts too difficult for this age level. The class discussed the difference between the two mediums, painting and photography, and the tools used in each—the photographer's camera, the painter's brush and paints. The teacher said that the group could either base their ideas on the photograph or on other scenes of the city they might think of, but they would express them in a new way. They would start their pictures as collages and then add painting. She pointed out that many modern artists use more than one kind of material. She said that the children would begin by arranging the colored pieces of construction paper, cut into geometric shapes, on their sheets of white drawing paper in a way that suggested buildings; then, after pasting the pieces down, they would add other buildings in paint. She emphasized that it was important to relate the colors of the shapes they painted to the collage shapes.

The children selected rectangles and squares of colored construction paper, and while they were free to use as many as they wished, the teacher reminded them that they should leave some space around the pieces they pasted on the white paper for the buildings they would paint in. Some children used a single vertical rectangle for a building, while others put squares on top of each other like building blocks. When the children had made arrangements that they liked, they pasted them down, and then they painted other buildings between the collage panels. The next step was to paint windows, storefronts, staircases, and other details on both the collaged pieces and the painted areas. The teacher then proposed that the children should decide the season, time of day or night, and environment of

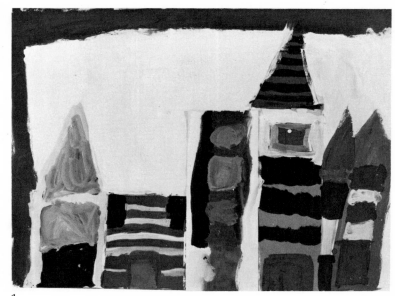

1

their buildings. They added skies, clouds, and other surrounding elements.

Joanie used vertical rectangles and cutout triangles for steeples and painted in an extra building (fig. 1). Leslie superimposed buildings both in collage and paint, which is unusual at this age, and also painted smoke patterns coming out of the chimneys (fig. 2).

Note: This project was conceived and carried out in progressive stages: first, the design of a collage; second, the construction of painted masses; third, the articulating of pattern and texture; and fourth, the establishment of time, mood, or environment.

APPLICATION TO OTHER AGE LEVELS

The project can be used with children up to the age of fourteen, or it can be made more complex, for example by employing a greater variety of paper shapes and devoting more attention to pattern and texture.

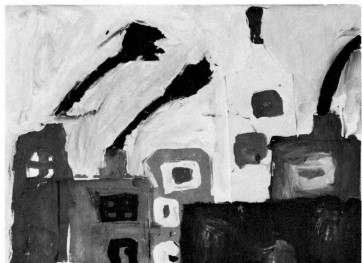

2

Clay and paint:
a family of clay
animals in two stages

It is advisable that this project be done only after the children have already had some experience with clay. It requires three sessions: one for modeling the animals, one for painting them, and a third for painting the background.

I: Clay

PURPOSE

To make children aware of size and scale by appealing to their love for animals and their young; to satisfy their desire to work with small things.

MATERIALS

Moist clay in balls about 3″ in diameter, at least one per child

Linoleum or floor tiles, approximately 9″ square, or metal trays to work on, one per child

Cardboard of plastic fruit or vegetable containers to hold the modeled animals, one per child

Swab sticks and tongue depressors

Paint

The teacher used the book of photographs by Hanns Reich, *Baby Animals and Their Mothers* (Munich: Reich Verlag, 1965, distributed by Hill and Wang, New York), but any photographs of animals and their young can be used. She discussed animals with the class, saying that they have families just as people do. Some animals have a few babies, others a large number. She told the children that they were going to make a family of clay animals, and that each child would choose the kind of animal he liked best; if possible, they were not to take an animal that another child had chosen. They could make a father or a mother, and as many children as they wished. The father or mother would be larger than the children. The animals could be separate or together, side by side or on top of each other; they could stand on a clay base, or without a base.

The children modeled the animals with their fingers, using the swab sticks or tongue depressors as tools if they needed them. It was not important that the clay pieces resembled the animals they had chosen, because at this age the suggestion of an animal is sufficient. They were allowed to use more than one ball of clay but cautioned to keep the families relatively small because the storage space was limited.

Barbara made a skunk family drinking out of a lake (fig. 1). Howard made a father alligator with a log in his jaws and with two babies watching him (fig. 2). Karen made a mother owl and her daughter (fig. 3).

When they were finished, each child's sculpture was stored away in a small container. The following week, the animals were painted with poster paints, either in one color or a variety of colors.

1

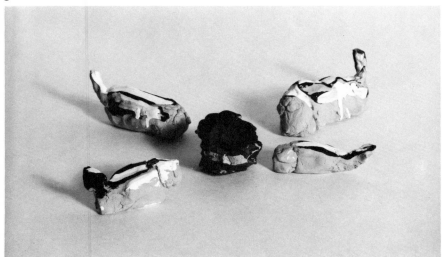

2

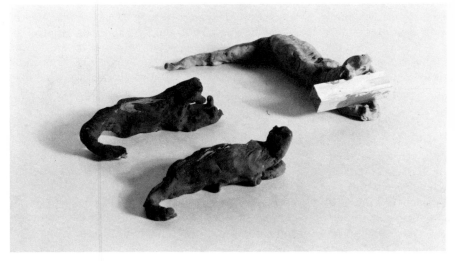

3

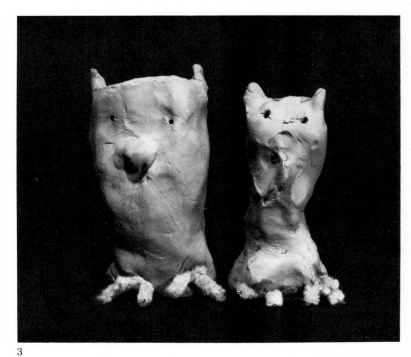

II: Painting backgrounds for the family of clay animals

PURPOSE

By relating clay and painting, to stimulate the imagination to conceive a two-dimensional design as the environment for a three-dimensional form.

MATERIALS

White poster paper (heavier than regular drawing paper), 18″ x 24″, at least one sheet per child

Paint

The teacher said, "We have finished making the families of animals and painted them. Now I would like each of you to think about where the animals are or where they live." She held a sheet of white paper behind an animal group and said, "We will paint a background for our animal families on a sheet of paper so as to tell where the animal is. Is it in a garden, on a farm, or in a forest? Maybe you would like to paint what the weather is like—is it a sunny day, or a stormy or rainy one? Perhaps it is night instead of day."

The children painted directly on the paper with their paints. When the paintings were dry, the teacher showed them how they could make a background for their animals by folding the paper five inches from each short end, forming three sides that surrounded the sculpture like a kind of open box. The backgrounds were varied. Most of the children painted the natural habitat or other homes for their animals, giving their pictures such titles as *A Garden* by Caron (fig. 4), *Birds in a Cage*, or *Snakes in the Forest*. A few painted the weather or the time of day, described by such titles as *It Is Stormy Around the Skunks* (fig. 5) or *Dogs Barking at Night*. For his alligators, Howard painted *A Rainy Day on the Okikenoki Swamp* (fig. 6).

APPLICATION TO OTHER AGE LEVELS

This is an ideal project for eight- to ten-year-olds, who can model a greater variety and number of animals. It will also go well with older children, but because of their greater sophistication the emphasis should be on animal groups rather than on animals and their young.

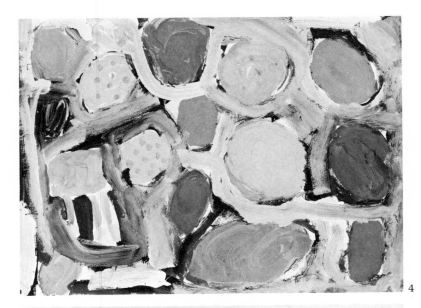

4

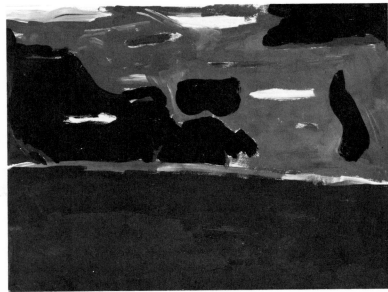

6

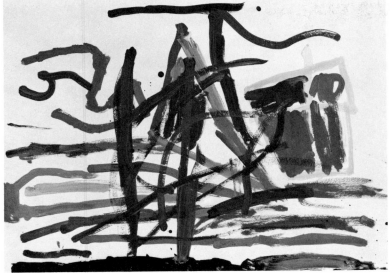

5

Painting: a family album

PURPOSE

To use an intimate subject to stimulate the child's interest; to establish a continuity of experience; to engender a group spirit.

MATERIALS

White drawing paper, 9" x 12", at least three sheets per child

Paint

Yarn, assorted colors, for binding

Scissors

The teacher proposed that each child make a family album in which he could include all of his family or as many members of it as he wished. One child asked whether he might include his dog and cat, because he considered them part of his family. Another child volunteered that his dog and cat appeared in the album of photographs of the family that his father had taken. The teacher said that anyone they wanted to include was welcome. The class discussed their family albums of photographs and the subjects they contained—for example, portraits, vacations, holiday trips, birthday parties, and other events. The teacher then introduced the materials—drawing paper and poster paints—and showed how the sheets could be made into the leaves of a book by punching or boring a hole in the upper left-hand corner, pulling a piece of string or yarn through the hole, and tying the ends together. She also suggested that the children might use a different color to paint each member of the family, so that there would be a variety of expression and that color would be associated with personality or mood.

The children set to work at once. Each seemed to begin with his favorite member of the family, but they were so eager to get everyone included that they hurried to finish one portrait so that they could start the next—talking all the while. They painted their grandparents, aunts, uncles, and cousins as well as their parents, brothers, and sisters. One child portrayed fifteen relatives; the least included was three. Often, the portraits were set into a specific scene or environment and given such titles as *Mother at the Beach, Father Reading,* or *The Family Looking at Television.* The enthusiasm and desire to paint as many pictures as possible were not only sustained throughout the class period but might have been continued for many more sessions.

APPLICATION TO OTHER AGE LEVELS

This project, which has a natural appeal and sustains children's interest, is suitable for any age level from six on.

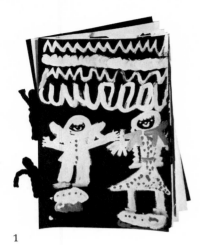

1

 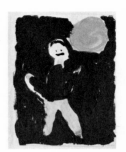

 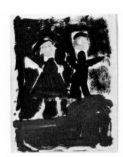

2

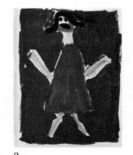 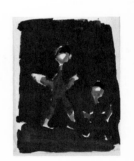

3

Black is a color, too

PURPOSE

To help the child discover the qualities of black as a color and become aware of its subtleties; to explore the variety of possibilities while working within the limitations of a single medium and color; to use the hands as a basic tool with a minimum of other tools or aids.

MATERIALS

Black construction paper, cut into 6" squares or 6" x 9" rectangles, two pieces per child, and 12" x 18" rectangles, one per child

Toothpicks, several per child

Rubber cement

As the children entered the class, the teacher handed each one a small piece of black construction paper. This aroused their curiosity, and when they were assembled, the teacher asked, "What have I given you?" "A piece of black paper," they answered in chorus. "Now we are going to make some experiments, so keep on your toes. Examine both sides of the paper carefully. Are they exactly alike?" "No," said Henry, "one is darker than the other." "Now fold the paper back about two inches from the edge and compare the difference in the sides." The children agreed that one side was noticeably darker than the other. The teacher suggested that they tear off a piece; when they did so, they were amazed to discover that the torn edge made a darker or lighter ragged line, depending on which side was facing upward. If the dark side was up, the edge was light; but if the light side faced up, the edge was darker. Then the teacher told them to poke a hole in the paper. (This could be done with a finger nail, but toothpicks were provided for children whose nails were too short.) One child remarked that the holes resembled ponds or lakes. The teacher referred to various kinds of black or darkness, for example, a dark night with no moon, when everything is pitch black; a night with a quarter or half moon, when things are indistinct because they are so close in darkness (value); a night with a full moon, when objects are sharply defined.

The children were then ready to undertake a collage in the color black. Each child took two small pieces of paper for tearing and a larger sheet for the background. They invented their own shapes by tearing and poking holes inside the edges with their fingernails or toothpicks, making islands or what one girl called "lake shapes." The teacher did not encourage the association with familiar objects, however, preferring to keep the project as abstract a problem as possible. This suited the children, even though some shapes occasionally reminded them of known objects. Some used the negative shapes—the pieces punched out of the holes—as well as the positive ones for their collages. They were so fascinated with the variety in the color black that no one missed or asked for brighter colors. Under other circumstances, the project might have been too sophisticated for six- and seven-year-olds, but because of its experimental nature and the excitement of discovery, it proved well suited to their ability and interest. One boy commented, "I never knew black could be so different."

APPLICATION TO OTHER AGE LEVELS

This project presents a concept that is too difficult for younger children but can be expanded with older groups.

1

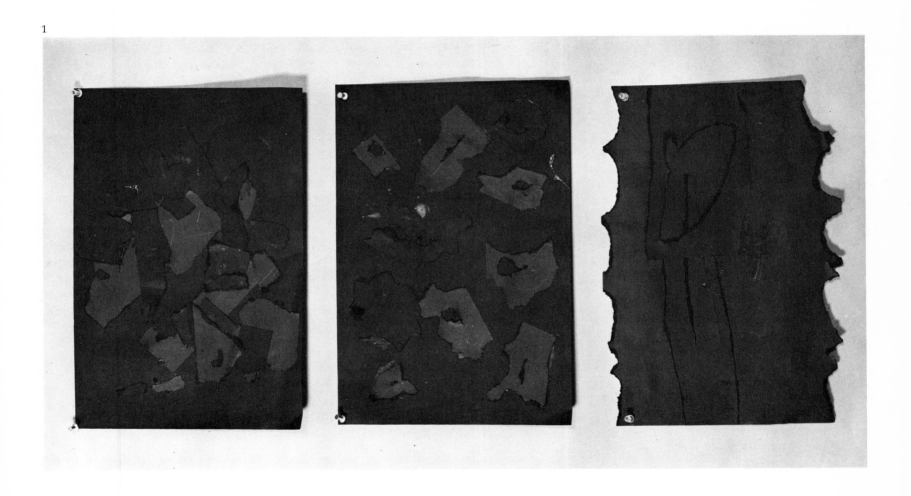

A string design

PURPOSE

To present line as a design element and increase sensitivity to its qualities; to teach drawing with an unconventional medium rather than with such conventional tools as pencil or crayon.

MATERIALS

Construction paper, various colors, 12″ x 18″, at least one sheet per child

Toothpicks, natural and colored, one box per child

String and wool, four-yard lengths of various colors, rolled into balls, at least one ball per child

The teacher tacked onto the board a sheet of white drawing paper, 18 by 24 inches, and said, "We're going to draw only in straight lines and with a new material." She drew several straight lines with the point of her charcoal: then she tilted the charcoal so that the lines she drew were thicker. Usually, children don't notice that lines vary in width, and one purpose of this project was to make them aware of this expressive quality of line. "I have used charcoal to make my lines thin or fat, but you won't use charcoal or pencil or crayon. You will use string and wool. How shall we make the string and wool stick to the background?" Several children proposed that they might use paste or glue. "Yes, we could do that, but it would be difficult and take a long time, so we shall use a new way." Taking another 18-by-24-inch sheet of colored paper, the teacher pushed a toothpick into it and then poked another hole through which she brought the point of the toothpick, so that both its ends showed on the face

of the paper. She placed several in this way at opposite ends of the paper and at random. Each end of the toothpicks stuck out about half an inch. Next she laced string around the ends of one toothpick and brought it around the ends of another one on the opposite side, producing straight diagonal, horizontal, or vertical

lines. She said that wool could be used to make a thicker line, and that a solid area could be achieved by passing the wool several times around the end of a toothpick.

The children followed this demonstration by punching several toothpicks into the colored paper at random and winding string around the ends. They were cautioned not to pull the string too hard, lest the paper buckle instead of remaining flat; but they were told that if the paper should buckle, they could unwind the string and then rewind it. When the designs were finished, they were tacked onto the board. There was great variety in the work. Some children had used only string, while others used only yarn. Some used colors of string or wool that contrasted or were complementary to the colored paper of the background (fig. 1), while others used closely analogous or related colors (fig. 2). Several designs were so complex in their interweaving of string and wool that the class said they looked like spider webs (fig. 3).

APPLICATION TO OTHER AGE LEVELS

This project should not be attempted below the six- to seven-year-old level but can be done with any of the older groups, using a larger background and more complex weaving. The background can be made of net to give more interest and allow for more intricately woven designs.

1

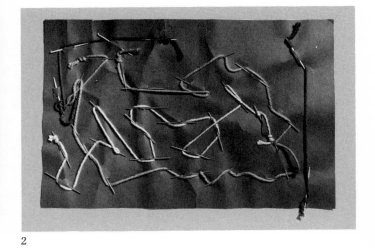

2

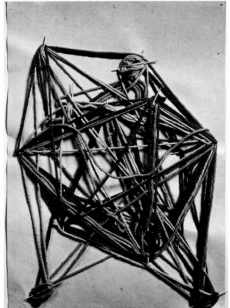

3

An every-which-way assemblage

To overcome any notion the child may have that a picture, design, or assemblage must always have a square or rectangular background; to give the child confidence either in working with a preconceived idea in mind or by developing the idea a little at a time as his work progresses.

MATERIALS

Burlap, corrugated paper, plain and patterned paper and cloth of various colors, cut into pieces about 3″ x 5″, 3″ x 6″, 3″ x 7″

Yarn, assorted colors and lengths

Pipe cleaners

Scissors

Staplers

Rubber cement

"We have made many designs on a background or sheet of paper with straight sides," the teacher said, and demonstrated this by taking up a colored sheet of construction paper 6 by 9 inches and pinning a few pieces of colored and patterned paper onto it. "Because the edges are straight and the corners are square, we often feel that we should make some of the pieces go with the edges. Today, however, we are going to make an assemblage in a different way. We shall not use a background at all. First, we'll select some materials we'd like to put together, and arrange them every which way. Instead of pasting them together, we'll staple them, because stapling will be faster and easier for this assemblage; the pieces must overlap a little so the staple will hold them. But we have rubber cement here too, if you prefer to use it for some of the joining. After a few pieces have been put together, we can look for others and add them. This is only a start, to show you how to work. First, select your materials—colored paper, burlap, and other things, but not more than five or six pieces to start with—and begin your 'every-which-way assemblage.'"

The children chose their paper and cloth materials from the collage table. A few worked deliberately, from a preconceived idea, but the majority used an informal, trial-and-error method, trying one piece against another to see how they looked and discarding those that did not suit them. The teacher reminded them that they could change the shape of a piece by cutting it. The pieces were overlapped slightly and stapled together. Some children used rubber cement to fasten paper to paper or corrugated board.

When the assemblages of paper and cloth were completed, the children were asked to study them and, if they felt they needed something more, to add strands of colored wool or pipe cleaners. The finished assemblages were hung on the bulletin board for discussion. A few children had made vertical or horizontal compositions (fig. 1). Some had chosen only geometric forms and used only one texture in their designs, instead of using free-form shapes and contrasting smooth or textured materials. The majority had made random designs that went every which way (fig. 2). The children thought that not having to work on a rectangular background all the time was a good idea and produced unusual effects.

APPLICATION TO OTHER AGE LEVELS

This project can be adapted for older children.

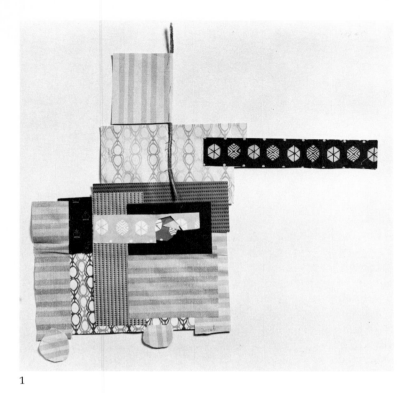

1

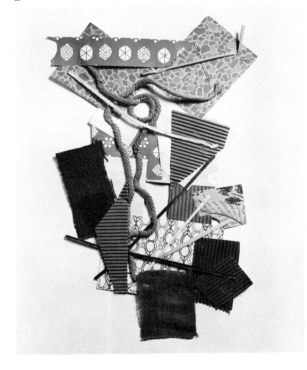

2

Flying creatures: assemblage in two stages

PURPOSE

To visualize an essential form in a simple skeletal structure and embellish it with color and materials, inventing designs based on flying creatures.

I: Skeleton (one session)

MATERIALS

Tongue depressors and coffee stirrers, about fifteen per child

Staplers

The teacher discussed flying creatures of all kinds: insects, birds, bats, flying fish, flying squirrels, and practically everything that flies, but especially more exotic ones, such as the prehistoric pterodactyl and even fantastic flying dragons, which were shown in illustrations tacked on the wall. She asked the children to think of the skeleton without flesh or skin, and not to be concerned with its head or feet but just to concentrate on the frame of the creature in flight. After the skeleton had been made of tongue depressors and coffee stirrers, it would later be decorated with paint and collage materials.

The teacher demonstrated the simple process of joining tongue depressors and coffee stirrers by laying one end of a stick on another to make an angle and stapling through them once or twice. Others were added to make a zigzag design. She showed how the overall design of the creature could be changed by narrowing or widening the angles made by the sticks. She cautioned the children against making their designs too long or too large because they would be difficult to handle and store. After each structure was finished, two strings were added so that it could be hung, producing the effect of flying.

1

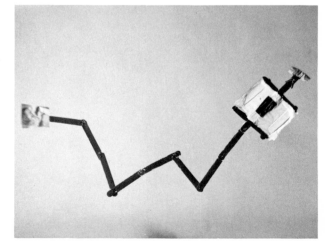

II: Decoration (one session)

MATERIALS

Tissue paper, net, crêpe paper, various colors, cut into approximately 3″ squares

Yarn, various colors

String

Paste

Scissors

2

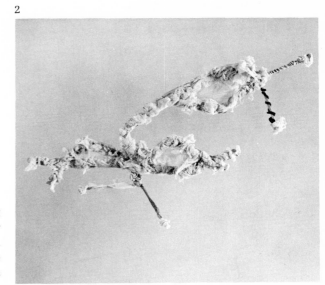

The teacher discussed the possibilities for decorating the skeletons of the flying creatures by making their surfaces smooth or rough, or very colorful. The children decorated their structures by painting directly on the wood or by pasting net, tissue paper, or other materials to the frame. (Only one side was decorated, because for this age doing both sides would prove tiresome and seem unnecessary.) Some just painted the sticks and added collage in only one or two spots (fig. 1), while others spaced their collaged pieces in an allover pattern (fig. 2). A few children stretched crêpe or shredded paper across the frames to fill them out and suggest other planes to add to the linear effect of the colored or decorated skeletons (fig. 3). When the creatures were finished, they were suspended from the ceiling by strings; the position of the strings could be changed to give an effect of more action, if the children desired.

APPLICATION TO OTHER AGE LEVELS

The project can be made more challenging for older age levels by laying the emphasis on imaginary animals and by decorating both sides of the frame.

3

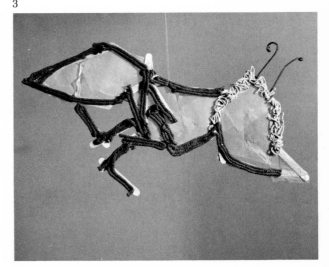

Construction of a seasonal subject: a flower garden

PURPOSE

To use the stimulation of a seasonal subject while avoiding the clichés and devices often attached to such projects.

MATERIALS

Molded cardboard egg boxes, separated into halves of 12 spaces or cut into quarters of 6 spaces, at least one per child

Florist's wire, 16 and 22 gauge, 18" long, six or more per child

Tarlatan, net, tissue paper, colored paper, in various colors, cut into 3" and 4" squares, six or more pieces per child

Balls of moist clay 4" in diameter, one per child

Yarn of various colors

Pipe cleaners, three per child

Feathers

Paint (primary colors only)

Paste

Staplers

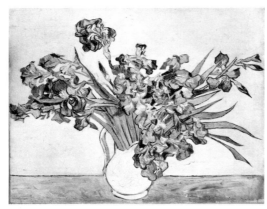

van Gogh *Irises*

The teacher used examples of flower paintings by modern artists, such as Vincent van Gogh's *Irises,* Odilon Redon's *Vase of Flowers* (see page 52), and Raoul Dufy's *Tulips and Anemones.* The children discussed flowers, naming or describing as many as they knew or could remember. Most were city children whose knowledge of flowers was limited, but this did not diminish their interest. The teacher asked how many had painted flowers. Most of them had. She inquired whether they knew any other way to represent flowers than by painting. One boy volunteered that he knew how to make flowers out of paper; it turned out that he had been shown how to imitate a flower through a kind of cliché device. The teacher then announced that the children were going to make flowers for themselves and could invent some flowers of their own. She said there were so many ways to make flowers that she was not going to show them any particular way, and they should find their own, but she would help them if they needed it. Then she showed the children the materials and how they could be used. First she threaded a piece of tissue paper on a thin wire and waved it back and forth to make it flutter.

She bent a thicker wire to indicate the lines of a stem, and also pointed out the colored pipe cleaners that could also be used for stems or that could be coiled at the top. She showed them how strands of yarn could be bunched up to make a blossom, or allowed to hang freely. Then she stuck the wires and pipe cleaners into clay, saying that each child would also plant his own garden either by using flowers all of the same kind and color, as van Gogh had in his paintings, or by using a variety as Redon had done. She suggested that the flowers might be tall or short, stand straight up in rows, or bend in different directions. In order not to complicate the problem, she made no mention of leaves.

The children selected egg boxes and filled the spaces evenly with moist clay in which to plant their flowers. They washed or wiped their hands afterward in order not to soil the materials. Each child started a flower by taking a wire for the stem and then making a blossom by crushing a piece of tissue paper, tarlatan, or net and binding it to the top of the wire with a thinner wire, or simply by folding a piece of paper or other material once or twice and threading the stem through it, bending the stem over at the top to hold the blossom

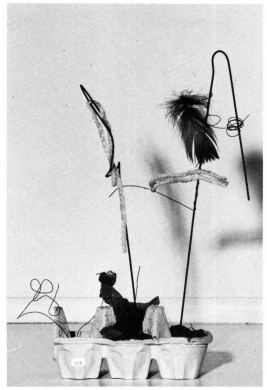

1

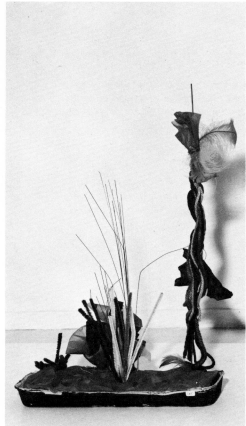

2

in place. A few strands of wool or a bunch of feathers could be fastened to the top of a stem by twisting the wire around them two or three times. Some children bent or coiled a pipe cleaner at the top, making blossom and stem all of one material.

As the flowers were finished, the children planted them in the boxes, studying the effect from all sides as they progressed and adding other flowers as they were needed. Several wires without any trimming on them were also planted. When the children were finished planting, they had the option of painting the outside of their egg boxes, choosing one color each to keep the effect simple. Some children evidenced a greater knowledge of flowers than others, but they all created fascinating and original flower gardens.

APPLICATION TO OTHER AGE LEVELS

This project should not be done with younger children but can be done with eight- and nine-year-olds. Boys who may feel it is childish or a girls' project can be attracted by the idea of inventing flowers as a scientific achievement.

A painted box construction in two stages

I: Construction (one session)

PURPOSE

To present construction in terms of volume rather than mass; to foster discipline in the selection of forms and materials, and restraint in working; to develop a recognition of subtlety in relationships and proportions.

MATERIALS

Boxes of various sizes and shapes—round, flat, square—including gift boxes, cigarette boxes, stationery boxes, stocking boxes, and clear plastic boxes, two to four per child

Cardboard rings, approximately 4″ in diameter, one or more per child

Rubber cement

Gabo *Column*

The children had had the experience of understanding the concept of mass by building with solid shapes of clay; now they were to experience the concept of volume by building with boxes. The teacher used a photograph of Naum Gabo's *Column* as visual motivation. She asked whether the children had ever seen anything like it before. No one had. What did it look like—a painting or a sculpture? Not a painting, the group agreed. One child said it was like a sculpture because it stood by itself and you could walk around it. The teacher said it might be called a sculpture, but there was a new name for it; it was called a construction. One boy thought that was a good name because it reminded him of a building—a skyscraper, maybe, and

skyscrapers were constructed. The teacher told the children that constructions could be made out of many kinds of materials: glass, plastic, wood, metal, and stone. She then introduced the project by saying that they would use only a few materials, mainly cardboard boxes. Each child was to choose no more than four boxes and arrange them in a construction. The boxes were not to be altered by cutting them with a scissors or in any other way but to be used just as they were, only put together in an interesting way.

Each child selected several boxes for his construction, some including a plastic one. The children were asked first to select one box as the base for the construction, then to place a second one in relation to it, then a third and a fourth. A few of the children added related elements, such as cardboard rings. At each stage the teacher stopped the children and asked them to consider the relationship of the parts. This was done to slow down the process and cause the child to use restraint and to observe the effect each time he added a box or changed its position. The teacher visited each child individually and heard his plan before any pasting was done. Some children changed the arrangement of their boxes several times before they were satisfied. Some did not anticipate the difficulty that they encountered in balancing the boxes or gluing them together.

Before finishing their constructions, the children were reminded to turn them around to see that they looked interesting from all sides. After the boxes had been fastened to the bases and to each other one at a time with rubber cement, the constructions were put away to be painted at the next session.

II: Painting (one session)

PURPOSE

To make the boxes, which differed in color and texture and had printing on them, more attractive and unified; to use paint to enhance the sense of the construction's volume.

MATERIALS

Paint

Liquid soap

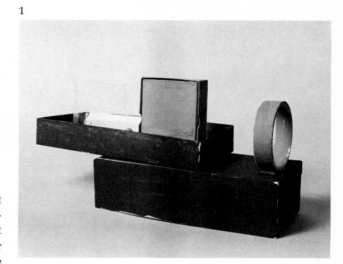

1

After each child's construction had been placed in front of him, the teacher pointed out that while the constructions were interesting and individual, the fact that they were of different colors and had printing on their surfaces was distracting and confusing. She advised the children to use an opaque color to cover the printing and unify the construction, and to add a second color of their choice for interest. The discipline of restraint and the freedom of choice were thus combined as part of the same problem.

When the children had selected their colors, about half a teaspoonful of liquid soap was added to each coaster to help the paint adhere to the resistant surfaces. (Boxes covered with glossy paper or oil-base inks often will not take tempera, but a little soap will overcome this difficulty.) The plastic boxes that formed part of some of the constructions were of course not painted; they added to the constructions a note of luminosity and gave them a contemporary effect.

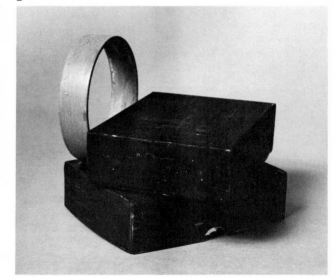

2

APPLICATION TO OTHER AGE LEVELS

This project should not be used with younger children but is suitable for older ones.

A tall box construction

PURPOSE

To use a common, everyday object as the basis for an interesting structure; to stimulate the imagination in the transformation of a discarded container into a personal three-dimensional design.

MATERIALS

Any discarded long cardboard boxes (such as empty one- or two-pound spaghetti boxes, or boxes from plastic bags, foil, or wax paper), about 12″ x 2″ x 2″ or 10″ x 4″ x 2″, prepasted on cardboard bases about 8″ square by opening one end of the box and pasting the flap down onto the base with glue or wide adhesive tape; one per child

Construction paper, various colors, cut into strips 9″ and 10″ long by ½″, ¾″, and 2″ wide

Rubber cement

Scissors

Paint

As motivation for the project, the teacher had prepared the basic constructions by mounting a number of long boxes on cardboard bases as described above. The children might have done this themselves, but the surprise of seeing the stark group aroused their curiosity and stimulated their imagination. "What are they?" one child asked. "Boxes, of course," said another. "I know that, but why are they fixed like that?" The teacher suggested that each child take one of the boxes to his place to examine further; the discovery that they were common boxes arranged in this strange manner increased their curiosity rather than satisfying it.

Teacher: Now you all know these are boxes. They were empty and about to be thrown out. I thought that you could do something with them, so I pasted them onto the cardboard bases. Here is a challenge for you. What can you do with them? Look at them awhile, not only with your eyes but with your imagination. They could be many things. What does yours look like to you when you see it with your imagination?

Many children: Mine looks like a tree.

Tom: Mine is a clock—a grandfather's clock, a big tall one that stands on the floor.

Ellen: I see a building in mine.

Arthur: I see a construction. It isn't anything like a clock, or a house, but just a construction.

Teacher: These old boxes are already changing into many different things because that's the way you see them in your imagination. You will each paint your box a color and then add these strips of colored paper to make your "imagination construction" become a real construction. Remember that the box has four sides and can be seen from all around, like a piece of sculpture, so keep turning it as you work.

To keep the project simple, each child painted his box and base with his favorite color. It was important for the children to do a craftsmanlike job, seeing that all sides were covered with paint and were thoroughly dry before they began pasting. While the boxes were drying, the children chose strips of colored paper, which could be either of one color or several, but of different widths. As usual, a few children had a clear idea of what they were going to do and set about it deliberately, while others explored each step. Some worked by trial and error. The children pasted strips flat to the sides of the box or attached them only at the ends so that they stood partly away from the box. They turned the boxes around as they worked and attached the strips to one or more sides as suited their design. The finished results included Tom's *A Broken-Down Clock*, with strips of paper pasted on the sides and hanging out in every which way to express the idea of being broken (fig. 1); and a tree that Terry made by attaching the paper strips in loops that hung out from the sides of her box (fig. 2). Others made abstract constructions that had no associations with familiar objects (fig. 3). In contrast to the rest of his class, who used a variety of colors, Ismael restricted his choice to black and white and one color, orange.

APPLICATION TO OTHER AGE LEVELS

The project lends itself admirably to older groups, with which it can be carried out in a variety of more complex ways.

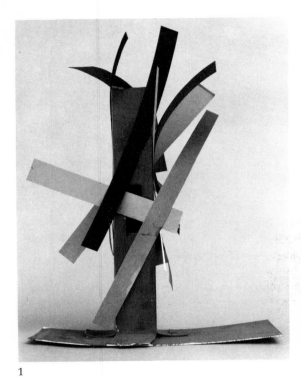

1

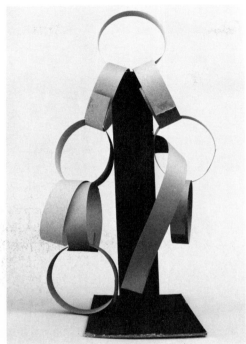

2

3

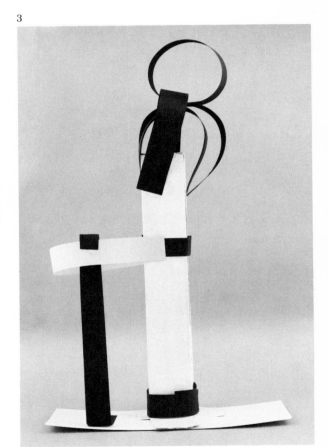

Projects for children eight to ten years old

FROM EIGHT TO TEN years of age, the child is enthusiastic, energetic, and restless. He is imaginative and excels in make-believe. He is capable of reasoning and is concerned with what is fair and just. The interest in the opposite sex is now developing, so that boys and girls make a considerable effort to attract one another's attention by teasing, complaining, or calling out in a loud voice.

By now, the child's span of concentration has increased so that he can sustain his interest from forty-five minutes to two or more hours at a time. Interest can also be carried over from one class period to another, or even to two or three periods on different days. Work habits vary; some children are patient and meticulous, others quick and careless, but the majority fall somewhere in between. Because of their increased skill and desire to do things correctly, they are attracted by stereotypes and copying. They wish the approval of the teacher rather than that of their peers, and their seeking for adult praise may lead them to practice the clichés admired by some adults who have little experience with children's creative abilities. There is a strong desire to draw more realistically and a fear of not being able to; therefore, those who believe that they don't draw well retreat into making designs, copying comic books, or following how-to-draw or how-to-paint books that offer short cuts and recipes.

For all these reasons, the teaching of art to this age level should be positive and direct. The motivations should stimulate the imagination and bolster the ego. The children should have the opportunity to explore a variety of individual ideas and expressions through their own interpretation and through having a choice and variety of materials. Being logical and eager to know the right way or the right thing to do, children of this age are capable of seeing the fallacy of using clichés or copying. The more they are challenged to use their own abilities, and the more they recognize the individuality in their work, the sooner they will relinquish the supporting crutch of imitation.

Assemblage offers activities that employ the abundant energies of the eight- to ten-year-olds to useful purposes. Instead of having to sit in one position and draw all the time, the child can move about to select his materials and can use his body in manipulating them. More body movement and less finger dexterity is involved than in simply drawing, painting, or modeling. There is a greater challenge to the child's creative and mental powers, because he conceives new ways of organizing designs and invents new ways of construction. Since there are as yet no academic standards by which either the child or the adult whose praise he seeks can evaluate his products, the tendency to use clichés and stereotypes is readily overcome.

Painting with tape: an aerial view

PURPOSE

To encourage conception of a picture in terms of simple lines and large shapes; to provide an experience of the magic of using tape in painting; to learn to appreciate the character of hard-edge painting.

MATERIALS

White drawing paper, 18″ x 24″

Paint

Masking tape, ½″ and 1″ widths, cut into 24″ lengths

Teacher: How many of you have looked down from a high place and seen what the world looks like below?

George: We took a plane to California to see my grandparents. Everything looks like a map.

Alice: We went to the top of the Empire State, and the buildings looked like blocks—thousands of blocks piled on top of each other.

Several others had seen aerial views of cities, farms, and forests on television. There was no one who hadn't seen the world from the air, either from a high building or a plane, or in pictures. The teacher then showed some aerial photographs of towns, farms, forests, and lakes.

Teacher: Look at these photographs a moment and tell us what stands out most.

Several, in unison: The streets and highways.

Teacher: What about the streets and highways, Jim?

Jim: They make big lines. Some are straight, others are slanting.

Matthew: I like the shapes the islands make in the water.

Teacher: We are going to make a painting, an aerial view, or a picture of what we see looking down from high up, and we are going to do it in a new way. Most of you have been impressed by the design the streets or roads make in an aerial view. You will show these lines by putting strips of masking tape on your paper. You can place them diagonally, or you can even curve them, or make wavy or irregular lines. When the strips of tape are in place, paint between them, over them, or over the edges. Suggest whatever you wish—a landscape, a seascape, or a city scene. After you have finished painting, pull the tape off carefully, and you will see a kind of magic effect.

As instructed, the children first placed strips of masking tape on the paper. They made large, simple linear compositions in this way. After pressing the strips down so that they stuck evenly to the paper, they proceeded to paint their pictures directly, using large or small brushes as they wished. Pamela placed her tape in parallel lines across the paper and painted rows of people walking, to show a city scene (fig. 1). The background was painted in black, so that when the tape was removed the lines showed up in crisp white bands. Matthew used small pieces of tape to indicate the landing strips on four islands in the ocean (fig. 2). Tony made a large V-shape on his paper to suggest the edge of the land with a highway nearby; with a dry brush, he roughened the hard edge left by the tape, to suggest water. Above this, he made patterns of islands with the tape and brushed color over them (fig. 3).

When the children had finished painting, they removed the tape. They were delighted with the stripes it had left; if the pictures seemed too stark, they colored the stripes or put patterns over them. All were impressed by the magic of painting with tape.

APPLICATION TO OTHER AGE LEVELS

This project should not be attempted with children younger than eight. It can, however, be used with any of the older groups. More complex designs can be made with the tape by putting it on in several stages and applying paint between each stage. This procedure can produce interestingly patterned designs.

1

2

3

People are shapes

PURPOSE

To stimulate the child's imagination in creating human forms out of simple shapes, such as bottles; to overcome his fear of inadequacy in drawing the human figure.

MATERIALS

Paper, white and colored, cut to different sizes, 4″ x 10″, 8″ x 15″, 4″ x 18″, sorted into sets of two of each size, at least one set per child

White paper, 18″ x 24″, for the background, at least one sheet per child

Pencils

Crayons

Pointed scissors

Rubber cement

Before the class arrived, the teacher arranged on a table a dozen or more bottles varying in sizes and shapes—tall, stately ones; short, fat ones; some medium size; and others very thin. Two that were exactly alike were included, to provide rhythmic repetition and suggest twins in the game of making bottles resemble people. The display aroused the children's wonder and anticipation, which was the object of setting it up beforehand.

Teacher: "I know you are wondering what these bottles are doing here and what they're for. We are going to play a game of pretend. Let's pretend they are people. Take a minute to look at a bottle and see whether you can tell what kind of person it is, and what he's doing."

The children caught onto the game at once and raised their hands eagerly, each wanting to be the first to describe his person. The teacher called on each child in turn.

Matthew: I see a broad-shouldered man with a long neck.
Laura: Mine is tall and skinny.
Mark: My man has a fat stomach.
Isaac: May I whisper something in your ear? (He whispered:) I see a woman. She's pregnant.
Laura: I see twins.
Susan: I see a woman. She's round-shouldered.

The teacher demonstrated the procedure to be followed by taking a piece of paper and drawing on it the outline of a short, squatty person. She cut this out with scissors, saying, "This woman is not just standing;

she's holding a bundle in her arms. Of course, you can't see arms and legs in the bottles, so you'll have to imagine them or make them up. Each of you has six pieces of paper of different sizes and colors. Choose a different bottle for each shape you want to draw, and choose the paper that fits the shape you want. Then draw the figure you see in the bottle and cut it out. Don't draw features or hair or other details, just the general outline of the shape, or the silhouette that the figure you see would make in the pose or action you imagine for it. If you want to make twins, cut two pieces of paper together. When you have finished cutting out your figures, arrange them in a composition filling your large sheet of white paper. Let them touch or overlap, to indicate that one person is in front of another, and relate them so that they suggest a group or a crowd doing something—watching or marching in a parade, having a discussion, or dancing."

The children drew six or more figures that they interpreted from the bottles, to fit the different-sized papers. Then they cut them out, cutting more than six if they were dissatisfied with some of them. They arranged the figures on the large white paper to touch, overlap, or have spaces between them. They moved the figures about on the background until they were pleased with the composition, and then pasted them down with rubber cement. Those who used white paper for their figures discovered that they did not show up against the white background and resolved the problem by making a black or colored outline around the cutout

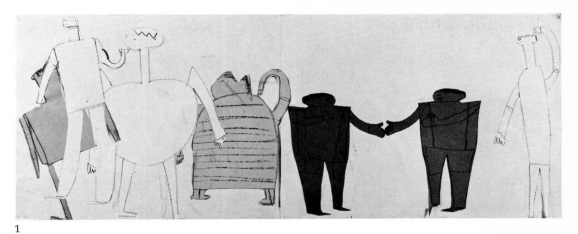

shapes with crayon or pencil. The themes included people watching a parade (fig. 1), people talking at a party (fig. 2), and people exercising in a gym (fig. 3).

Children at this age and later want to use figures in their art work and are often frustrated, because they want to make them realistic but lack the skill. This project demonstrates an easy and inventive way to achieve figures and provides both the interest and skill leading to further study. The conversion of bottles into people provides a fascinating game, a kind of caricature; since it is a spoof on the human figure, there are no mistakes to be ashamed of, whereas if they attempt to draw figures on paper they are sometimes too concerned with their mistakes and spend more time erasing than drawing. The procedure gives them great latitude in arranging the shapes on a background and recutting them, or cutting additional figures and choosing those they like the best for their compositions. Another great advantage is that the approach overcomes the general tendency at this level to make pretty girls with fancy hairdos or create pseudo-fashion figures.

1

APPLICATION TO OTHER AGE LEVELS

This project is particularly adaptable to older ages—preadolescent and adolescent—but the emphasis should be on caricature, and the purpose should be to overcome clichés or unimaginative efforts at realistic figure drawing.

2

3

Painting with mirrors

PURPOSE

To explore the idea of multiple images; to exploit the interest of this age level in the human figure as a subject; to allow the "good drawers" an opportunity to use their skill.

MATERIALS

Mirrors, about 12″ x 18″, two (these can be borrowed from the domestic-science department, if there is one; a full-length mirror would be even more desirable)

Pocket mirrors, about 3″ x 5″, three or four to be shared

White paper, 18″ x 24″, one sheet per child

Paint

The teacher had groups of children look into the large mirrors, which were placed at an angle so that the children could see themselves and others and visualize multiple images. The children used the small mirrors, tilting them to observe parts of their bodies. The teacher then led a discussion of various kinds of reflected images, both natural and distorted, that the children had seen. Several mentioned having visited amusement parks where they saw the distortions made in curved mirrors, some of which made you look tall and thin, while others made you small and fat. Other mirrors did both, making parts of the figure, for example the head and neck, appear long, while other parts seemed short and fat. The children also mentioned mazes with many mirrors, in which one sees oneself multiplied a number of times. They also referred to other images, such as the reverse figure or the figure seen upside-down in water. The discussion led to the subject of the reflection of multiple images. Eliot remembered seeing a number of images of himself in the mirrors at the barber shop; Janet had seen images of herself in two full-length mirrors set at an angle, while she was having a dress fitted.

The project was to draw either multiple images of one's figure full-length, or parts of the figure, as seen in two or more mirrors; or to draw distorted or reflected images, either from memory or the imagination. The children drew directly with paint. Theo drew a series of full-length mirrors, arranged accordion fashion, and showed a different image of himself in each mirror (fig. 1). Stacey repeated her portrait several times in vertical bands, as she saw herself reflected in the hall mirrors at home (fig. 2). Thomas painted a number of full-length and partial figures and separated them by lines arranged in a staggered up-and-down pattern (fig. 3). Instead of painting the human figure, Elise made a picture called *A Whale Seeing Himself in the Water*, showing the surface of the water broken into a number of facets like those the waves make in the ocean (fig. 4).

APPLICATION TO OTHER AGE LEVELS

This project is especially suited to older age levels, whose interest in the human figure becomes progressively more absorbing.

1

2

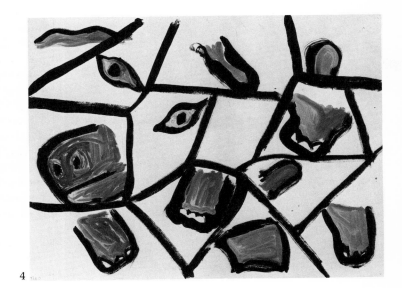

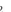

3

4

Collage: an allover design

PURPOSE

To exercise discipline through economy of means in the use of materials.

MATERIALS

Construction paper, various colors, 6" x 9", at least two sheets per child, and 12" x 18", at least one sheet per child

Collage boxes (see page 16)

Scissors

Paste

Staplers

The teacher said, "It is easier and probably more fun to use a lot of materials in making a collage, but today we will limit ourselves to only a few materials and use them in a particular way. This is both a challenge and a kind of game. Each of you take a sheet of the larger-size colored paper for your background, and two of the smaller-size pieces of different colors. Cut or tear the smaller sheets into interesting shapes. If you cut forms out of the pieces, for instance circles, free forms, or objects, save all the pieces out of which you cut them, because the main object of this lesson is to use all the pieces in your collage. Nothing is to be left out. When you've torn or cut the pieces, lay them out on the background sheet to make a design; you can overlap some of the pieces, if you wish. Arrange them so that the shapes and colors are evenly distributed—that is, so that there aren't too many of the same shape or color in one spot; move the pieces around to change the arrangement until you have a harmonious effect. The result will be an allover or surface pattern. When the effect pleases you, paste the pieces down. Then, if you feel the design needs more interest, you can add other materials—for instance, yarn, colored tissue paper, pipe cleaners, or fabric—out of the collage boxes."

Several children put both pieces of their colored construction paper together and cut out identical shapes. Some folded the paper to produce symmetrical shapes; some cut geometric figures, and others produced more complex forms by cutting shapes within shapes. A few tore shapes with their fingers. When the shapes were assembled on the background and pasted down, most of the children selected other materials with which to embellish their collages, but a few were satisfied with their designs as they were and did not add anything to their cut or torn paper patterns.

Gregory combined tearing with cutting, he used one sheet by cutting in the middle with a free, irregular line and pasting the pieces—one the negative of the other—at either side of his collage (fig. 1). Allison crumpled small pieces of tissue paper and pasted them together with other materials, at intervals on her collage (fig. 2). Pia added toothpicks and bits of cloth and yarn to her design (fig. 3).

APPLICATION TO OTHER AGE LEVELS

This project will work well with students in junior high school or above.

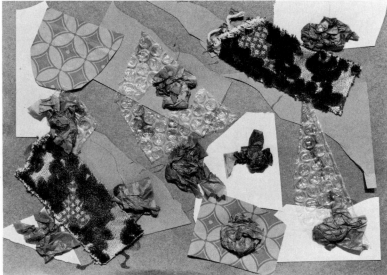

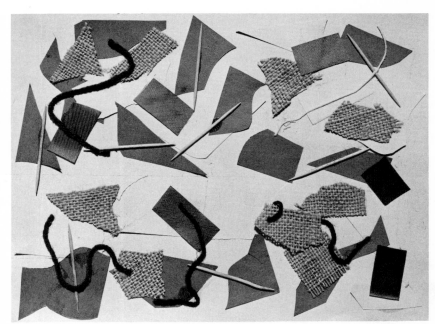

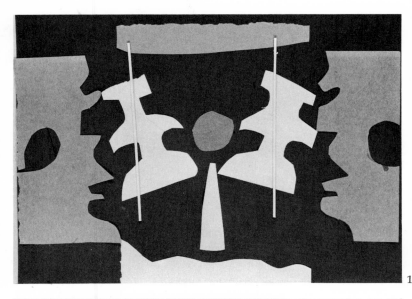

Collage: a mythical flag

PURPOSE

To capitalize on the interest in flags by encouraging enjoyment of their aesthetic quality as well as of their symbolism; to use imagination in inventing a flag.

MATERIALS

Construction paper, various colors, 6″ x 6″, 6″ x 9″, 3″ x 9″, enough for one or two sheets per child

Glossy colored papers, 4″ x 4″, one sheet per child

Stickers, in colors and gold, in various shapes—circles, stars, loose-leaf ring-binder reinforcements, legal stickers, pictures (six boxes for the class)

Yarn

Pipe cleaners

Dowels, ¼″ in diameter, for flagstaffs, one per child

Scissors

Paper punches

Rubber cement

Staplers

The group looked at the flags of the United Nations, particularly those of the new nations. The teacher pointed out that flags and banners are designed by artists, and that there have been many kinds throughout history. The discussion focused on the standards that medieval knights carried into battle, and someone mentioned the flag borne by Christopher Columbus when he landed on San Salvador. A discussion of yachting and golfing flags brought the class back to modern times. The teacher said that banners are often used purely as decoration, and she asked whether anyone remembered those that are hung outside The Museum of Modern Art on various occasions. Ellen remembered one design with an allover pattern of circles, and Charles thought he had seen one with stripes and circles. These were both abstract designs. The teacher said that they would design their own flags and either use abstract forms only or include representations of objects. She showed the variety of stickers, among which, besides abstract shapes, were some depicting fish, rampant lions, and birds. She held up pieces of the colored construction paper in different sizes and said they were to be used as backgrounds, but she emphasized that flags do not have to be square or rectangular—they can be any shape.

The children selected their stickers and different sizes and kinds of paper. Although the teacher had suggested that the glossy paper be used to give accent to their designs because of its shine and richness of color, many children preferred to use it as a background laid against the background, cutting it into interesting shapes (fig. 1). A few ten-year-olds punched holes in the paper to make a pattern, and one child even pasted punched-out circles on the flag. Still others embellished their flags by gluing or stapling on yarn or pipe cleaners (figs. 2, 3). Some flags had allover patterns, and others had motifs pasted in a free or regular arrangement. Each finished flag was given a staff by covering a dowel with glue and turning the edge of the paper flag over it; a few students stapled the edges to the dowels. When displayed around the room, the flags made a gala effect.

APPLICATION TO OTHER AGE LEVELS

This project can also be done with six- and seven-year-olds, as well as with older groups.

1

2

3

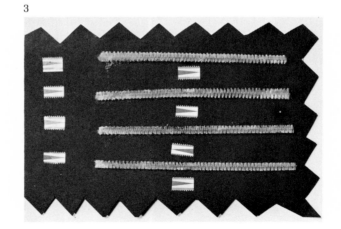

A painting
inspired by flags

PURPOSE

*To capitalize on the enthusiasm gener-
ated by one project by making it the
motivation for further expression; to
use the children's own work as the
basis for their next creative efforts; to
introduce the sponge as a painting
tool.*

MATERIALS

*White drawing paper, 18" x 24", one
sheet per child*

Paint

Sponges, one per child

Since the children were so enthusiastic when the flags
they had invented in the previous project were dis-
played, the teacher suggested that they go on to make
a painting using the flags as their motif or subject. She
said, "You seemed to like making the collage flags and
especially to enjoy the gay effect they made when they
were all shown together. Today, you will make paint-
ings using flags as your subjects or parts of your de-
signs. Each of you can use the flag you made last time,
or design a new one, or make a painting of many flags.
The only important thing is that all the flags must be
invented ones."

The children discussed the situations that their
paintings might illustrate: a flag raising, a parade, a flag
on top of a government building of a newly created
country, a procession of flags. The teacher reminded
the children that whether their paintings were stories
or just designs, the flags should be the most important
elements. She also introduced the sponge as a painting
tool, showing how a texture could be produced by
dipping one end of the sponge in paint and dabbing
it around the edges of the flags or other painted objects.

Some children painted their flags first and put in the
background later (figs. 1, 2), while others reversed this
process (fig. 3), completing the background first and
painting their flags over it. A few used their collage
flags as inspiration, but others made new ones.

APPLICATION TO OTHER AGE LEVELS

This project can be done with six- to seven-year-olds
and with older children.

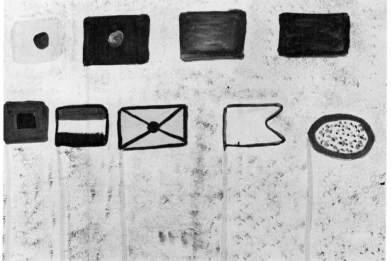

1

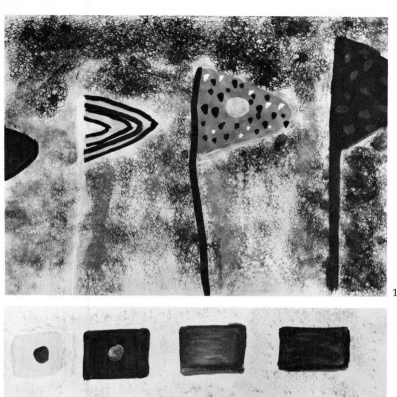

2

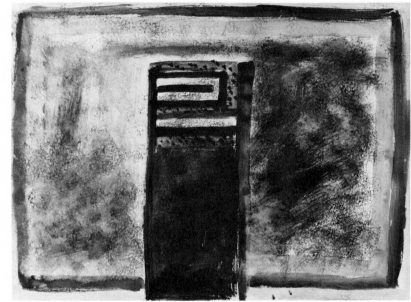

3

A burlap
assemblage

PURPOSE

To think about composition in a new way, by challenging the assumption that every work of art must be done against a predetermined background.

MATERIALS

Burlap, various colors, cut into pieces about 3″ x 5″, at least eight per child

Yarn, various colors

Pipe cleaners, various colors, at least three per child

Construction paper, various colors, 12″ x 18″, at least one sheet per child

Large needles with eyes big enough for yarn, one per child

Staplers

The teacher said, "Usually you find paper or cloth or some other material to work on. You paint a picture on a large sheet of white paper, or you make a collage on a piece of cardboard or colored paper. Can anyone tell me what that material is called when you use it in that way?" "A background," Henry said. The teacher continued, "Yes, and it gives you a good way in which to start the things you make because it gives you a working space for planning your design. But today we're going to start in a very different way. If you look at the materials laid out here, you will find no pieces that are large enough to serve as a background. Instead, you will find a great number of small pieces of burlap. Now, here is the difference between this way of working and the others you have learned. You are going to build up your composition with these small pieces, starting with one piece and adding others. Choose four or five pieces. There's also going to be another different way of working that will add to your design. If you want to, you can pull out a few threads along some edges of the pieces to give a frayed edge, which is softer and can be more interesting than a hard, straight edge." She demonstrated by pulling some threads out. "You'll

find the threads are easy to pull out, and you can pull some out of the middle, too. Notice that you have created a new kind of shape, an irregular one with soft, frizzy edges. Now add other pieces to the first one, either by stapling them together or by sewing them together with a needle and yarn. For greater interest, you can also use the needle and yarn to weave a design on the burlap, or you can add pipe cleaners."

After choosing pieces of burlap, the children made frayed edges by pulling out some of the threads. Several were fascinated by the designs they produced when they pulled threads from the middle of the pieces, especially when they were removed both horizontally and vertically. Most of the children chose to staple their pieces together, but a few sewed them together with yarn (fig. 1). The teacher called attention to the variety of shapes and edges produced and the fact that each child had created his own. The children proceeded to the next step, weaving colored strands of yarn into the burlap and embellishing the design with coils and bundles of yarn, or with pipe cleaners. Francine used the threads she had pulled out of the burlap for decoration (fig. 2). A few children noticed that they had pulled

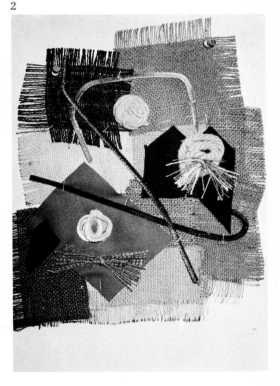

1

2

out so many threads that their work was quite transparent and needed more contrast. This had been anticipated by the teacher, who directed them to the colored paper that she had provided to meet this need. Those children who wished to do so mounted their collages on colored paper to give them a more finished appearance, but others preferred to leave theirs unmounted.

Disraeli once said, "Take nothing for granted." This is particularly true of art. Any approach that causes children to think in a new way or to solve a problem differently is desirable, no matter how simple the project. There is nothing wrong with the usual method of beginning with a standard background—a rectangular piece of paper for painting, or a square piece of cloth for embroidery or tapestry—unless the child takes it for granted as a requirement and assumes that all art must have a predetermined background. By building up the assemblages with pieces of burlap without any background, this project challenges that assumption.

APPLICATION TO OTHER AGE LEVELS

Good for any older group.

A wire clothes-hanger construction

PURPOSE

To create planes from lines, by making a three-dimensional construction based on line.

MATERIALS

Thin wire clothes hangers, such as those on which clothes are returned from the cleaner (these are easily bent and can be acquired at no cost; the children can bring them from home), at least one per child

Tissue paper, various colors, cut into pieces about 6″ square, at least twelve per child

Heavy yarn, feathers, sequins, small buttons, for decoration

Paste

Scissors

Taking a simple wire clothes hanger, the teacher demonstrated how it could easily be bent into various shapes. She asked the children whether the shapes suggested anything to them. Some saw the possibility of making birds, animals, or people and visualized how the hook at the top could form a head. The teacher said that the wire made linear outlines of shapes to be filled in with colored tissue paper to form planes.

The children bent the wire hangers into various shapes, some suggesting recognizable objects, others making abstract designs. Colored tissue was pasted across the framework by coating the wire with paste and turning the edges of the tissue over it. Not all the areas had to be filled in with tissue; some could remain as open spaces within the design. If a piece of tissue was not long or wide enough to span a space, another piece could be pasted onto it—sometimes of a different color, which added to the variety of the design (figs.

1, 2). After finishing their constructions with paper, the children could embellish them, for instance by adding yarn for a tail, feathers for plumage, or a sequin or a button for an eye (figs. 3, 4).

The object of this project was to convert linear contours into flat planes. The process used is much simpler than working with papier mâché, but it involves neatness and care in workmanship and so helps to develop necessary discipline at this age level.

APPLICATION TO OTHER AGE LEVELS

Because of the somewhat exacting technique required, this project should not be attempted with younger children but can be adapted to any older group by making the problem more complex, for example by using more than one hanger and giving greater emphasis to the three-dimensional construction.

1

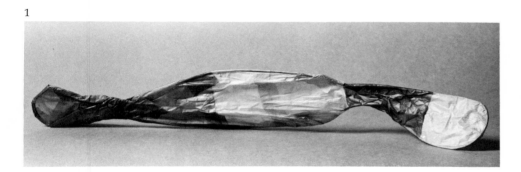

2

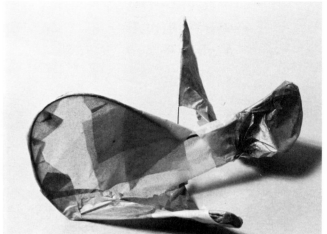

3

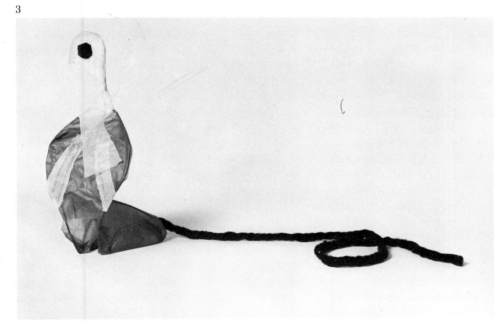

4

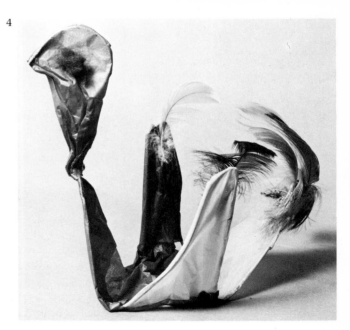

Using the human figure, I: a clay figure

(two sessions)

PURPOSE

To meet the ever-present interest in the human figure; to engage in a three-dimensional experience; to study form.

MATERIALS

Moist clay, rolled into balls 4″ in diameter, at least one per child

Linoleum or floor tiles, about 9″ square, for bases, at least one per child

Clay tools, or tongue depressors cut to a point at one end

Paint

The teacher explained that in making the sculpture of a single figure out of clay, the figure should either be doing something or be in some kind of relaxed pose. She discussed the properties of clay and how easily it can be modeled, but also how difficult it is for a clay structure to support itself. (The children had already worked with clay and were acquainted with some of its properties.) She suggested that the children visualize their figures in actions or poses that formed masses that could easily support themselves—for instance, a person reading a book or playing a musical instrument, or a figure relaxing, lying on its elbows, or sunning himself. She further suggested that the children start by taking the clay balls, pulling out the arms and legs, and squeezing out the head without attempting at first to shape the figure, but only to suggest its general action or posture. She emphasized that the head should be squeezed out of the clay, not added as a separate piece.

Some children tried to work flat, cutting the figure out of the clay as if they were making paper dolls, but these figures collapsed when the children tried to set them up. The teacher cautioned them against working flat in this way and again advised them to build up the action at once as a mass. Some children made several attempts before they got the idea of bulk, as contrasted with flat forms. After the figures were roughed out, they were shaped with fingers and tools.

A second session was devoted to painting the figures with poster paints, in whatever colors the children desired.

APPLICATION TO OTHER AGE LEVELS

As the human figure is always appealing to children and offers them a challenge, this project can be done at almost any age, but older children will find it even more absorbing. The single figure should be attempted before making groups of two or more.

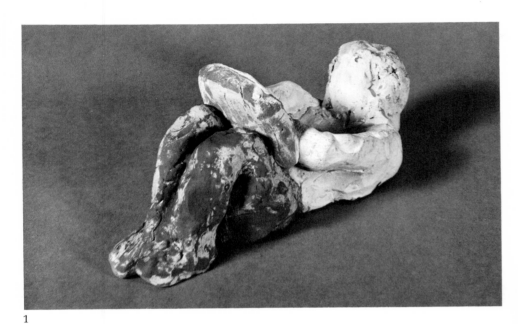

1

2

Using the human figure, II: a group sculpture in clay

PURPOSE

To develop insight into the problem of sculptured forms; to explore the problem of group composition; to further understanding of contemporary expression; to integrate appreciation of work by others with one's own personal creative experience.

MATERIALS

Moist clay, rolled into balls about 4″ in diameter, at least two per child

Linoleum or floor tiles, about 9″ square, for bases, one per child

Clay tools, or tongue depressors

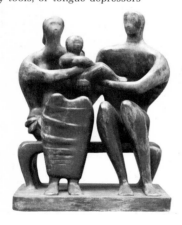

Moore *Family Group*

This project should follow the modeling of a single figure and explore the interrelationship of forms conceived as part of a group. The teacher displayed a large mounted photograph of Henry Moore's *Family Group.* When the children had gathered about, she said, "This is a sculpture by a famous English artist, Henry Moore, and is called *Family Group.* Some of you may have seen it in the Sculpture Garden of The Museum of Modern Art [several hands went up] but if you haven't, this photograph will give you a pretty good idea. You can see there is a father and mother holding a child between them. It's a large sculpture, almost five feet tall—will someone show us how high five feet is?" Thomas placed his hand above his head, saying, "I'm almost five feet tall." The teacher continued, "Works of art give us feelings that we can't really describe in words. But in a few words—maybe just one or two—try to tell us a little about how this sculpture makes you feel. I'll write the words down as you say them."

The following words were volunteered by the class: togetherness, happiness, trio, friendliness, motion, comfort, joy, love, abstract, smooth. The teacher read the words aloud and commented, "Some of you have used words that expressed the feeling you had when looking at the sculpture—'joy,' 'friendliness,' and 'love'—while others have used words that described the sculpture itself—'simple,' 'abstract,' 'well constructed,' 'motion.' The artist has created a sculpture that expresses in a strong and simple way the tenderness in a family. He wasn't interested in a photographic reproduction of people but made simple shapes, with just the suggestion of features. Except for the mother, who has a suggestion of a skirt wrapped around her legs, he hasn't shown them with clothes on. Their waists are very narrow, their shoulders are broad, and they sit solidly on the bench. Moore has created his own forms and shapes to express the human figure. The photograph shows only one view of *Family Group*, but of course as you know a sculpture is made to be seen from all sides. Remember this when you make your own, and keep turning it to look at it from different sides. You've already made a single figure; now you will model two or more people in a group. To give better support to the clay, it may be easier if you have the figures sitting or lying down. You may want to make a base for the group, or perhaps a bench if the figures are seated. It may also be helpful to start with one figure and have the others lean on it, or be joined to it."

The children got underway, starting with one ball of clay. Some made each figure separately and then

joined them together. Others made rough masses and shaped them with their fingers or tools, cutting or pulling pieces away here and adding others there. Charles made two people back to back—they were not on speaking terms! Cynthia made a mother and child asleep with three other children nearby (fig. 1). Eliseo made a family trying to watch television with little brother disturbing them (fig. 2). Thomas made a grandmother and her grandchildren (fig. 3); Andrea, children dancing around their mother (fig. 4).

The figures were left unpainted, because the quality of the sculptural grouping was sufficiently interesting in itself. When all the groups were finished, the teacher again displayed the photograph of Moore's *Family Group* and asked the class how they felt about it, after their experience in making groups themselves. Cynthia said she liked it better, because now she had made a family of her own. Eliseo and Thomas wanted to visit the Museum's Sculpture Garden and look again at the Moore there.

APPLICATION TO OTHER AGE LEVELS

This project can be carried out with any of the older age levels, making as many figures as desirable, taking economy of materials and storage space into consideration.

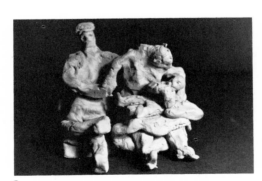

1

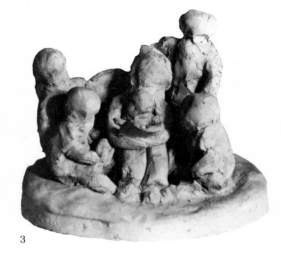

3

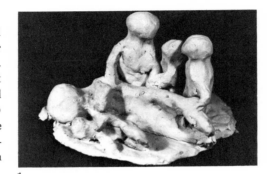

2

4

Initials modeled in clay

PURPOSE

To use the alphabet imaginatively; to further understanding of abstract sculpture by working with a familiar abstract form, the letter.

MATERIALS

Moist clay, rolled into balls about the size of a baseball, at least one per child

Clay tools, or tongue depressors cut to a blunt point

Linoleum floor tiles or masonite squares, about 9″ square, for bases, one per child

Noguchi *Bird C (Mu)*

Chillida *Place of Silences*

The teacher showed the class about a dozen photographs of abstract sculpture, including Isamu Noguchi's *Bird C (Mu)* and Eduardo Chillida's *Place of Silences*. She said that the class would play a kind of game, in which the object was to discover in the sculpture shapes that resembled letters of the alphabet. They would start by trying to find an O, a V, an L, or an S, but if any other letter revealed itself they were to call out and identify it. The letters could be on their sides, or upside down; they might be distorted, wavy, jagged, or uneven. She emphasized that it had not been the intention of the artists to include these letter forms in their sculpture, but the experience of hunting for them would make the children look at the works harder and perhaps understand them better, and anyway it would be fun. The class responded to the idea immediately and within minutes had discovered more than a dozen letters. The teacher said that the next step was to create letters of their own; they might enjoy designing one or both of the initials of their own names and modeling or carving them out of moist clay. The initials did not have to be in their proper sequence, but might be reversed, or stand on top of one another, perhaps with one lying down and the other standing upright.

A letter could be a single mass and could be different in front from in back, but it should be kept as simple as possible—not for the sake of recognition but in order

1

to make a strong design. Each child was invited to take one or two balls of clay and begin by shaping it roughly with the hands by pulling and squeezing it. By turning the piece and working at it from all sides, it would be sculpturally interesting from any angle. Bits of clay were pulled out and attached to other parts, if needed, then blended with the mass by using the fingers. After the piece had been roughly formed, it was smoothed with the fingers or tools to produce well-modeled surfaces or crisp edges. The teacher said that since the object was to produce a simple structural mass, it was advisable not to add textures, but that when the letters were dry the children could paint them with poster colors or use color to simulate the various materials—wood, marble, bronze, iron—that had been used by the artists whose sculptures they had seen in photographs. Some painted their pieces (fig. 1), but most preferred the natural clay (fig. 2). A few children had retained the precise shape of the letters, but the majority enjoyed altering them to inventing new shapes.

2

APPLICATION TO OTHER AGE LEVELS

This project is not suited to younger children. For older students, it can be made more complex, for example by modeling entire words or piling letter forms on one another in a vertical or pyramidal structure.

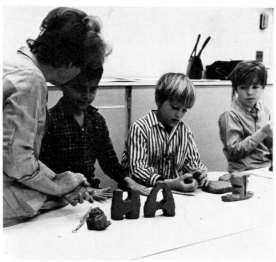

3

A moving sculpture or mobile

PURPOSE

To explore motion as a design element; to experience balance, both kinesthetically and visually.

MATERIALS

Florist's stakes, ⅛″ diameter and about 3′ long, to use as dowels, at least two per child

Reed, ⅛″ thick and 3′ long, presoaked in warm water for half an hour for easy shaping, one piece per child

Thin binding wire

String

Poster or rail board, various colors, cut in shapes—squares, circles, diamonds, crescents, free forms—or pieces from which children can cut shapes of their own, various sizes, 1″ to 2″

Buttons, wooden beads, paper cups

Scissors

Paper punches

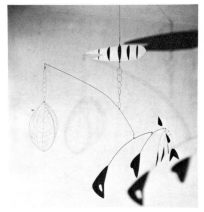

Calder *Lobster Trap and Fish Tail*

The teacher displayed several reproductions of mobiles by Alexander Calder. She discussed Calder as the inventor of a new form of art, the mobile, and asked whether anyone could describe a mobile. One child said it moved; another defined it as "moving sculpture." The teacher asked for other characteristics of the mobile. Victor said it had balance; certain parts were made to balance others. "How does a mobile make you feel?" the teacher asked. Eleanor said it made her feel like dancing when the whole mobile, or parts of it, moved. The teacher discussed different types of mobiles and said that since this was the first one the class would make, they would try a very simple approach. She described the project as involving two basic parts: the structure itself, and the shapes or motifs—free form or geometric. She diagramed several basic structures. Drawing a horizontal line, she said this could be the dowel or stick on which the shapes were hung. The line could be doubled so that one stick hung above the other; or two lines could be crossed, making an

X-shape, bound together at the middle with fine wire. The X-shape also could be doubled, with one hung above the other or side by side to form a pair.

The teacher then introduced the idea of using curved lines or shapes instead of straight ones. In this case, reeds instead of sticks would be used to form the structure. She demonstrated the following structures: a simple curved line; two curved lines, one above the other; two curved lines making an X-shape; curved X-shapes hung one above the other.

She said that as a further step, the structure could be a shape instead of a line, for instance by making the reed into: a circle; an oval; a crescent.

These demonstrations were meant to serve as suggestions, but the children were encouraged to try to make different structures and motifs of their own. The shapes were to be hung onto the completed structures.

The first step was the making of the basic structures at the table. Straight pieces (dowels) were used singly, or doubled and wired together; or curved shapes were bent out of reed and joined together with binding wire. The structures were then hung from a clothesline stretched across the room. (For large groups, two or more lines can be set above the heads of the children.)

The strings for hanging the structures should be of various lengths so that each child can hang his at the height most convenient for working.

Next, the teacher demonstrated the method of hanging shapes onto the structures, using various light objects or geometric forms cut out of poster board. A hole was punched into each of the shapes and a string tied to it, neatly and securely. Then the pieces were tied to the structure at various intervals, so that they balanced and looked well. The teacher demonstrated fulcrum balance, showing how a small shape can balance a large shape if it is placed at a greater distance from the center of the stick or reed. She pointed out that the mobile should appear visually balanced as well as being balanced in weight; for example, the color of a small red shape can balance that of a larger blue shape.

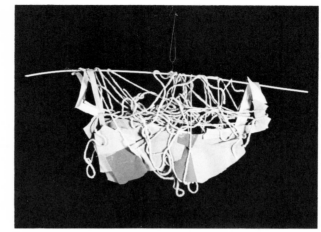

1

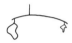

A great variety of mobiles was produced. Marc used a single dowel, on which he hung a net of string and cloth (fig. 1). Alix crossed six dowels and bound them together for the base, to which he attached ovals of paper, pinning them around the dowels with toothpicks (fig. 2). Another child made a base similar to Alix's, but speared cubes of styrofoam with the dowels and moved the cubes to balance his mobile. One boy balanced conical paper cups on a horizontal stick structure. A girl made two loops of reed to suggest a butterfly's wings, and covered her structure with net.

APPLICATION TO OTHER AGE LEVELS

This type of mobile should not be attempted with younger children.

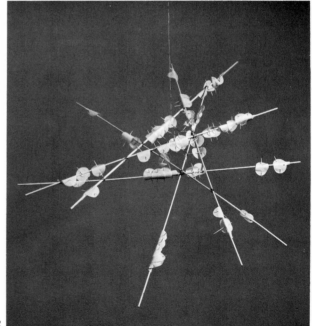

2

Projects for the preadolescent
of eleven and twelve

THE BEHAVIOR OF CHILDREN of eleven and twelve has the ambivalence typical of early adolescence. They do not like to be called children, nor do they think of themselves as children; they tend, however, to act like children, although with occasional spurts of adult insight and behavior. This is an age of rapid mental, emotional, social, and physical growth, and perhaps its most marked characteristic is the variation in behavior, tastes, and attitudes. Instead of being interested in gangs of their peer group, as formerly, young people at this age tend to choose a few close friends. Girls mature earlier than boys, and therefore they regard boys of their own age as young or children and are inclined to admire older boys. The interests of boys and girls are more separate than at earlier age levels, so they tend to divide into groups according to sex, pretending to oppose each other—or often even showing hostility—but actually behaving in a way designed

to attract the attention of the opposite sex. Boys indulge in horseplay, and girls try to act and dress like women. There is an emergence of social interest and a compassion for the underdog.

The preadolescent is curious, observant, and interested in nature and natural phenomena. He has an abundance of energy, and unless it is absorbed in meaningful activities, it may be expended in noise and just moving about and handling things. His span of attention and concentration increases, and there is a growth in the ability to manipulate materials.

In art, the preadolescent is inclined to admire realism or skill in representation, owing in part to his interest in nature and his wish to be adult. In his desire to be representational in his work, he often attempts problems that are beyond his ability and experience and feels frustrated when he fails to achieve his objectives. The teacher must therefore motivate him away from

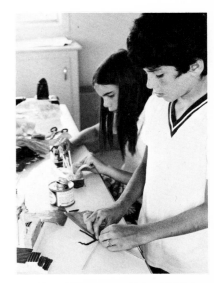

imitation and clichés by offering him experiences that absorb his natural interests and lie within the technical ability of his age level. Although young people of this age feel attracted to clichés or "shortcuts" in art, they are also challenged by new ideas and methods of creating. Their creative efforts can be extraordinarily fruitful if the group and the individual are properly motivated, and if the art experience is structured to meet the interests and capabilities of their age level.

For eleven- and twelve-year-olds, therefore, assemblage is the "open sesame" to a variety of interests and activities. In assemblage, the individual reacts emotionally and intellectually to concepts of design and structure, rather than working by rule, recipe, or preconception. Three-dimensional expression is particularly effective, because it employs an abundance of energy and satisfies the desire for manual dexterity and manipulation.

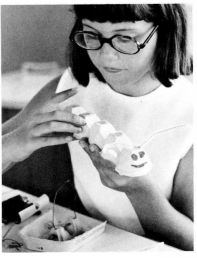

Collage painting: a dream or mystery picture

PURPOSE

To stimulate the imagination by using fantasy or dreams as the subject matter; to integrate collage with painting by using collage as the motivating element in the picture.

MATERIALS

Images cut from illustrations and photographs in magazines, in color and black-and-white, varying in size from 5″ to 12″ in the longer dimension; at least three per student. (The cutouts should be shapes or silhouettes of people or parts of figures, such as heads, hands, feet, eyes, lips, noses; and the whole or parts of animals, architecture, and objects such as fruit, furniture, clocks, automobiles, men's pipes, etc.)

White drawing paper, 18″ x 24″, at least one sheet per student

Paint

Scissors

Library paste or rubber cement

Magritte *The False Mirror*

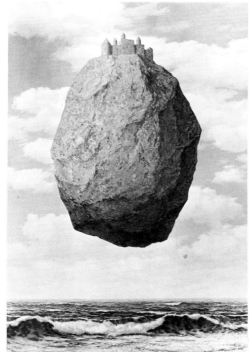

Magritte *The Castle of the Pyrenees*

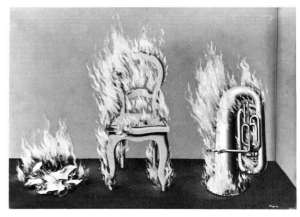

Magritte *The Ladder of Fire, I*

The teacher discussed the strange, unreal, or fantastic things that happen in dreams. The students related some of their dreams; some referred to programs they had seen on television. The teacher said, "Artists often paint dreamlike subjects or things that seem unreal or impossible. Such pictures might be said to have a kind of mystery or magic about them, because they show things we don't see in our everyday work but which we can dream up. That's what the imagination is for." As examples she showed three paintings by the Belgian Surrealist René Magritte—*The False Mirror, The Castle of the Pyrenees,* and *The Ladder of Fire, I*—and asked the class to find the unreal or magic elements in them. Of *The False Mirror* Mary said, "It looks just like a human eye until you see the clouds, and then the pupil becomes a black sun, and the eye is a window; and instead of its looking at you, you are looking through it at a big sky." *The Castle of the Pyrenees* provoked much comment. George said, "If the big rock with the castle on top weren't there, it would be just a nice seascape." Ellen retorted, "You're silly, that's what makes it a magic painting." Another student said, "How can such a big rock hang in space, or float? I guess that's the magic, too." Tim said, "It could if it were in outer space, but it isn't; it's just about a hundred feet above the ground. Boy, that's weird!" The students

found *The Ladder of Fire, I* very funny as well as intriguing, because one of the three objects that were burning so gaily, the bass tuba, was made of metal. The teacher agreed that they had the idea, and told them, "You are going to make a dream or mystery picture of your own, but it will be a very special kind of painting, because you will start it with a collage. I guess we can call it a 'painting collage.' I have here several pictures cut from magazines, some in color and some in black and white. For example, here are a power boat, a bookshelf, a speeding train coming toward us, a fruit bowl, and so on. Come up and look at them. When you find one that stimulates your imagination, take it with you to your place. You may take more than one, if your idea needs it. You may also reshape the picture by cutting off part of it, or perhaps you may want to paste two together. When you have made your choice, paste it on your sheet of white paper, wherever you feel it will make the best effect. It doesn't have to be in the middle. Then paint your magic around it with poster paints."

The students looked over the cutouts and discussed how they might be used. Since there were three times as many cutouts as students, there was no need for anyone to try to get there first or compete for the best. They studied the pictures with deliberation, each dis-

carding those that failed to stimulate an idea for him; but often a cutout discarded by one turned out to be the inspiration for someone else. The project demanded a quite different basis of choice from most, for instead of being made according to aesthetic content or individual likes or dislikes alone, the choice in this project was made according to the cutout's potentiality for evoking a strange or magical response. The cutouts selected were pasted on the sheets of white paper and the surrounding spaces painted with shapes, colors, and objects to produce the surprise effect. The results included the following: Tom balanced an automobile precariously on the point of an ice pick resting on the edge of a cliff (fig. 1). Mark assembled various parts of his cutouts in a curious way. He pasted part of a boat in one corner of his paper, and on the opposite side the head of a large bird; he placed a slice of an orange to make its eye, used a woman's lips with a toothpick protruding from them for a beak, and set a captain's hat on top of the bird's head. Then he completed his composition with colors and textures related to the cutouts (fig. 2).

Willy painted a large rooster, with a cutout of a speeding train pasted so that it seemed to be going into the rooster's mouth (fig. 3). One girl used a variety of cutouts—a bookshelf, a human eye, and several record jackets from an ad for popular music. She pasted the bookshelf near the middle of the paper and painted more books on each side of it; above the books, she pasted the eye as if it were looking out. In the lower half of her paper she arranged the record jackets in a random pattern suggesting a parade—a protest march against the books.

Another girl chose a picture of the television-program family "The Munsters" and added a picture of a child nearby. Then she painted a large rose around the group, so that the Munsters and the child were surrounded by the rose. One boy painted a large tree and hung several cutouts of men's pipes in it. He called it *A Pipe Dream*.

APPLICATION TO OTHER AGE LEVELS

This project would also appeal to adolescents, because of their interest in psychological effects and brain teasers. These older students would probably find the magic or mystery even more challenging than do the eleven- to twelve-year-olds, and they could do more provocative and interesting compositions. The motivation also could go more deeply into the study of Surrealism with examples by such artists as Salvador Dali, Max Ernst, and Yves Tanguy.

1

2

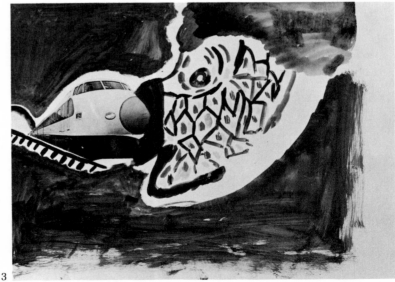

3

A collage using geometric and free forms

PURPOSE

To foster awareness of free-form and geometric shapes; to use them individually and in combination.

MATERIALS

Construction paper of various colors, 18" x 24", one sheet per student, 9" x 12", 6" x 9", 6" x 6", at least six pieces per student

Rulers

Compasses or round objects with which to make circles

Yarn, different colors and thicknesses

Pencils

Scissors

Paste

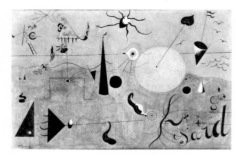

Miró *Catalan Landscape*

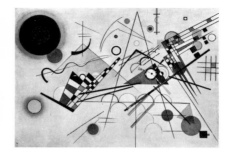

Kandinsky *Composition 8, No. 260*

Joan Miró's *Catalan Landscape* and Wassily Kandisky's *Composition 8, No. 260* were shown to the students by the teacher, who asked for comments on them. The discussion brought out the fact that whereas Kandinsky had used geometric shapes such as circles, triangles, and squares in his painting, Miró had used irregular shapes that suggested living organisms such as animals or plants (free-form). The teacher discussed vocabulary, emphasizing such words as "free-form" and "geometric" and having the students define them in detail. Another point that the students noted was that the shapes in both paintings looked as if they were pasted onto the background rather than painted. They observed that the shapes varied in size, and that sometimes the same shapes were repeated in different sizes. Kandinsky's composition was thought to be like an explosion, in contrast to the quiet and peaceful one by Miró.

The teacher had prepared several shapes in colored construction paper, including both geometric and free-form shapes, and smaller geometric figures to be superimposed on the free forms as well as smaller free forms to be pasted onto the larger geometric shapes. Using two rectangles of the same size but of different colors, she demonstrated how color can seem to alter size as well as affect the spatial relation to the background. She said that the students would make a collage using geometric and free-form shapes and that, for added interest, they could divide the background into areas of different colors, as Miró had done, relating the superimposed shapes to this background.

Each student selected a sheet of the 18-by-24-inch construction paper for his background and as many of the smaller-size pieces as he wished for the shapes. He drew his shapes in pencil and cut them out with scissors, remembering to make smaller free-form and geometric shapes to be superimposed on the larger ones. When he had arranged the shapes on the background to his satisfaction, he pasted them down, selecting additional paper from the general supply if he felt he needed more shapes for his composition. Finally, lines of yarn of different colors or thickness were pasted down for added embellishment.

APPLICATION TO OTHER AGE LEVELS

This project can be successful with younger age groups, from the six- to seven-year-olds on, but for younger children the free-form and geometric shapes should be precut. The project can also be used for older levels.

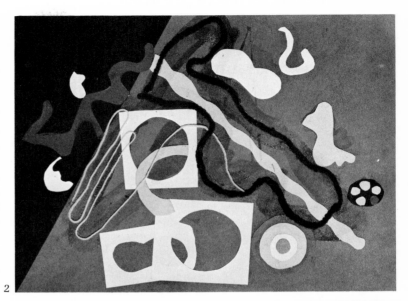

2

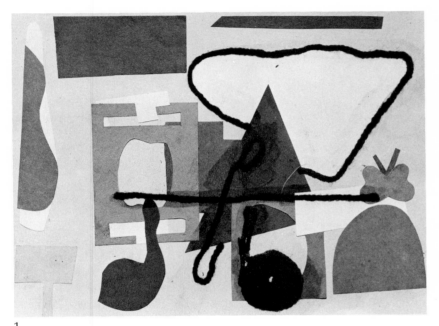

1

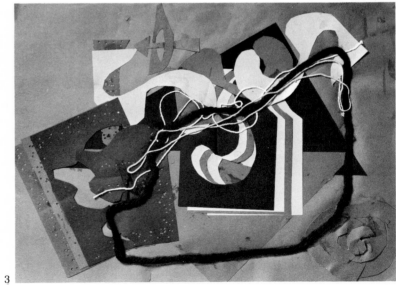

3

A figure-drawing collage inspired by primitive sculpture

PURPOSE

To encourage personal inventiveness in rendering the figure; to develop an appreciation of primitive sculpture.

MATERIALS

Construction paper, black, gray, and brown, 18″ x 24″, at least one sheet per student

White drawing paper, precut in various sizes and shapes, at least eight pieces per student

Black crayons or pencils

Paint

Paste

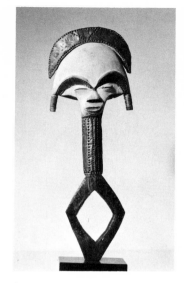

Ancestral Figure

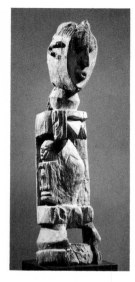

Female Figure and Child

Photographs of African sculpture were tacked up on the bulletin board, and the class was asked to comment on them. The group made remarks such as, "They are stiff," "They look unrealistic," and "The arms are too long." The teacher pointed out that these sculptures had been carved out of pieces of wood of different sizes and shapes, and that the artists were more concerned with fitting the figures into the shapes than with representing human figures in their true natural proportions. This concern with overall design is as important a factor for primitive sculpture as it is for modern. She told the class that she had prepared a number of shapes cut out of white drawing paper, rather than carved wood or stone, and that the aim of the project was to fit figures into these shapes. She suggested that if the students squinted at the photographs of the primi-

tive sculpture hung up as illustrations, they would be able to see the main contours of each figure more easily without being distracted by details. They could then perceive that the shapes were essentially square, or long and narrow, or squat; or round, slightly curved, pointed, or straight at the ends.

Each student was given seven or eight of the shapes cut out of white paper. Using a soft pencil or black crayon, he drew the contour of a figure to fit within each shape and then cut the figures out along the contour lines. Next he arranged the simplified figures on a background sheet of black, gray, or brown—these being colors often used by primitive people. He moved his figures around until he found the most satisfactory arrangement. The teacher circulated through the class, offering suggestions when these seemed to be needed and commenting on the groupings. When the student achieved a result that satisfied him, he pasted the figures down and then added painted patterns, textures, or masses to the figures or background to enhance his design (fig. 1). Ileana filled her background with dots placed at random (fig. 2). Rita pasted two backgrounds together to make a frieze, thus requiring more figures (fig. 3). The project combined an introduction to the art heritage with original treatment of the figure motif, an exercise in the simplification of form, and compositional problems that involved texture, pattern, and the embellishment of collage with paint.

APPLICATION TO OTHER AGE LEVELS

This project can also be done at the junior high-school level and above.

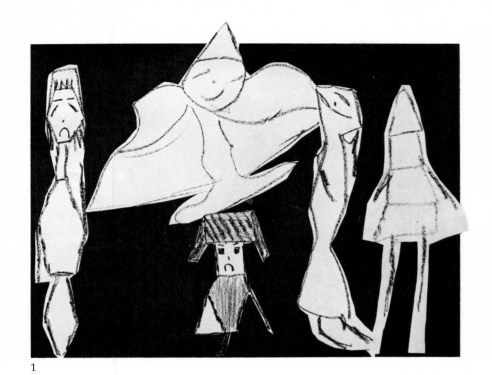

1

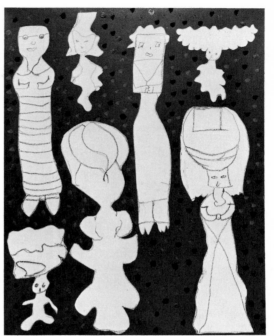

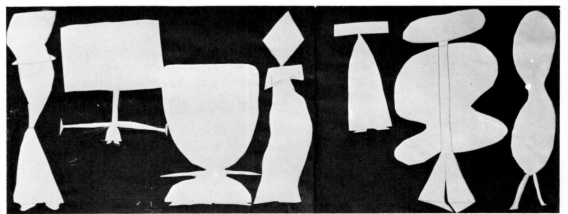

2

3

A collage based on patterns from nature and the everyday environment

PURPOSE

To create an awareness of the patterns around us and encourage seeing them selectively; to use patterns in creative work.

MATERIALS

Construction paper, various colors, 18″ x 24″, one sheet per student

Materials such as gelatins, tarlatan, shiny paper, tissue paper, corrugated paper, burlap, etc., of different colors, cut into small pieces 1″ x 3″, 3″ x 3″, and 4″ x 5″, sorted into piles of the same material

Scissors

Staplers

Paste

The teacher had posted for display several photographs and reproductions from magazines, among them a view of New York City skyscrapers at night with lighted windows, a closeup of a flagstone walk, a wall of weathered marble slabs, bicycles in a rack, an orchard, and a wheat field.

Teacher: There are patterns all around us—in the city, the country, at home, at school, and in our neighborhood. Study these pictures and tell me what you think the word "pattern" means.

Gregory: It's a design.

Teacher: What makes the design? Give me an example from the pictures.

Annette: The windows in the skyscrapers. They make a design all over.

Teacher: That's good. The repetition of the windows makes an allover design.

Lydia: The flagstones make a pattern, too.

The teacher commented that although the stones were not of exactly the same size and shape, the repetition of similar shapes nevertheless created the feeling of pattern. Someone pointed out that the slabs in the wall made a similar informal pattern. The teacher then said, "We will all make patterns; everyone will choose one material and repeat similar or identical shapes."

From among the materials laid out, the students chose pieces of the same or varied sizes and placed them in orderly fashion on sheets of colored construction paper. Some rearranged the pieces several times; others changed the background of colored construction paper, or cut the rectangular pieces into oval or free-form shapes to suit their ideas. When they were satisfied, they pasted the pieces down. A variety of patterns resulted. Laura arranged rectangular pieces of gelatin in a rectangular pattern (fig. 1). Louise overlapped rectangles of tarlatan of different colors in a diagonal arrangement (fig. 2). Gregory, inspired by the photograph of bicycle wheels, cut oval-shaped pieces and overlapped them slightly. Patricia used squares of tissue paper and pasted small crumpled pieces of tissue informally along the edges, in an effect that resembled a view from above of a flagstone terrace surrounded by shrubs (fig. 3).

APPLICATION TO OTHER AGE LEVELS

This project is not applicable to children younger than ten but can be used effectively with older age levels.

1

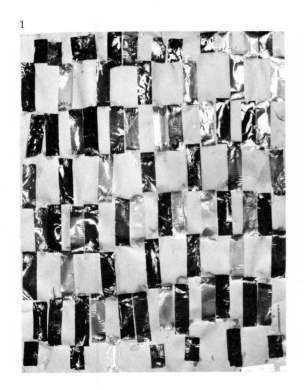

2

3

A collage book: the story of a shape

PURPOSE

To develop continuity of interest and expression, both individually and as a group; to encourage the expression of ideas by means of abstract form and lead students to recognize that abstract shapes can be interpreted subjectively or convey a meaning just as well as representational art.

MATERIALS

Construction paper, black, gray, dark blue, brown, 6″ x 9″, at least six sheets per student

Scraps of colored paper, varied shapes and sizes, saved by the teacher from previous projects with this project in mind. Both negative and positive shapes should be collected in a tray or box, but if sufficient scrap is not available or special shapes are wanted, they can be cut.

Scissors

Paper punches

Paste

String or paper fasteners

This project is a kind of game for capturing the interest of a group and sustaining it throughout the effort.

Teacher: We are going to make up a story of a shape; in fact, it will be a storybook telling about a shape or shapes. Most stories are expressed in words that describe things or people and tell us something about them. They are usually printed in black type on white paper, and sometimes they have pictures or illustrations to explain and dramatize the story. For example, if a girl is happy, she is shown smiling. We can convey the same idea with colors or shapes. Some colors seem gay and others sad. Can you give any examples?

Markand: Yellow would be gay, while blue would be sad.

Alice: Orange would be happy, while black would be very sad.

Teacher: Of course, for some of you it might be just the reverse: blue might be gay, and yellow might be sad. It is up to the artist to decide. The next step will be a little more difficult. This is reacting with different kinds of feelings to shapes. (She held up a round shape and a crooked one.) Here are two shapes. Can you react to each of them separately.

George: The round shape might be a gay shape.

Janice: Then the crooked one would be funny.

Ellen: But I don't see how we can make a story about a shape.

Teacher: Very well, let's try it. (She picked up a strip of long black paper.) Here is a tall sad man. (She then held up a wiggly strip of red paper.) He meets a happy lady. (She held up a third shape, a piece of round blue paper.) Now you continue the story.

Alice: It's daytime and the sky is blue.

The teacher held up an irregular shape of orange paper.

Markand: They meet a strange beast.

Teacher: You have the idea; now make up your own stories. Remember that we are going to tell stories with shapes and only a few words, or perhaps no words at all. First we shall make a book of several pages and then paste on the pages the shapes that tell our story.

Each student selected four or five sheets of colored construction paper (he could take more later if he needed them). Along one edge of each page, he punched two or three holes, through which he would later thread string or put paper fasteners to hold the pages together. From the scrap box, he selected shapes that

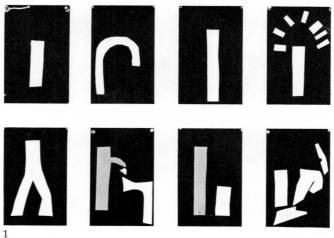

1

fitted the size of the pages of his book, or if he wanted he could cut new shapes out of colored construction paper, using both positive and negative shapes. (Left-over scraps were saved for another class or project.) The object was to choose a single shape to begin the story and then add others as the story progressed. The students could use a single color, or more, depending on the story. Some wrote in captions for their pictures with pencil, while others had stories without words. At the end of the session, each one told his story to the group, turning the pages of his book as the tale developed. One of the aims of the project, in fact, was to verbalize the story as well as to express it in visual terms.

APPLICATION TO OTHER AGE LEVELS

This project can be done with children as young as seven, on a simpler basis, or it can be adapted for older age levels by using more complex ideas and techniques.

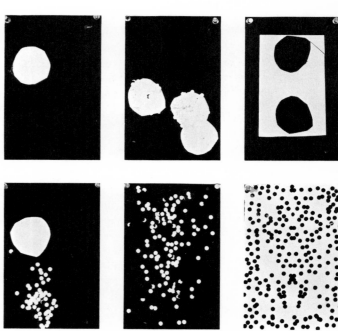

2

A lettering collage: names

PURPOSE

To present lettering as design and develop an interest in typography as an art form; to create lettering.

MATERIALS

Construction paper, various colors, 18" x 24", at least one sheet per student; 12" x 18", 6" x 18", 9" x 12", 6" x 9", at least two sheets per student

Newspaper, a few sheets to be shared by the class

Scissors

Paste

Davis *Visa*

The teacher showed a reproduction of Stuart Davis's painting, *Visa*, in which lettering has an important role in the design. She also ran a short film, *Zig Zag*, based on neon and other lighted signs seen in New York City.* In the discussion that followed, the teacher said that many painters today are interested in typography and lettering as art elements and include them in their work. She pointed out that more than half a century ago, Pablo Picasso and Georges Braque had pasted newspaper clippings and theater tickets in their collage paintings, not because of their content but because of the visual effect of the printing. She told the class that in their next session, they would try a painting using lettering as the major element, but that first they would do a collage, which is a simple and direct approach to designing with letters.

Each student was to use the letters of his first or last

*Zig Zag by Frank Stauffacher; 1 reel, color, sound; 8 minutes; can be rented from Radim Films, 220 West 42 Street, New York 10036. The project can be motivated without the film by using reproductions of paintings including lettering by other artists as well as Stuart Davis, but use of the film is desirable because it heightens motivation by introducing another visual medium.

name and create his own lettering in any style he wanted. He was not to be concerned with readability; in fact, the letters could be reversed or turned upside down, if his design required it. The letters could differ in color and value; they could be all of one size or of different sizes. The students were to make the letters by cutting or tearing them directly from colored construction paper or newspaper. They were also to design other shapes and arrange them on a background; then they would paste the lettering on top. The problem required designing both shapes and lettering as well as selecting colors and values that worked together in an interesting harmony.

The students began by selecting 18-by-24-inch sheets of colored construction paper for their backgrounds, and several sheets of the smaller-sized papers for the shapes and lettering. The shapes were first cut or torn out and laid on the background. Some students used a single large free-form shape; Laura used several irregular shapes and distributed them over the sheet (fig. 1). Francisco cut a large oblong and crossed it with several strips (fig. 2). The letters were then cut or torn out and arranged over the shapes; a few used newspaper from which they cut out their letters. Those who needed advice consulted the teacher before pasting, but others pasted directly. In some works, the lettering made the names easily legible; in others, it was used to create an abstract pattern against the background. In Markand's collage, background and lettering were subtly merged (fig. 3).

APPLICATION TO OTHER AGE LEVELS

This project can be done with six- to seven-year-olds, using patterned wallpaper instead of cut or torn-out shapes as background. It is especially well-suited to older age levels.

1

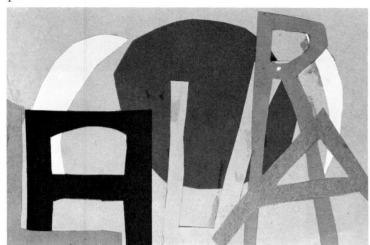

2

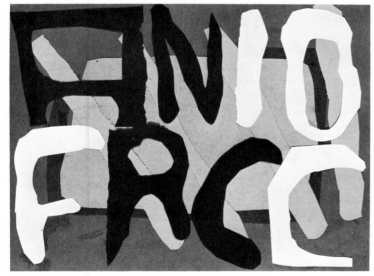

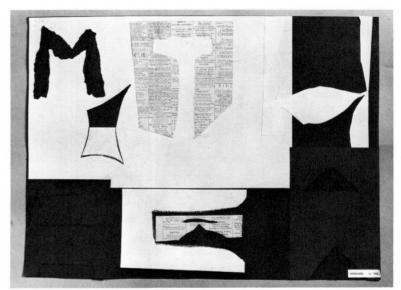

3

A lettering painting

PURPOSE

To continue the development of interest in lettering as an art form; to use the experience gained by the student in one project as a stage in developing another creative work.

MATERIALS

White drawing paper, 18" x 24", at least two sheets per student

Paint

Pencils

This project followed "A Lettering Collage," utilizing the experience gained by cutting and relating letters as a foundation for drawn and painted lettering. The teacher put up for display all the lettering collages that the students had done in the previous session and asked for discussion of them. The students were impressed by the variety and individuality of design possible in lettering. Most of them had not realized that printed words or letters contained any aesthetic qualities or that printing types were created by artists. They had thought of printing only with respect to its content, not as having visual or aesthetic possibilities. They criticized the lettering collages in terms of their composition, color, and value. Some they found too busy and thought the compositions could have been simplified by using fewer background shapes. In other works, they found the colors used for the letters were too bright, so that they dominated the more subtle colors; a similar criticism was made of the use of dark and light values, which in some cases contrasted too strongly with the background, while in other cases the values used for the letters were so close to that of the background that they seemed to undulate, creating a "jumpy" surface.

The teacher said that in the paintings they were about to do, they would have a second chance at the problem and could correct any of these flaws. She emphasized that the project involved a relationship of shapes and masses that looked well together. She said that the object was not to copy their own collages in paint but to use the experience they had gained and approach the problem in a fresh way. She suggested that those who preferred to draw the lettering first and paint around it could feel free to do so, but she pointed out that this was a more complex and difficult method than painting the background first and then designing the lettering over it. The students used both approaches—some drew the letters with pencil first and then filled them in with paint (fig. 1), and others painted the letters directly on the background (fig. 2).

APPLICATION TO OTHER AGE LEVELS

This is too difficult a project for younger age levels but can be used with any older groups.

1

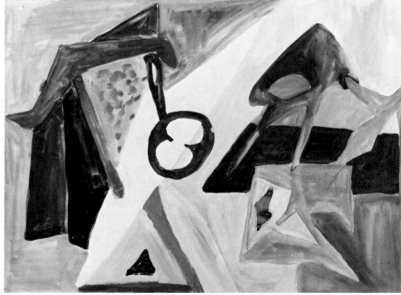

2

An assemblage of sticks and straws

PURPOSE

To explore linear design by using as elements materials that have a line quality; to investigate how line may be used to produce texture and pattern.

MATERIALS

Cardboard strips, 2″ x 8″, 2″ x 12″, 4″ x 8″, 4″ x 10″, at least three per student

Three kinds of sticks—swab sticks, coffee stirrers, tongue depressors, at least twenty-five per student

Multicolored cellophane and paper drinking straws, one box per student

Scissors

Staplers

Rubber cement

The teacher said, "A line can be made in many ways. We are most familiar with lines drawn with a pencil or crayon on paper. But a line can also be something like a stick—for example, a swab stick on which the doctor puts cotton to paint or swab your throat when you have a sore throat. It can be thin like the swab stick or this drinking straw, or it can be wider like this coffee stirrer, or still wider like this tongue depressor, which the doctor also uses to examine your throat. Now look. When I put several of them together side by side, they produce a surface with a texture you can feel when you run your finger over it, and they make a pattern when you look at it. If you use straws or coffee stirrers, you would make different textures and patterns. We are going to make an assemblage on a cardboard background, gluing a design made of one of these materials to it to produce pattern and texture.

"The shape of the background can be made with a single strip of cardboard, or with two strips laid on top of each other, or with three or more strips.

Staple the pieces together, but keep your backgrounds reasonably small, because you'll find that gluing the straws or other materials that you choose is rather painstaking, and the operation may become tiresome if your background is too large. Choose only one kind of material, straws or sticks, at least at the start, for simplicity of design and ease in working. Cut the material to the size you want, but let it overlap both sides or the ends of the background; later, you can cut or trim it evenly with scissors, if you want. When you are ready to lay the material on the background, cover only a small area of the background with rubber cement; this will prevent the rubber cement from drying too soon and make it easier to control your work. You can arrange the material to make a linear pattern in various ways. The lines can run in one direction, horizontally or vertically, or diagonally,

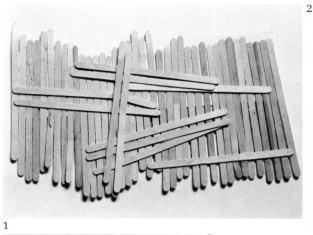

1

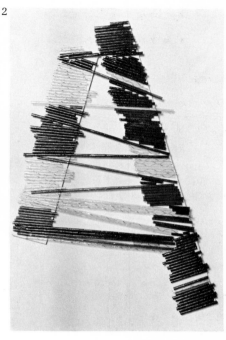

2

or they can make a zigzag pattern, or a pattern of alternating verticals and horizontals, or they can ma'.e two layers crossing each other.

When your assemblage is finished, you can trim or shape the edges evenly like a beard, if you want; however, you may find the irregular edges prove more interesting and decide not to trim them."

APPLICATION TO OTHER AGE LEVELS

This project can also be used with any of the older age levels.

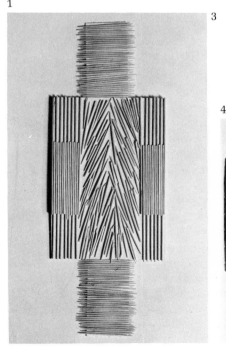

3

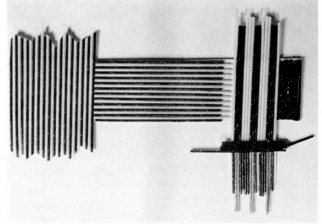

4

A construction made of sticks and reed

PURPOSE

To stimulate the ability to conceive a design in abstract terms; to construct a stabile by means of lines, planes, and spaces; to discover the basic principles of design that underlie subject matter in sculpture.

MATERIALS

Reed, ¼" thick, in lengths varying from 24" to 30", presoaked for half an hour in warm water to make it pliable; at least two lengths per student

Dowels, ¼" diameter, in lengths varying from 15" to 24", at least two per student

Rail board, various colors, strips varying from 1" to 2" wide by 10" to 12" long

Corrugated paper, various colors, cut into small pieces (can be scrap)

Toothpicks, swab sticks; binding wire; string; masking tape

Styrofoam blocks, about 5" square x 4" high (blocks of clay will do if styrofoam is not available), one per student

Staplers; paper punches; scissors

The teacher discussed the problem of the basic design in a stabile, a three-dimensional construction without motion. She said that some stabiles were based on a vertical structure, some on a curve, and others on a diagonal. She demonstrated the vertical design by sticking two or three dowels in a block of styrofoam and suggested that they might be connected with horizontal strips of paper. Taking a piece of reed, she bent it into a curve, then joined the ends to form a circle or an oval; this could provide the basic shape for a curved stabile. A diagonal structure was demonstrated by sticking a dowel into the styrofoam block at an angle.

The students began by making their basic shapes first, with dowels or lengths of reed; then they added other materials. Malcolm stuck dowels into his styrofoam block so that they stood upright, and connected them with bands of corrugated paper, spaced at varying intervals. He overlapped the ends of the paper and stapled them together, then stapled the bands to the dowel sticks to keep them from slipping down (fig. 1). One girl modified the idea of a vertical structure by sticking dowels into each corner of the styrofoam block

at a slight angle, so that they splayed outward. After cutting strips of colored rail board, she punched holes in the ends, then slipped the strips over the dowels so that they tilted at an angle. The result was a design of angular lines in opposition to one another. Henry curved lengths of reed in wide arcs and stuck the ends into the block so that the curves stood upright; next, he punched holes in the ends of strips of rail board, which he pushed up across the curved reeds until they were held in place by tension (fig. 2). Emily made a diagonal construction of pieces of rail board stapled together in a complex zigzag pattern dangled from dowels set into the styrofoam base (fig. 3).

The students found the project interesting and did not require a theme or subject. A project presented as a problem in abstract design is sufficiently challenging to absorb the interest of young people.

APPLICATION TO OTHER AGE LEVELS

This project can be adapted to any of the older age levels by making the problem of abstract design more complex and demanding.

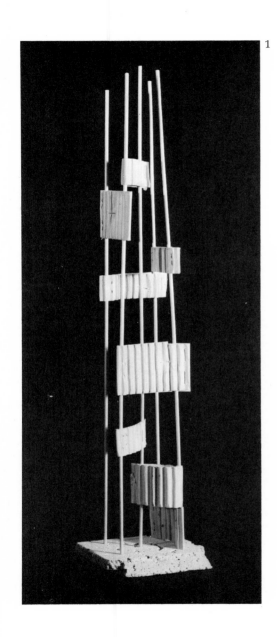

1

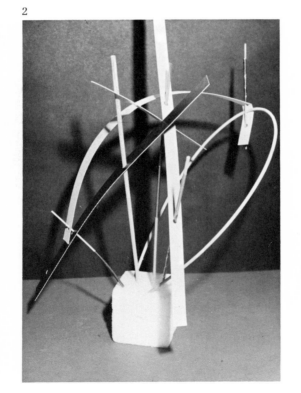

2

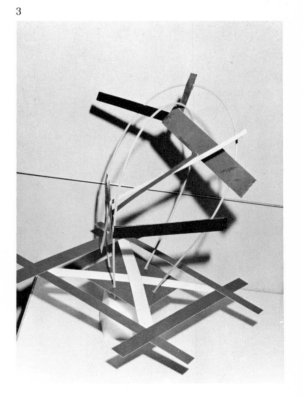

3

Clay modeling: sculpture from a sphere

PURPOSE

To derive an abstract sculpture from a clay ball; to explore positive and negative shapes; to study light and shade as expressed in the manipulation of form.

MATERIALS

Moist clay, balls 6″ in diameter, one per student

Clay tools or tongue depressors

Poster paint, black and white

Holding up a ball of clay, the teacher said, "Here is a challenge to your imagination and your manipulative skill. This is a familiar, common shape—a ball—which you are going to make into a sculptured form of your own." She pushed her finger into the clay and made a hole, which she called a negative shape. She showed how the hole could be changed by altering its contour, or by widening or deepening it. Then she made a second, shallower hole and pointed out how, when the ball was held up to the light, the deeper hole looked darker than the shallower one. She turned the ball around and made a number of holes of different depths and shapes by pushing in the clay or scooping it out, until the sphere had acquired an interesting sculptural effect. She said that the object was for each student to articulate the ball in as many ways as he could invent, using his fingers and tools and turning the ball around as he worked.

After taking their balls of clay, the students first as a manipulative exercise shaped them into cubes by flattening the sides; after forming them into balls again, they made them into cones by rolling them to a point at one end; finally they returned them to their original spherical shape. The object was to gain an impression of simple mass. Next, each student made one, two, or more holes in his ball of clay, shaping them into various contours and leaving them shallow, deepening them, or piercing them through. The sculptures were completed in successive stages; in some, the shape of the original sphere was retained, while others were flattened and given irregular shapes or pierced openings. The project provided a first experience in making abstract sculpture, as the students were interested in the ball as a mass, in the holes and shapes, and in light and dark effects. They felt no need for expressing any recognizable object.

In the second stage (which can be done in another class session), the sculptured ball was painted with black and white poster paints, in order to emphasize the form by painting certain parts dark and others light. Tim increased the effect of depth of the holes in his sculpture by painting them black (fig. 1); Christine made her holes seem larger than they were by painting rays that extended outward from them (fig. 2).

APPLICATION TO OTHER AGE LEVELS

This project can be used with any of the older groups.

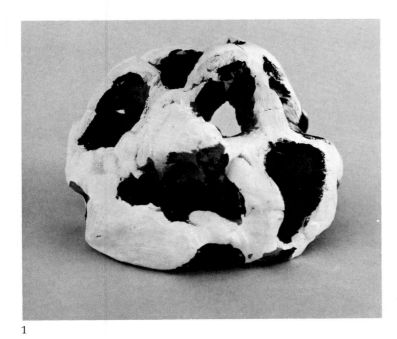

1

2

Mobiles made with cardboard mats

PURPOSE

To challenge the imagination and skill of young people by using discarded materials to make a new and different three-dimensional form.

MATERIALS

Lightweight cardboard framing mats, approximately 12″ square with 1″ border, at least two per student. (Oak tag lightweight enough to be bent into curves can be used, or colored construction paper; within a 1″ border, the center should be cut out with a razor blade or sharp knife, 12″ square or any other desired size or shape.)

Tissue paper, tarlatan, various colors, cut to the outside dimensions of the mats

Assorted fabrics, yarn, other collage materials

Rubber cement

Staplers

Scissors

Wire

The teacher had discovered lightweight cardboard mats in the mounting room of a framer's shop; they were about to be thrown out as rubbish, but she had asked to have them because she saw the possibility of the students making something original out of them. They had been intended as mats for photographs, but the students were to use them in a different way—a three-dimensional rather than a two-dimensional way. She demonstrated several methods by which the three-dimensional form could be made out of the flat frame—by curving it around into a cylinder, bending it so that it had a sway or bulge, folding it in half like the pages of an open book, or folding it into unequal sections. One boy asked whether he might use two of the mats; the teacher replied that he might even use three, but suggested that the forms not be made too complicated, both for the sake of appearance and for ease in handling. She said that the openings within the frames could be filled in with tissue or tarlatan. The group discussed what they should make. Several suggestions were offered, but finally the class decided to make something suspended in space, so that its form could be better appreciated, and mobile, so that the element of motion would be added to the spatial form.

Each student thought of a shape for his mobile and selected one or more mats for its structure. Before folding or bending the mats, he carefully pasted on transparent tarlatan or tissue paper. If the tension created by bending the piece into a curve required it, the sides were stapled to hold them together. The constructions were hung on a string, suspended at two points if an even balance was desired, or from a single point—such as a corner—to create a rakish effect. Then the mobiles were hung on a clothesline stretched across the room, so that the students could embellish them by adding other materials, such as tarlatan, fabric, or yarn, which were pasted or stapled to the surface or made to dangle from the edges. Finally, the finished mobiles were suspended on string or fine wire so that the students could carry them home.

APPLICATION TO OTHER AGE LEVELS

This project is not recommended for younger children, because of its complexity, but is applicable to older students.

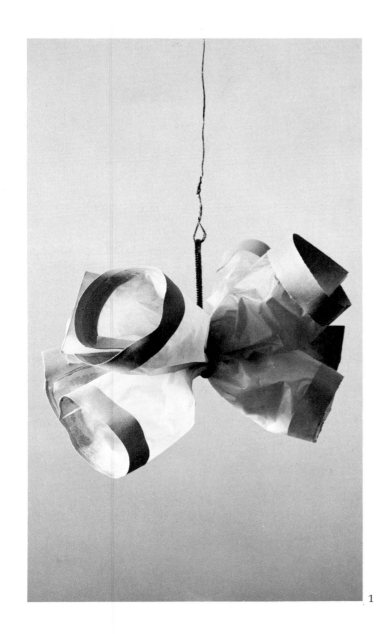

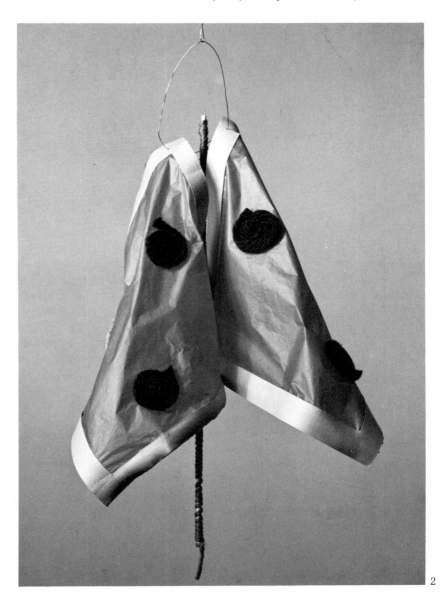

1

2

Projects for the young adult
of thirteen and fourteen

THE INDIVIDUAL of thirteen and fourteen years is no longer a child but an adolescent, who wishes to be regarded as an adult. He therefore reacts strongly against being referred to as a child or being associated with childish behavior and things. Yet he is more ambivalent than an eleven- or twelve-year-old. His behavior vacillates between that of a child and that of a grown-up. There is opposition to authority, especially that of parents and teachers. While claiming to be a nonconformist, the young adolescent is both a conformist within his peer group and imitative of adult ways and mannerisms. Often physically awkward, he is at times surprisingly graceful. He is growing rapidly—physically, mentally, and emotionally—and has an overabundance of energy and enthusiasm.

Even more than at the earlier age level, the young adolescent, because of his desire to be an adult, rejects the naive aesthetic qualities so greatly admired in children's art works, and his desire to imitate the mature artist makes him an easy prey to stereotypes and clichés. Most teachers, in evaluating the art work done at this stage, bemoan the loss of spontaneity, freshness, and natural sense of design that characterizes children's art and complain about the interest in realistic representation and loss of free expression.* This de-

* This complaint is made not only by American teachers, but by teachers the world over. In visiting various countries with the Children's Art Carnival, it was found that teachers in Italy, Spain, Belgium, and India had all observed the same decline in creative work as children approached adolescence. The

140

cline in creativity is not inevitable, however, for it can be prevented or overcome by positive motivation and guidance by the teacher. The object is to direct the interests and energies of the young person into new creativity congenial to his age level, rather than to keep him working like a child.

The adolescent is growing in his awareness of life around him, of natural phenomena, and of the whole universe. He is particularly interested in man—man's role in nature and in the social order—which is why he admires realism in art and tries to become representational in his own work; more than at any earlier stage, the young person of this age admires the "good drawers" and regards them as talented. The art teacher can do much to overcome this predilection. Contemporary approaches of automatic and gestural drawing can form the basis of the study of the human figure, replacing the traditional copying of the model or obsolete methods of studying anatomy and analysis of the figure. Similarly, the adolescent's interest in nature can be satisfied by the study of the texture and structure of materials and appreciation of the aesthetic qualities

Carnival, an experiment in creative teaching that combined a motivational and a workshop area, was created by Victor D'Amico. An annual event at The Museum of Modern Art for many years, and presented continuously at the Harlem School of the Arts in New York since 1969, the Carnival has also been shown under the Museum's auspices as part of the U.S. representation at trade fairs in Milan and Barcelona, and at the Brussels World's Fair.

in "found art," thus developing his tactile and visual senses. By increasingly using this heightened awareness in his own work, he learns to integrate observation with creativity. When the adolescent discovers that these qualities are the very ones that the modern artist most values in nature, he achieves a new understanding of the arts of his time and of man as a creative being. Furthermore, the adolescent is acquiring a sense of abstract values and relationships. Because of his interest in science, new technology, and the exploration of outer space he is extremely well oriented to abstract forms and concepts, which makes him sympathetic to abstract relationships in art. He can understand pure abstraction in painting, sculpture, and assemblage and finds no conflict between this and his love for natural forms and images.

The new approaches to art education through assemblage, as set forth in this book, can overcome the adolescent's notion that creative ability can be equated with facility in representational drawing. They offer instead concepts and mediums that can evoke personal and creative expressions. The projects presented in this section are geared to the nature of the adolescent and his stage of development, and have been devised expressly to use his curiosity, interests, energies, and capabilities constructively. In this way adolescence, rather than being a period of regression and reaction in art, can bring a new flowering of creative growth based on the discoveries and deeper insights of the maturing young adult.

A memory collage

PURPOSE

To use memories of people or events as the subject of a collage; to intensify the art experience by using materials or objects that belong to the student or are associated with some earlier experience.

MATERIALS

Shirtboards or odd-shaped cardboard, for backgrounds, at least one per student

An assortment of colored construction paper, newspaper, wallpaper, corrugated paper, silver foil, pages torn from magazines, old birthday and greeting cards, charts, maps

Scissors

Rubber cement

Dove *Grandmother*

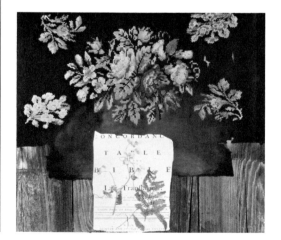

In actual construction, this project is similar to the making of an abstract collage in which materials are chosen for their textural qualities only; here, however, nostalgia is used to intensify the art experience. If the project is discussed in advance of the class session, students can bring personal things from home to use with materials from the general supply.

The teacher began by holding up a reproduction and saying, "Here is a collage that I think will interest you. We might call it a memory collage, because the American artist who made it, Arthur Dove, chose things that reminded him of his grandmother, in fact, he called it *Grandmother*, so it is a kind of portrait, but not in the usual sense. Most portraits are painted of the people themselves and so look like them. This picture, on the other hand, contains things that recalled his grandmother to Dove: some pressed ferns and flowers, a page from an old Bible, a piece of faded needlepoint embroidery, a row of weathered shingles turned gray with age. Each of these things suggests some aspect of the idea of grandmother—her age, her fragility, her silvery hair, her patience, her piety. The artist has combined them in a visual poem so that, put together, they take on an identity.

"We all save objects, such as theater tickets, clippings, souvenirs, postcards of places we have visited, wrappers and ribbons from birthday gifts—all things that remind us of a person or an event. Make believe

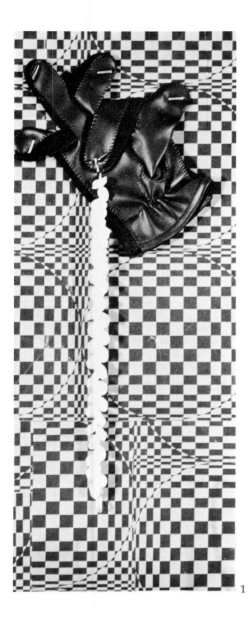

1

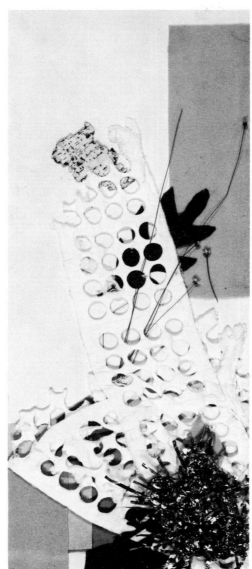

2

you are cleaning your room, or the chest of drawers in which you keep your belongings, and that you come across some things you have saved and are going to put them together to make a collage that will have a special meaning to you personally. Recall some event, long past or recent, such as a party, a wedding, a trip; or think of some person whom you can express through a collage."

The students went in groups of five or six to select their materials from the assortment prepared by the teacher. Each student approached the problem in an individual way, as the following descriptions of some of the collages indicate.

For her collage, *My Dog Passed Away,* Katherine used many fabrics—a piece of embroidered velvet resembling her bedspread, and a little white wool scattered over it as a reminder of her dog's shedding. She selected a black sock and a white glove, cut and shaped them, and pasted them into the collage to symbolize the many socks and gloves he had chewed up as a puppy.

My Summer (fig. 1) by Denise was a simple, selective, and effective collage made with only three items: a piece of gift-wrapping paper with an "Op" design in purple and black, used as a background to express her exciting summer; a black glove pasted to it, which suggested the coolness of the mountains where she summered; and a section of a white shell necklace that dangled from the glove and represented a gift she had received for her birthday.

I Once Hatched an Egg (fig. 2) by Margaret was made mostly of the kind of soft, perforated wrapping paper used for fragile articles. She made a chickenlike form of metallic ribbon and nestled it in some finely cut paper at the bottom.

Deborah's *Autumn with a Little Bit of Summer Left In* (fig. 3) was as poetic as its title. She used some birch bark, as well as earth-colored materials, cork wrapping paper, several kinds of cones, and bits of fabric. She added a touch of color—a reminder of summer—in the form of a sprig of pink artificial flowers.

Maria made a somber collage called *My Aunt Died* (fig. 4). Sadness and gloom were symbolized by a piece of black leather and a dark-colored cloth that partially covered two black-and-white reproductions cut from magazines—one of a statue with a mournful face, the other of a woman's face with hands pressed over her eyes.

The titles of some of the other collages made by the group indicate the diversity of subjects: *My Father, We Took A Trip to the Rockies One Fall, I Visited the Sunken Forest on Fire Island, A Wall at Camp, I Walked in Protest to Washington,* and an evocation of the four seasons called *This Past Year.*

APPLICATION TO OTHER AGE LEVELS

This project, simplified in concept and statement, may be used for lower age levels but not with children younger than eight. It is adaptable to older groups.

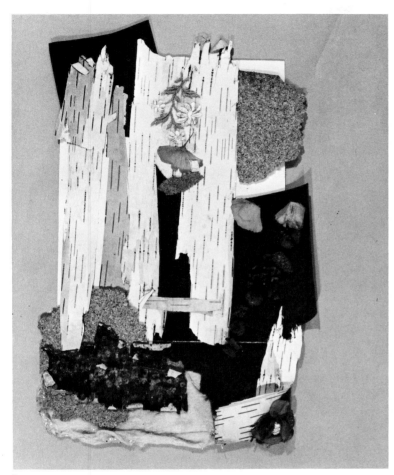

3

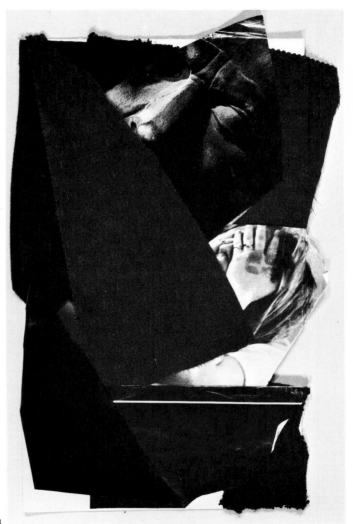

4

A collage tapestry

PURPOSE

To develop a simple, direct means of working, employing collage and a kind of tapestry method.

MATERIALS

Shirtboards or any cardboard, about 9″ x 15″, at least one piece per student

Stiff netting, white or colored, about 9″ x 15″ (the same size as the cardboard), at least one piece per student

Construction paper, various colors, 12″ x 18″, at least one sheet per student

Assorted fabrics, cut into pieces about 3″ x 6″ or 6″ x 4″, at least six per student

Yarn of various thicknesses and colors

String and twine, various thicknesses

Toothpicks, natural or colored, wood or plastic, one-half box per student

Staplers

The teacher displayed photographs of a variety of woven hangings and tapestries by modern craftsmen. She explained that these had been done by complex methods that required special equipment, but the group was going to use instead a very simple and direct method that she had invented for the purpose. The object of the lesson was for the student to work out a design directly with the materials, improvising as the design progressed, working without a preliminary sketch and even without an idea of the finished work in mind. The project primarily involved the relationship of lines made with wool, string, or twine and shapes made of bits of fabric, but there was an added element of color or transparency involved. The piece of netting that was to be used as a background for weaving would be stapled to a shirtboard at the edges to keep it rigid while the student worked, but this would be removed when the tapestry was finished. Then everyone would have the choice of leaving his tapestry without a background, so that one could see through it, or stapling it to a piece of colored construction paper for added color interest. The project was to provide a spontaneous way of designing, allowing the student to change a line or add a shape at will. Thicker lines could be made by doubling the yarn.

Each student took a piece of shirtboard, a piece of netting of the same size, and toothpicks and selected a few pieces of fabric, yarn, and string. After the netting was stapled to the cardboard along the edges, toothpicks were woven into it at intervals, with their ends left exposed so that yarn could be wrapped around and under them. The position of the toothpicks determined the structure of the design. The string or yarn stretched between or wrapped around the ends of the toothpicks was drawn tightly enough to be taut but left sufficiently loose to prevent the background from puckering. Other toothpicks were used to fix patches of fabric in place. Some students stretched yarn on top of the pieces of cloth (figs. 1, 2, 3). Vicky designed her tapestry keeping the two elements—line and shape—separate (fig. 4). When the shirtboards were removed and the netting left transparent, some students felt the need of a background or the contrast of another color and backed their tapestries with construction paper. This age group is capable of doing projects that require more complex and exacting techniques, but occasionally a simpler one is stimulating and refreshing.

APPLICATION TO OTHER AGE LEVELS

This project can be applied to children as young as six (compare "A String Design," page 76). By making it more challenging in design and construction, it can also be used for older age levels.

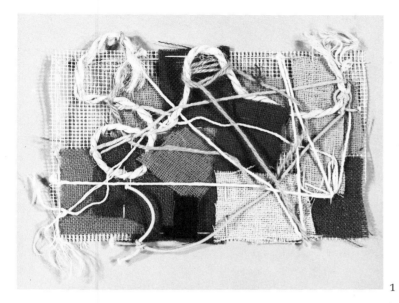

1

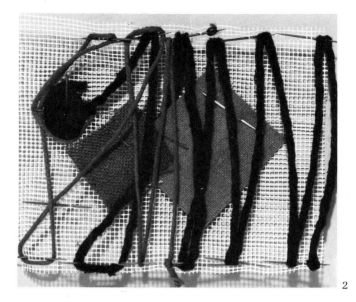

2

3

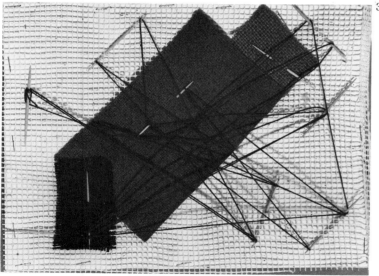

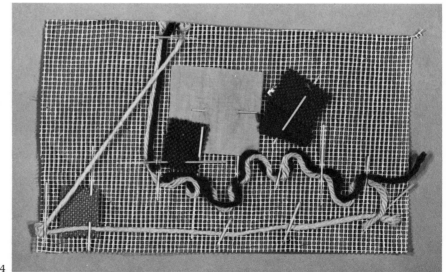

4

Direct drawing in line and mass

PURPOSE

To interpret a collage in painting; to draw directly with paint; to experience the discipline of working only in black and white.

MATERIALS

White paper, 18″ x 24″, at least one sheet per student

Paint, black and white only

The reproductions of examples of weaving and tapestry that had been used for motivation in the preceding project were displayed again. The teacher said, "In your previous project you made a design in yarn and fabric. You used yarn, string, or twine as line. Some of the lines were straight because they were pulled taut; where they were slacker, they were free-form. Similarly, the edges of some of the fabric shapes were sometimes sharp and hard-edge, sometimes frayed or torn. Now you are to use brush and paint to suggest straight, crisp lines and hard-edge masses, or irregular, free-flowing lines and soft-edge, irregular shapes. On these masses you will also suggest a pattern, which in your collage was an actual part of the fabric. Keep your collage in mind, but don't try to reproduce or copy it. Use only black and white paint so that you can concentrate on line quality and texture."

To refresh their memories, the students examined the collages they had made but made no further reference to them or to the examples of weaving by modern craftsmen that were displayed. They chose their brushes according to the thickness and character of the line they wished to produce and began drawing directly in black lines and masses. In the collages, lines had been made with wool or string and were generally straight, and the pieces of cloth were rectangular; but now there was no restriction whatever, and the students could work as freely as they wanted in their drawing and painting, using white as they wished to modify the black. In their finished works, however, the interlacing and complexity of the drawn lines had the quality of weaving, and the surface textures of the masses resembled fabric (figs. 1, 2, 3, and 4).

APPLICATION TO OTHER AGE LEVELS

This project should not be attempted below the thirteen- to fourteen-year age level but can be used with any high-school classes.

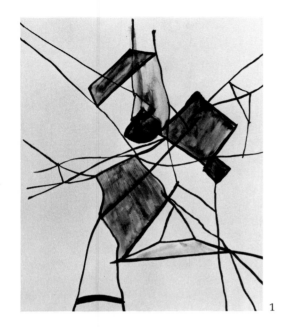

1

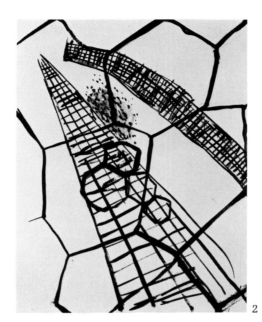

2

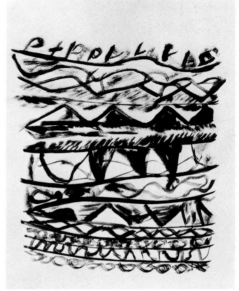

3

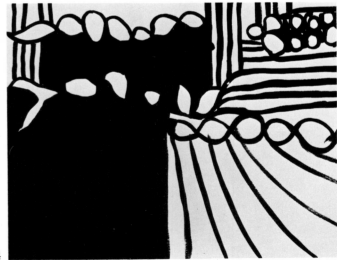

4

Painting the human face

PURPOSE

To deal with the problem of relating the features to the face; to explore a novel approach to drawing the face.

MATERIALS

Heavy yarn, any color, cut into pieces 25″ long, two pieces per student

Paper, 18″ x 24″

Soft pencils

Paint, black and white only

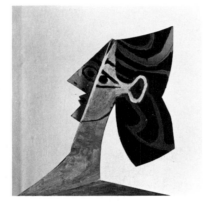

Picasso *Head of a Woman*

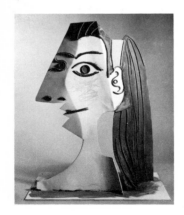

Picasso *Jacqueline with a Green Ribbon*

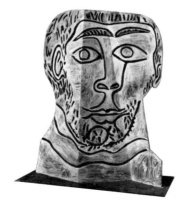

Picasso *Head of a Bearded Man*

The project serves both as a means toward appreciating the work of Pablo Picasso and as an opportunity to overcome the clichés that young people at this age often adopt from comic strips when rendering human faces. The class had visited the exhibition *The Sculpture of Picasso* while it was on view at The Museum of Modern Art, and the teacher asked them to recall especially the heads of cut and folded metal which are among Picasso's works of the 1960s. To refresh their memories, she showed them reproductions from the catalogue, including *Jacqueline with a Green Ribbon* and *Head of a Woman*. The woman's hairdo attracted the girls, so she included *Head of a Bearded Man* for the benefit of the boys. The group was quick to recognize and appreciate the humor of the designs and the ingenious way in which Picasso had constructed his sculpture by cutting and folding the metal.

The teacher proposed that the students try to design heads of their own, but she said that they would make them by drawing rather than as sculpture and would paint them in black, white, and shades of gray. The purpose was not to make a sculpture in the style of Picasso but to conceive the human face in a new way. She said that instead of making an oval for the face and placing the features within it, as in the traditional method of drawing, they would draw with yarn first. They might begin by drawing the features and continue to the hair, an ear, or the contour of the face; or they might start with the hair and proceed to the features.

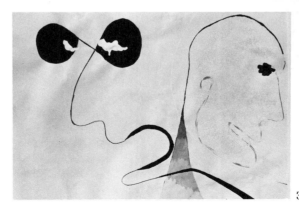

1

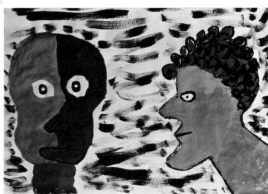

2

She demonstrated by taking two pieces of yarn, each about twenty-five inches long, and shaping them on a piece of paper so that one formed the eyes, nose, and line of the forehead, the other an ear and the contour of the head. After doing three or four variations, she told the students they should try making their own yarn drawings of heads, and when they were satisfied with a particular design, they should trace along the lines with a pencil. She also proposed that they might try two views of the face, a profile and a full view.

The students drew rapidly with the yarn, some forming the features first and then proceeding to the contour of the head, others beginning with an ear and working inward. They were fascinated with the process because of the facility in drawing that it allowed, and also because it produced unusual, unpremeditated shapes. Whenever a student achieved an effect that satisfied him, he traced his design by following the line of the wool with a soft pencil. To give the heads further definition, the lines and planes were painted in black, white, and values of gray. Many students adhered to fairly realistic images (figs. 1 and 2), but Stella as well as several others produced free-form designs that were only somewhat suggestive of faces (fig. 3).

APPLICATION TO OTHER AGE LEVELS

This project is too sophisticated for younger groups but should prove interesting and valuable at older levels.

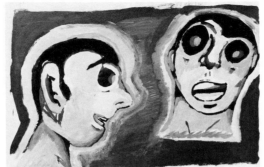

3

A banner
in two stages

PURPOSE

*To express a symbol graphically; to
adapt a design to a specific space
and size; to interpret the traditional
idea of a banner by means of a con-
temporary motif and a new material.*

I: Drawing (one session)

MATERIALS

Manila paper, 18" x 24"

Felt pens or soft pencils

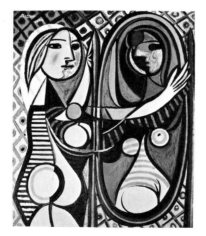

Picasso *Girl Before a Mirror*

The teacher discussed the use and meaning of banners
throughout the ages. She also talked about the contem-
porary uses of banners—as flags on top of the city and
state capitols, as pennants on sailing boats and ships,
as signs in rallies and protest meetings, and as purely
decorative elements at fairs and carnivals. She said:
"Banners, pennants, and flags have meant many things
to many people at different times in history. Today we
are going to make banners of our own. As a symbol
or motif, we shall use some part of the human figure,
such as a face, an eye, an ear, an arm, or a leg. First
you will draw the figure or part of the figure that you
are going to use later in the banner. This lesson will
be devoted to drawing. There are many ways of draw-
ing, and you may each choose your own. You can draw
in a continuous contour line, you can sketch, you can
make double lines. Make several drawings on your
manila paper; fill it with shapes. Here are some exam-
ples of drawings by modern artists." She showed

drawings by David Smith, Paul Klee, Joan Miró, and Saul Steinberg, emphasizing the differences in the character of their line and the relative elaboration or simplicity of their shapes. (If the teacher wishes, the idea of the principle of simultaneity as used by the Cubists can also be illustrated, for example by showing such a work as Pablo Picasso's *Girl Before a Mirror,* in which both the front and profile view of the face are shown within the same head.)

Each student selected the parts of the body he preferred to draw: eyes, ears, hands, arms, legs. Drawing was done from direct observation, using classmates or themselves as models. There was no attempt to make a likeness or a realistic image, however, but rather to produce an interesting linear design, simplifying the shapes or the views for that purpose (fig. 1). A hand might be drawn flat like a glove, or an eye shown in front view while the face was drawn in profile, as in Egyptian wall paintings.

II: Painting and construction (one session)

MATERIALS

Transparent self-adhering plastic wrapping, 12″ wide, enough rolls to provide two pieces 18″ long per student

Felt pens, for drawing lines about ⅛″ thick

Acrylic paint, red, yellow, blue, green, one 2-oz. bottle of each color for a class of twenty-five students

Gelatin scraps, a variety of colors

Camel's hair brushes, no. 5

Dowels, ¼″ diameter, one per student

Masking tape

Scissors

The teacher said: "We are going to use a material that we have never used for art work before. Your mothers probably have it in their kitchens. It is plastic wrapping, the kind that is put around food to keep it fresh while it is stored in the refrigerator. It is made so that it sticks to itself and seals the food inside. This property presents an advantage and a disadvantage for us. The advantage is that we can stick two pieces together for extra strength. The disadvantage is that the pieces tend to stick together very rapidly, but if they are uneven or wrinkled when put together, it will be poor workmanship and the effect will be spoiled. To prevent this, it will be necessary for you to work in teams of two. After each one has cut for himself two pieces eighteen inches long from the roll, one of you should hold the bottom piece flat while the other spreads the top piece over it; then repeat this, so you each have a double sheet. If the edges are uneven and do not match, they can be trimmed with scissors.

"The next step will be to transfer onto the plastic the drawing of a part or parts of the figure that you made last time. Lay the plastic over your drawing and trace the lines with a felt pen; you will find that though the plastic sticks to itself, it won't adhere to the paper.

"The third step will be to add color. You will use acrylic paint, a plastic paint that is soluble in water but is waterproof when dry. Paint inside or outside the lines or shapes, or anywhere else you wish, but paint on the side of the plastic on which you did not make your tracing, so that you don't obliterate the black lines. Some of you may wish to explore a variation of this process. Before you stick the two pieces of plastic together, draw your line design on one and paint the other with color in a random design, not related to the drawing, or affix to it pieces of colored gelatin in a random design. Then stick the two pieces of plastic together as described before."

Those who wanted to have the color follow the lines and shapes in their drawings first put two pieces of plastic together. Although working in teams of two, as instructed, they found this was not always as easy as it seemed; but in the end, a smooth enough double sheet was achieved by each student. After making their tracings with felt pens, they applied acrylic colors to the opposite side of the sheet and allowed them to dry. Several chose to paint the color at random or use pieces of gelatin for color; they put the color or gelatin on one piece of plastic and traced the drawing on the other before sticking the two together.

Marie used a leg as her motif and followed her drawing (fig. 2) quite faithfully in her finished work (fig. 3). In the course of tracing his design, Donald discovered the possibility of moving the plastic sheet, so that he could make certain shapes overlap, repeat a form, or trace a form upside down or sideways (fig. 4, right).

The final step was to mount each banner on the end of a dowel with masking tape, which was allowed to extend ¼ inch beyond the edge of the plastic to adhere to the stick.

APPLICATION TO OTHER AGE LEVELS

This project should not be attempted with students younger than eleven.

2

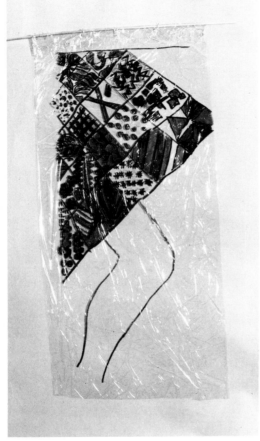

3

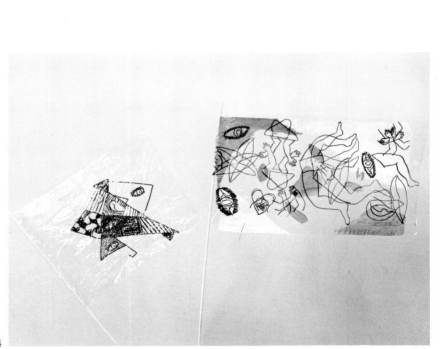

4

An architectural assemblage

PURPOSE

To convert a horizontal structure seen from above into a design to be seen vertically; to make the individual aware of the abstract relationships in the elements of his environment.

MATERIALS

Cardboard, white, cut into rectangles 3" x 3", 4" x 4", 4" x 8", 5" x 14", 6" x 9", 8" x 14", 10" x 10" and into circles 2", 4", and 6" in diameter, at least six pieces per student

Cardboard 12" x 16", 14" x 20", 10" x 18", for background, at least one piece per student

Cardboard strips, 1" wide, of varying lengths, for C-shaped supports, at least eight per student

Elmer's glue

Paint

String or wire

Scissors

In this project, a three-dimensional construction of blocks suggesting a model of a building is changed into an abstract assemblage in high relief to be hung vertically on a wall.

A B

The teacher asked how many of the students had seen buildings from the air. Several had seen cities, villages, and clusters of houses or farms from airplanes; the remainder had seen such views on television programs. The teacher arranged a group of building blocks, and each student looked down on them so that he could see the geometric shapes and patterns that the elements of the structure made. The students moved the blocks about to change the overall effect. The teacher pointed out the different levels produced by the variation in the heights of the "buildings." She said that they were going to make similar constructions; the tops of the buildings, of varying heights, would constitute the shapes, and the sides or walls would be omitted. They were to think of their assemblages as architectural constructions of white cardboard that would eventually hang vertically on the wall.

Each student selected a piece of cardboard for the background, several of the geometric shapes to suggest the tops of the buildings or structures, and strips for making the supporting C-shapes. They began their constructions by laying out the shapes on the background to get an idea of the general composition; if they were not satisfied with the shapes they had first chosen, they could exchange them for others. Then they mounted the shapes on the "C" supports, which had been scored with a sharp tool and folded at each end. The height of these supports varied according to the height of the shapes to be supported, more than one "C" support being needed to hold up a large or long shape.

The supports were glued to the shapes, and after the glue had set they were then glued to the base. The teacher said that if they wanted, they could add color to their constructions to give them more interest, but that only one or two colors should be used in order not to complicate the design. Most of the students preferred to leave their assemblages unpainted (fig. 1). Finally, a thin wire or string was fastened to each construction at one end and secured with tape, so that the work could be hung on the wall.

APPLICATION TO OTHER AGE LEVELS

This project can be done with younger age levels, even with eight- and nine-year-olds, for whom the cardboard pieces might be cut smaller. Colored construction paper can also be used instead of white cardboard.

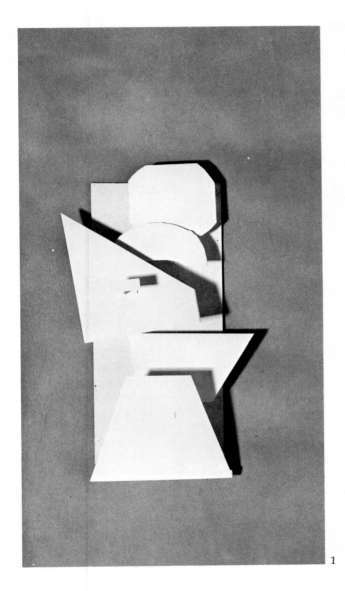

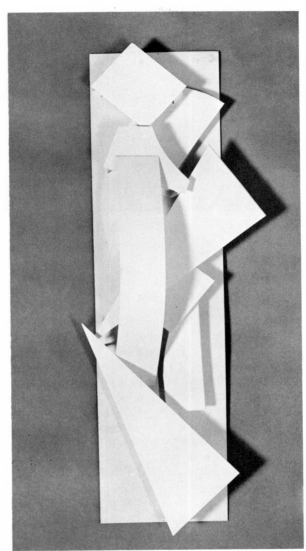

1

2

Structural volumes: buildings of the future

PURPOSE

To develop the concept of volume as a structure composed of linear elements defining a geometric shape; to develop discipline, skill, and concentration; to encourage the ability to create directly and spontaneously in space; to counteract the stereotyped methods and preconceptions in many "do-it-yourself" crafts sets for this age level.

MATERIALS

Swab sticks and dowels, ⅛" in diameter, of varying lengths, 4", 8", 10", or more, fifteen per student

Modeling wax or plasticine, one pound per student

Perforated acoustical ceiling tile, asbestos tile, or pegboard, ½" thick, 12" long, and in varying widths, 4", 6", 8", one per student. (Pieces of heavy cardboard or building board will do.)

Florist's wire, 20 gauge, or pipe cleaners

Cloth and tissue paper, pieces of various colors

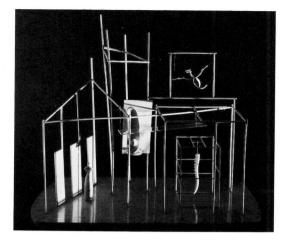

Giacometti *The Palace at 4 A.M.*

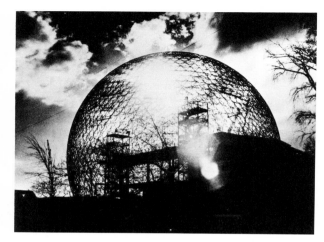

Fuller *Dome for U.S. Pavilion, Expo '67*

The teacher showed reproductions of Alberto Giacometti's *The Palace at 4 A.M.* and Buckminster Fuller's dome for the U.S. Pavilion at Expo '67, Montreal, pointing out that although one was a sculpture and the other a functional structure, both were examples of volume and space described by a linear skeleton. She presented the group with the problem of inventing shapes that would have a sculptural quality but be defined only by linear elements joined together. They did not have to follow any prescribed or conventional architectural form but might suggest buildings of the future, which could be constructed in any shape that the students conceived, within the limits of the medium used. She suggested that each student begin with some general idea or form in mind and then proceed to build it spontaneously, being prepared to change the design as the materials and means of construction might suggest as the work progressed.

After each student had selected an assortment of swab sticks and dowels and a piece of tile or pegboard for a base, and had made about two dozen balls of plasticine, each about three-quarters of an inch in diameter, the teacher said, "Think of the skeleton of a building. You have seen the horizontal and vertical steel beams of a building being riveted together. The wax balls will be like rivets holding the sticks together; however, you can build not only vertically or horizontally but in any shape or direction you wish." The students began working out their structures. Some began at the base and built upwards; others made flat triangular, square, or polygonal motifs and then joined them together as if erecting a building of prefabricated parts. The shape of any part, or of the whole structure, could easily be changed by removing the sticks from the plasticine balls and starting again. The structures were anchored to the bases by inserting the sticks into

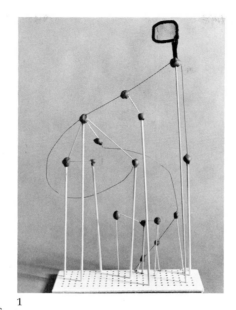

1

a block of styrofoam or into the holes of a piece of pegboard (fig. 1). Charles anchored his structure in a block high enough to keep it free of the table, thus achieving a free, almost floating effect (fig. 2). When the buildings were finished, the teacher proposed that the students add flags to them. These were made of colored tissue paper or cloth, mounted on florist's wire or pipe cleaners, and fastened to the structures.

APPLICATION TO OTHER AGE LEVELS

This project in simplified form can be adapted to younger ages (see "A Construction of Clay and Toothpicks," for four- to five-year-olds, page 58), but it is especially suited to junior and senior high-school grades, for which the problem can be more advanced, and both design and structure can be more complex.

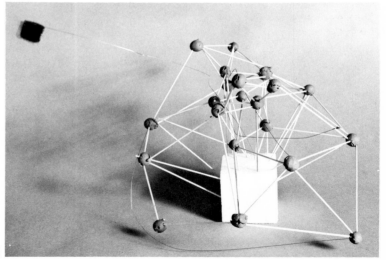

2

Creating a robot from found materials

PURPOSE

To use found materials as the basis for an imaginative idea; to work within a certain discipline.

MATERIALS

Materials brought from home by the students (see below)

A selection of materials for joinings: wooden spools, paper clips, paper fasteners, tacks, nails, string, rope, and thin wire, 22 gauge

Boards of various kinds for backgrounds: cardboard, pegboard, wooden panels, scraps from the school's carpentry shop, at least one piece per student

Scissors

Small hammers

Small hand saw

Elmer's glue

Paint

Two or three weeks before, the teacher had presented the project as a challenge to the students' ability to seek for interesting materials, without having an end product in mind, and said that they would invent from what they found. She asked them to look for unusual materials and things, rather than obvious ones, and suggested that they might find such objects stored away at home and forgotten. They should secure the co-operation, and especially the permission, of their families in gathering such materials. If they could find several of each thing, they would be able to use them in their work to create a sense of rhythmic repetition. She asked whether any of the group could think of kinds of such materials that might be found around their houses. John said that his father owned a radio and television repair shop and had quite a collection of old parts. Clara said that her father was a druggist and had a number of very pretty colored bottle stoppers. Kim knew that her mother had some peacock feathers which she was quite sure she would be willing to contribute to the project.

Two or three weeks later, when each student brought to class a box or bag of materials, each had succeeded in finding unusual treasures. Maggie had brought a dozen or more cones of incense; Peter, some wood scraps cut into various shapes; Beth, plastic spoons, forks, and knives, as well as a pack of paper matches. Jane brought 2-by-2-inch paper-mounted slides that her father had discarded because they were overexposed and black. Tony had several small plastic boxes. Marie brought an assortment of nails and a small copper cup.

The teacher told the class that they were to create robots from the materials. They could be made either as collages against a background, or freestanding. The subject of robots was an interesting and timely one for this age level, and it had immediate appeal not only for the boys but also for the girls. Most of the students were able to create a robot from the materials they themselves had brought, but a few discovered that their materials did not lend themselves to the subject and made abstract collages and constructions instead. The teacher pointed out that this was a good experience in letting the material dictate the form.

There was great variety in the results—in the three-dimensional robots and those made as collages in low or high relief, as well as in the abstract designs. The following examples are among the works produced: Beth painted her cardboard background black and glued down her plastic forks, spoons, and knives in the form of a woman walking. By using the same kind of elements several times, she suggested motion in the way that Futurist painters did. She glued match heads to the ends of the arms and legs to give the effect of painted toenails and fingernails and used a paper star to suggest a face (fig. 1).

Thomas painted a large piece of cardboard with red poster paint. He made the torso of his robot out of a small pocket radio with its front removed to show the insides. He attached wooden ice-cream spoons and springs to the sides for arms and added wheels for the head and feet. When the robot was finished, he painted two others in blue and white paint to contrast with the red background; this gave his collage the effect of a scene and enhanced his total design (fig. 2).

Maggie painted the shape of a figure on her pegboard and arranged her cones of incense and paper clips to give a suggestion of interior forms and movement. The holes in the pegboard and the cones produced a defi-

nite, repetitive staccato rhythm, while the chains of paper clips acted as connecting passages (fig. 3).

Marie made a freestanding robot from the nails and copper cup she had brought. She mounted the cup upside down and spread the nails out like four legs, winding wire around the tops spirally. She added two kidney shapes cut out of black cardboard as arms or wings, and painted a broad yellow band around the lower edge of the cup; above this she painted two large eyes. The effect was mechanical and unearthly (fig. 4).

Kim discovered that she could not make a robot with the peacock feathers she had brought, so she fastened them together at the bottom and let the tops spread out in a circle. This did not please her, however, because it looked too much like a bouquet of flowers. She solved the problem by tying the feathers together horizontally, one below the other, to produce an effective wall hanging.

Jane also found that her materials were not suitable for making a robot; instead, she used her paperbound slides to make an unusual collage. She painted the white mounts black and arranged them against a black cardboard background. The glossy black of the film and the dull black of the mounts set off against the black background produced a unique and restrained design.

The project is ideal for this age level because it challenges the students' powers of invention, develops their technical facility, and uses their excess energy in a constructive way.

APPLICATION TO OTHER AGE LEVELS

This project should not be used with younger students but will be interesting to older groups.

1

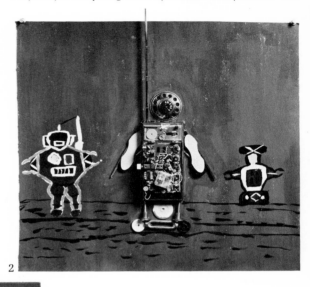

3

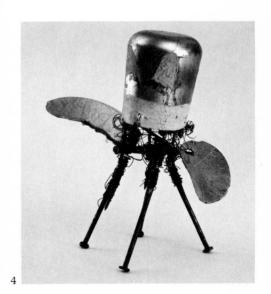

2

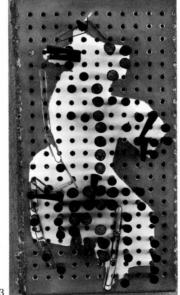

4

Wire sculpture with transparent planes: a new species of creature

PURPOSE

To develop imagination; to make a wire sculpture, introducing the concept of transparent planes and employing a household material as an art medium.

MATERIALS

Millinery wire, three gauges: light (no. 28), medium (no. 24), and heavy (no. 18), at least six pieces per student

Transparent self-adhering plastic wrapping, cut into pieces about 12" long, at least one per student

Building board, celotex, acoustical tile, or soft wood for bases, ½" to ¾" thick, 5" x 10", one per student. (A 4' x 4' piece of celotex is quite inexpensive and will yield enough bases for an entire class.)

Paste

Scissors

Wire-cutting pliers

The teacher introduced the project by referring to an article that had appeared in the *New York Times* a few days before, under the headline "Geneticist Reports on the Start of a New Species." The article discussed the emergence of a new species of insect, then went on to say that the development was so gradual that it might take a human lifetime before the species could be definitely described. The group speculated about what such an insect might look like, discarding all descriptions that seemed imitative or applied to known insects. The teacher presented the challenge of trying to design a new species of creature. She said that each student would make a model of his creature, using only two materials, wire and the kind of transparent self-adhering plastic used in the household for wrapping food. The problem involved creating a design by making linear shapes and then covering them with plastic to create transparent planes.

The students used the heavy wire to shape the large parts of their creatures—body, wings, or legs. Medium wire was used for the smaller shapes and members, and light wire for antennas and for binding larger parts together by twisting it around the joints. Sheets of plastic were cut about half an inch larger than the shapes, then turned over the wire and pasted along the edges to re-enforce the self-adherence. The students began their sculptures on bases made of scraps of asbestos ceiling tile from a house under construction; it was soft enough to insert wire into, so that the creatures could be made to stand. (Styrofoam or asbestos tile is ideal, but any other soft building board will do; if the board is too hard to push wire into, holes can be made with an awl or a fine nail.) Each part was anchored to the base and integrated with the other parts as the students worked and their designs progressed.

Although the newspaper article had been about insects, few students chose to make insects. The works produced varied from those that definitely suggested insects and animals with bodies and legs (fig. 2) to abstract free-form structures (fig. 3). The more articulate students had elaborate descriptions for their creatures, for which they invented scientific-sounding names. The less verbal ones merely said that they were "just something" or "nothing," but their sculptures were just as interesting and creaturelike in design and construction as those of the others. Among the titles used by the students were: *Two Creatures and a Plant, Half Frog and Half Unknown, A Junglelike Creature, A Flying Creature, A Large Walking Creature—Half Caterpillar and Half Flying Bird,* and *A Non-Flying Bird.*

APPLICATION TO OTHER AGE LEVELS

This project is effective with any of the older ages but because of the craftsmanship required is not suitable for younger groups.

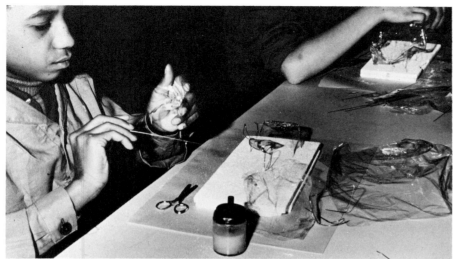

1

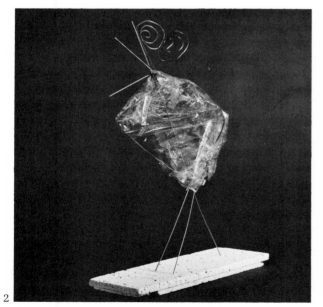

2

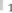

3

A machine assemblage: computers, control panels, electronic devices

PURPOSE

To develop the concept of the machine as a design or potential work of art.

MATERIALS

Odds and ends of electrical and plumbing materials: sockets, plugs, candelabra sockets, lamps, metal and rubber washers, metal fittings of various sizes, hose clamps, short lengths of rubber hose, odd-sized screws, small and large nails, insulated wire (bell wire, lamp cord, BX or Romex cable); telephone parts from toy telephones or requested from telephone repairmen; gears, wheels, coil springs from discarded toys or clocks

Household goods: curtain and drapery rings, shower and cup hooks, upholstery nails, thumbtacks, pushpins

Film cans and their screw tops, exposed film, used flash bulbs

(Almost anything that is shiny or looks mechanical can be used.)

Shallow boxes, gold, silver, or black, like those used for ladies' stockings, for backgrounds; Elmer's glue; scissors; cutting pliers and common pliers; tack hammer

The project should not be too definitely planned in advance, since the purpose is to have the students work spontaneously, guided by their imagination and feeling for space, organization, and pattern. For the same reason, the assemblage should be completed in one lesson. The students can, however, be asked in advance to hunt for different kinds of suitable materials by visiting local stores, bringing in parts of old toys or discarded appliances, and asking their parents for stocking or gift boxes. The teacher deliberately did not use any illustrative material for this project, because she wanted the students to work entirely from imagination and create a machinelike construction rather than attempt to imitate any existing machine. Each student was required to call upon his own imagination and memory and adapt ideas suggested by the available materials. The problem was to create a collage in low relief that would give the impression of some kind of electronic machine—a computer, a circuit, a remote-control panel, the dashboard of a space rocket, a radar unit—anything that the student's imagination could devise.

Before the class began to work, the teacher asked the students to give their reactions to various kinds of electronic devices that they had seen. Some said that they recalled a great complexity of parts: wheels, knobs, wires, and dials crowded together. Others recalled a regular order of things, and many dials. One boy said that he had seen the inside of a television set, and that it was a mass of metal wires with dozens of soldered connections. Another remembered that some switchboards and electric panels had a simple but irregular order. The teacher pointed out that there was order in all machinery and every mechanical arrangement, but that in some it was obvious, while in others it was subtle or hidden; this order created a sense of beauty. She held up various objects—a washer, a spring, a screw—and discussed their possibilities for a construction. She advised the students to choose materials that were similar in rhythm and character, selecting a few others for contrast or accent; she said it would be best to keep the whole simple in design and not complicate it with too many different kinds of things. She showed the class how a stocking box could be used as a background for mounting the parts.

By the time the students selected their materials, they had some idea of how their assemblages would be constructed and what they would look like. The teacher suggested that if they were going to include wires, it would be more practical and would give linear harmony to the whole design if they were added last. Laying the boxes flat on the table with edges down, the students made trial layouts on them, changing the arrangement and materials before fastening down the parts. When they had their final design, the pieces were attached to the background with drops or puddles of Elmer's glue, which was allowed to set overnight.

The boys had been excited about the project from the outset; as the work progressed, there was as much enthusiasm and variety of expression on the part of the girls. The boys, however, tended to have particular names for their constructions—Thomas called his *Rocketry*, Ben's title was *A Portable Computer* (fig. 1), and George said his was *An Electronic Panel for Directing Spaceships* (fig. 2)—whereas the girls said their constructions were "just machines" (figs. 3, 4). When the completely dry assemblages were hung on the wall, making decorative panels, one could not distinguish between the machine collages made by the boys and those made by the girls.

APPLICATION TO OTHER AGE LEVELS

This project is not suitable for younger ages but could be made challenging for older students, especially by having them use working mechanisms to produce kinetic designs or constructions employing lighting.

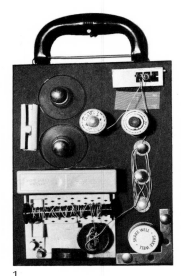

1

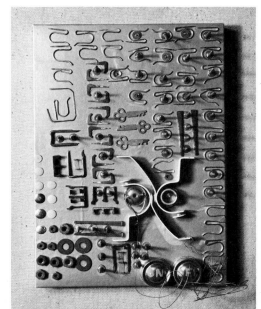

2

3

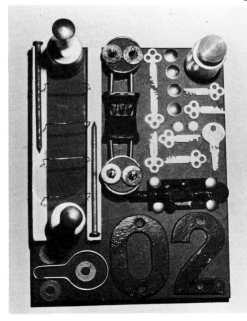

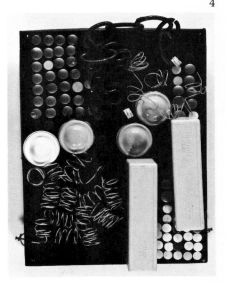

4

Unidentified flying objects

PURPOSE

To challenge the imagination and develop aptitude in the manipulation of materials by using a timely subject matter of particular interest to this age level; to combine drawing with construction.

MATERIALS

Sections of mailing tubes, various sizes, 1½″, 2″, 2½″, 3″ in diameter, cut into 6″, 8″, 12″, 15″ and 18″ lengths, at least one per student

Plastic spools from ribbons, tape, etc.

Round cereal boxes

Dowels, ⅛″, ¼″, and ½″ in diameter

Reeds, various thicknesses, presoaked in warm water for half an hour to make them pliable

Transparent self-adhering plastic wrapping

Construction paper, various colors (can be scrap)

Aluminum foil; drawing paper; paint; pencils; Elmer's glue; masking tape; binding wire; scissors; staplers

Small hand saw for cutting mailing tubes and dowels

This and the following project aim at developing two necessary disciplines, drawing and construction, by using them in conjunction. As the project involved much construction, however, it may be desirable to plan on two class sessions for its completion. In this session, drawing and construction were motivated simultaneously, because the drawing was to be a visualization of the construction—a U.F.O. This subject was chosen because, besides being timely, it allows the utmost freedom of invention. The teacher showed pictures of flying saucers, satellites, radar stations, and launching pads taken from scientific magazines, periodicals on current events, and other sources. She said that the students were to invent their own flying objects, and that the basic material for their construction would be a portion of a mailing tube. The tube was to form the capsule to contain the mechanism and the operators, and the rest of the device would be designed around the capsule. The students were asked to project their ideas in advance and begin by painting their capsules with whatever colors they preferred. While the paint was drying, they made drawings of the way their U.F.O.'s would look when finished. Each student made at least three line drawings in pencil of ideas for his construction (fig. 1), but these were to be used only as starters and need not be copied or adhered to closely in their final constructions (compare fig. 2).

Using the pieces of mailing tube as the core or basic structure, the students built their flying devices on the table (figs. 3, 4). Reeds of various thicknesses, made pliable in advance by wetting, proved useful for making curved shapes for wings or projecting parts. Some filled the linear outlines with transparent plastic, which was cut to the shape needed and fitted by turning it over the edges so that it adhered to itself or could be glued in place. Aluminum foil or colored construction paper was used to make fins, wings, or other projecting parts, which were fastened to the tube and to each other by staples or masking tape. As the work progressed, the constructions were hung on a clothesline stretched across the room so that their appearance at various stages could be examined. Wires or string were added at strategic points to give the best effect of flying.

The results varied widely. Most of the boys had a specific design for their U.F.O.'s in advance and drew them as they imagined them, supplying explanations of their mechanisms and flying operations; they tended to follow their drawings closely in making their constructions. The girls, on the other hand, regarded the project as a problem in making an abstract construction and were not particularly concerned that it should be a U.F.O. Both enjoyed the project, nevertheless, and one could not tell the devices made by the boys from those of the girls.

APPLICATION TO OTHER AGE LEVELS

This project is particularly suited to the junior high-school years, when manipulative and inventive interests are at their peak; but it is also adaptable to older ages, for whom the design and construction might be made more complex.

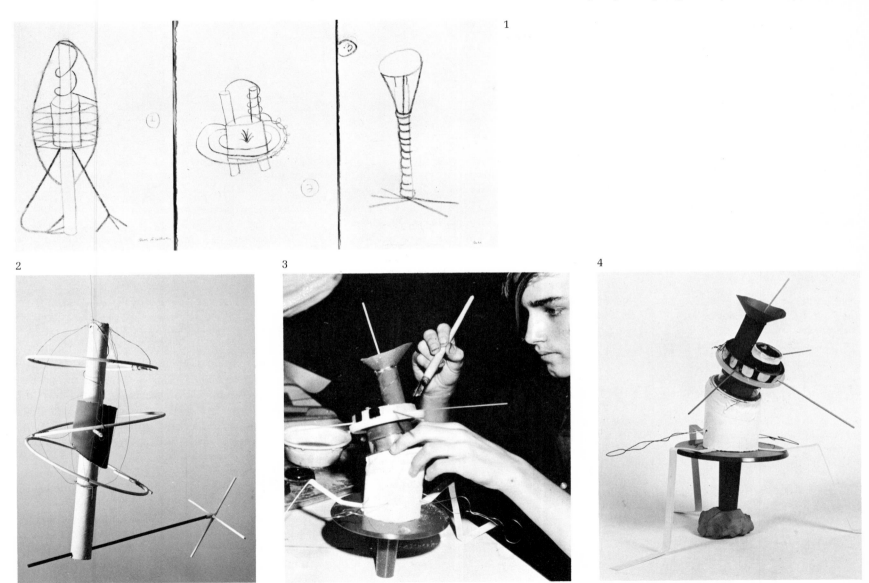

A mobile inspired by a film, *The Works of Calder*

(two sessions)

PURPOSE

Using the motion picture as a teaching tool, to stimulate creativity through observing the work of a modern master; to develop appreciation of an outstanding American artist, Alexander Calder.

MATERIALS

Clear plastic and sheet aluminum cut into geometric shapes: triangles, rectangles, circles, at least ten per student

Metal foil containers of different shapes, such as those used for butter, candies, or fruit; tinfoil plates; bottle caps; film containers; at least eight units per student (These had been gathered by both the teacher and the students for use as motifs in the mobiles.)

Reeds

Dowel sticks

Wire

String

This project is of an advanced nature and should follow the making of a simple mobile (e.g., "A Moving Sculpture or Mobile," page 112), so that the students do not encounter too many technical problems at one time. The film *The Works of Calder* * was shown to the class and the teacher discussed Calder as the originator of the mobile and the outstanding master of this medium. As the students had made mobiles of their own, their interest and appreciation were heightened. In order to increase awareness and stimulate reactions to the film, each child was given a list of questions to which he was to respond in writing or by drawing.

1. Describe the movie you have seen, using only adjectives, use as many as you can.

2. Draw the shapes you remember and invent three of your own (use the extra blank sheets attached).

3. Draw three lines you remember and invent three of your own.

4. Name three elements in nature that inspired Calder's mobiles.

5. What mood did you get from the film? How did it make you feel?

The Works of Calder, produced and narrated by Burgess Meredith; photographed and directed by Herbert Matter; narration by John Latouche; music by John Cage. 20 minutes, color, 16 mm. Available from The Museum of Modern Art Film Library.

Here, gathered from the entire class, are a few of the responses:

1. Imaginative, mysterious, silent, colorful, round, blaring, curved, modern, fascinating, inspired.

2. and 3. The drawings expressed the essences of certain shapes rather than just copying them. The shapes invented by the students were personally motivated.

4. Seagulls, jellyfish, leaves, birds, sun, sky, earth.

5. "Like a dream; I felt close to nature, which gave me a lonely feeling because I was isolated from other humans."
"Silent, lonely, but an intense mood."
"Something was escaping within me."
"I never saw a movie like this before; it was inspiring."

Each student in his own way had received an impact from the film on Calder. They were eager to try their own ideas for mobiles and discussed the problems both of design and of technical construction. They noted that some mobiles dangled from strings and used arms to balance the parts, while others were set up on their own bases on a table or pedestal.

The teacher showed the class the available materials and called attention to the fact that these could also be used to include sound, suggesting the whistling of the wind or the rustling of leaves. She said that the mobiles were to be planned in two stages. First, the students were to make a design or sketch suggesting the materials to be used; second, they would construct the actual mobiles.

The remainder of the first session was devoted to planning, either by making sketches or thinking the problem through. These sketches were intended as diagrams describing the materials to be used, rather than drawings of the appearance of the finished mobile. Some students, however (particularly the boys), made precise drawings which they later followed through. A few made no drawing at all but just talked out the problems with each other and the teacher. Several students found the problem of incorporating sound a real challenge; others avoided it, and a few gave it up after an unsuccessful attempt.

Charles had been impressed by some of Calder's works that were basically stabiles but had small mobile parts, and he chose to make a construction of archlike shapes surmounted by a double bell made of metal bottle tops, the whole suggesting a chapel (fig. 1). Stella cut strips of foil of varying lengths, which she suspended on strings from two concentric circles attached to an arched reed (fig. 2). Chris used two opposing units hung from dowels suspended from an arched reed, arranged so that metal weights on one struck against tin pans on the other (fig. 3).

APPLICATION TO OTHER AGE LEVELS

This can be done with older groups, with greater emphasis on producing sound.

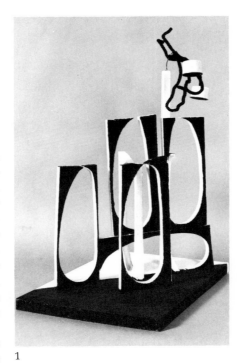

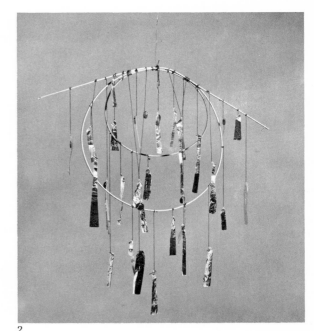

1

2

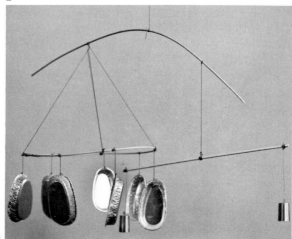

3

Progressive projects: teaching in depth

Continuity and progression in art experiences are fundamental to creative growth. The project completed within a single period develops spontaneity, and a variety of projects motivated by different ideas, mediums, or materials serves to explore the child's creative power and extend his vision; but for depth of learning there must also be continuity and progression between activities directed toward specific goals. Painting and assemblage are not one-time experiences; the child does not make just one painting, one collage, one construction. He produces many of each, but he looks for and experiences new values each time. There should therefore be repetition in the projects, but at each stage in the repetition the child should be directed toward new objectives and new values. For example, the young child may begin by exploring paint, discovering that mixing pigments produces new colors. Next, he may be given only a few colors—red, yellow, and white—to see what he can do with a limited palette; and so on. In collage, the child may first be introduced to a great variety of materials from which to select what he wishes. A next step may be to produce a collage devoted to textures and guided entirely by the sense of touch. A third step might involve the response to, and selection of, certain textures only—materials that are rough or smooth, or those that are soft and warm. In sequence, the child may further explore texture and color together, value, and contrast. The child himself, particularly the young child, may not be aware of this progression in his activities, but the teacher concerned with his growth guides him through such sequences toward more profound learning.

Progression through linked activities may be achieved in several ways. The most common type of progression is through a project that requires several stages for completion. For example, a group of six- or seven-year-olds plans a puppet show: first they make the puppets, then they improvise the action or scenes, next they make the scenery, and finally enact the play. This takes place in a succession of at least four periods. Or a class of thirteen- and fourteen-year-olds plans a collage mural made of molded cardboard cartons. The first period is spent exploring how to use the cartons and planning the composition of the whole mural; the second and third periods are devoted to painting individual designs on the cartons; and the fourth is used for arranging the individual designs within a finished mural. A satisfactory progression can also often be made by exploring a concept in several mediums in succession. An excellent example of this is the face or mask project done by a class of thirteen- to fourteen-year-olds. They first draw a head with pencil in terms of planes and geometric shapes, then interpret it in a collage emphasizing the planes and shapes. A third step involves painting an abstraction interpreted from the paper collage.

Following this, the students make a clay bas-relief of a head in flat planes and paint it. The final step requires using the bas-relief as a source for the painting of a head.

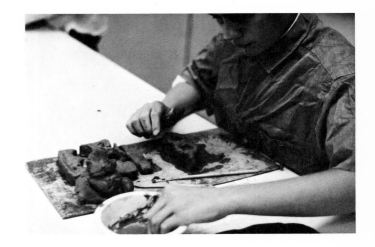

Unless one is concerned only with the techniques involved, it is neither possible nor desirable to determine ahead of time exactly what number of steps will be required for a progressive project with a particular group. A project may begin anticipating two or three stages and grow to twice that number as the interest and possibilities develop. For instance, a class might begin with the idea of doing a group painting; as work progresses, this might develop into a collage mural and later into a kinetic one, with moving elements suspended or attached to it. Certain projects, such as illustrated booklets or accordion-fold leaflets, are open-ended and can grow to an almost unlimited number of stages. It may be necessary, however, to remotivate progressive projects at intervals, to introduce new concepts, review certain basic aesthetic principles, or revitalize students' interest. A prime value of the progressive project is that it gives children practice in planning ahead and organizing their procedures. Evaluation of the project at each stage is an important discipline within the child's growth; it may also serve to modify the course of the project.

Progressive projects should be related to the interests, concentration span, and creative abilities of the group that undertakes them. A project may extend through six stages with one group and last for only three with another. The teacher might predetermine that logically a project should take five stages but discover that interest was waning at the end of three; he might then find himself either forcing the students to finish the project or ending up with a number of uncompleted works. Or a teacher might decide that a project should take only two periods and then be compelled to rush in order to finish on time. The overstructured curriculum planned ahead for an entire semester or year is apt to become arbitrary and artificial. The creative program is one composed of projects that are fluid and elastic; it provides for growth and change and for new events or interests that may prove exciting or fruitful.

The progressive projects in Part Three have been carried out by children and young people of different age levels, and they are offered to teachers as examples and guides for creating their own projects rather than for following verbatim. Projects extending through two or more stages have been included in earlier parts of the book, but progressive projects are not merely those made up of multiple stages or taking several periods; they are experiences that require the students to engage in preplanning. Although the examples presented here are for children of six and seven, and thirteen and fourteen only, they can be upgraded or downgraded to suit all levels.

Progressive projects for children six to seven years old

A project in three stages

I: A round castle— construction

PURPOSE

To use a subject that is stimulating to children's fantasy for a simple problem in three dimensions.

MATERIALS

Corrugated paper, various colors, cut into pieces 1″ high x 12″ long, 3″ high x 12″ long, and 6″ high x 18″ long, six pieces per child. (Note that the corrugations should relate to the height, that is, run up and down when the cylinder is shaped. Corrugated paper that can be curved must be used, not corrugated board, which is rigid.)

Swab sticks and toothpicks of natural (unpainted) wood

Masking tape

Staplers

Paste

Colored tissue paper

The teacher displayed illustrations of English, Scottish, and French castles cut from the *National Geographic Magazine* and asked, "Has anyone ever seen a castle?" All the class had seen castles in the illustrations of fairy tales or on television; some children had visited Phillips Castle at Tarrytown, New York. "What is a castle like?" Answers included such information as: "It is big and has towers. Some castles are round, some square, and they have balconies and bridges." "Would you like to build a castle?" They were all enthusiastic. "We'll build a round castle." The teacher took a piece of colored corrugated paper and made a cylinder by bringing the two ends together, overlapping them half an inch or so, and stapling them in place. "This can be your main castle, and you may add towers." She made some smaller cylinders and demonstrated how two forms could be joined by inserting toothpicks or the longer swab sticks into the corrugations at the bottom of one and the top of the other, so that parts such as turrets could be added to the main structure. "There is masking tape, and the stapler, too, if you want to use them to stick pieces together."

174

The children made the main cylinders of their castles first, using 6-by-18 inch pieces of corrugated paper and stapling the overlapping ends together. Then, using the narrower pieces of corrugated paper, they made towers and fixed them to the edges of the castles so that they were cantilevered to extend outside or within the walls, or both (fig. 1). Some children made freestanding cylinders and joined them to the castle, adding turrets to them too. Bridges and hanging balconies were also added. A few children made their constructions all of one color, but the majority used a number of colors. As a final touch, flags made of colored tissue paper pasted to sticks were slipped into the corrugated walls of the castle and turrets (figs. 2, 3).

APPLICATION TO OTHER AGE LEVELS

This project should not be done with children younger than six; it can, however, be done with great success with older children, using more elaborate designs and constructions.

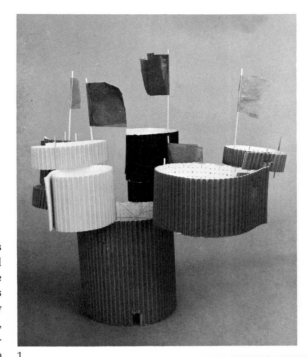

1

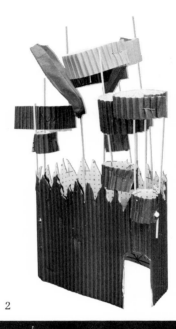

2

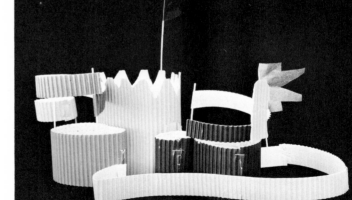

3

175

II: Kings and queens—collage

PURPOSE

To develop continuity of interest; to have children become involved with the problem of the human figure; to introduce collage and relate it to construction; to offer the challenge of cutting into a large piece of cloth.

MATERIALS

Paper, white or colored, 18″ x 24″, one sheet per child

Assorted fabrics, cut into pieces about 12″ wide x 15″ to 18″ long, at least one per child

Wallpaper, colored construction paper, tissue paper

Collage boxes (see page 16)

Scissors

Rubber cement

Paste

The teacher said, "Last time we built castles, and they were very good castles. Now let's think about the people who live in the castles. Who knows what kind of people lived in castles?" The children had read about castles in fairy tales and heard about the bygone ages when castles were built, so their answers came readily: kings, queens, nobles, knights. The teacher continued: "We will make a full-length collage portrait of a king or queen, one that will show the whole body from head to foot. The figure should be as large as the paper, touching the top and bottom edges. You will use the large pieces of fabric for the dresses and robes, and other kinds of materials for the heads, features, crowns, and decorations. Anyone who feels ambitious can make both a king and a queen." The boys in general decided to make kings and the girls queens, but a few chose to do both.

The full-length portraits were done on 18-by-24-inch sheets of either white or colored paper. The heads were made of contrasting colored paper or wallpaper, the bodies or costumes cut from the large pieces of fabric. The arms were of separate smaller pieces of cloth or paper, which permitted the child to suggest such poses as having the arms folded or extended, or holding the scepter or some other object. Folds made in the cloth gave the robes a convincing effect. Most of the children gave their kings and queens flowing robes, so that there was no need to show trousers or legs (fig. 4), but a few dressed their figures in short costumes and made legs of paper (fig. 5). In pasting the fabrics, it was not necessary to cover the entire area with paste but only to dab rubber cement along the edges and press the fabric down. Smaller pieces like hands and objects cut out of paper or other materials were pasted down, and rubber cement was used to add decorations such as buttons and trimmings.

APPLICATION TO OTHER AGE LEVELS

The project is too difficult for children younger than six but is suitable for eight- to ten-year-olds.

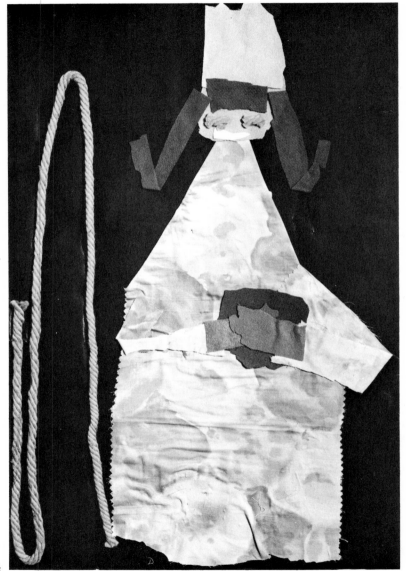

4

5

III: A castle—painting

PURPOSE

To capitalize on interest in a romantic subject; to develop the imagination; to overcome the cliché concept of a house; to use paint to explore mass, shape, color, and mood.

MATERIALS

Paper, 18" x 24", one sheet per child

Paint

Reproductions of paintings with castles and similar buildings were displayed to show the variety of shapes and masses in entrance arches, doors, drawbridges, and moats. Some were shown because of the mood, environment, or weather conditions they suggested. Among the examples were El Greco's *Toledo in a Storm* and Sassetta's *Journey of the Magi,* both in the Metropolitan Museum of Art, and *Guidoriccio da Fogliano,* by Simone Martini in the Palazzo Pubblico, Siena.*

The teacher discussed the castle as a home or place in which people lived. She asked the children to compare castles with the houses and apartment buildings in which they lived and to notice the variety in both kinds of dwellings. The class talked about the paintings of castles and the effect they produced. The children said they felt scary, spooky, lonely, haunted by ghosts.

The teacher recalled the castle constructions that the children had made and announced that now they were going to make a painting of a castle, expressing any

*All three paintings are reproduced in Thomas Craven's *A Treasury of Art Masterpieces,* New York: Simon and Schuster, Rev. ed. 1952.

feeling of their own that they wished. They could either paint directly or, if they wanted to make a drawing first as a guide, they could sketch it in a light color and paint over it afterward.

Most of the children painted their castles directly in color and added the background later (figs. 6, 7); only a few put in a mood color first and then painted over it (fig. 8). None felt the need for sketching the castle first, but having an option to do so gave them greater security.

Throughout the three stages of this project, the children's interest was sustained, while they explored a single subject from different points of view and used a variety of mediums.

APPLICATION TO OTHER AGE LEVELS

The painting of castles, if treated as fantasy, is stimulating to most children. The project can be enjoyed by eight- to ten-year-olds and even by the eleven- to twelve-year-old age levels, but the subject is limited by the interest in castles.

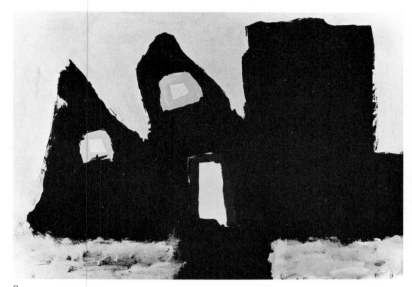

6

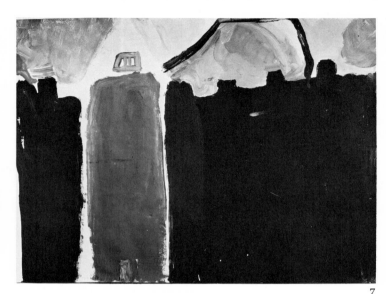

7

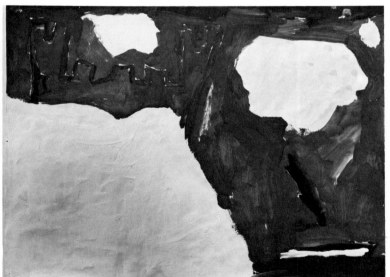

8

A project in kinetic design in two stages

I: A two-dimensional kinetic construction

PURPOSE

To experience the magic of lines and colors in motion; to explore motion as a factor in design.

MATERIALS

White cardboard, cut into 9″ squares with a hole pierced in the center (left-over scrap cardboard, pieces 7″ or more square, will do), at least three pieces per child

A fourpenny nail (common nail with head), about 1½″ long, placed in the center of each cardboard in such a way that when it is held firmly with one hand, the cardboard can be spun with the other

Paint

The teacher began with a demonstration: holding up a cardboard about 9 inches square, she spun it around a nail set in a hole through its center. Then she painted a black arc on the cardboard, which she spun again. She pointed out how the arc seemed to become a circle. The children were fascinated; it was sheer magic! The teacher told the children that they could try their own experiments, starting with a few lines, then adding more. She demonstrated optical color-mixing by painting two areas in different hues side by side and spinning the cardboard until the eye blended the colors.

Each child took a nail and two or three of the cardboard squares with holes pierced in their centers. They first made linear designs (figs. 1 and 2) and spun them; they were not only fascinated with their own results but had to see the effects produced by every other member of the class. Next, they tried color experiments, using only two or three colors applied in large contiguous areas (fig. 3) or spaced apart. Spinning produced a new and exciting color that disappeared as soon as the cardboard stopped spinning. Successive steps, for which the backs of the cardboard could be used, involved more complex designs as well as color (fig. 4).

APPLICATION TO OTHER AGE LEVELS

This project is appropriate for older children, who respond with even greater interest and enthusiasm; not only can they achieve more complex designs and color effects but they can discuss the scientific principles involved in Op Art and the mixing of colored light, as contrasted with pigment.

1

2

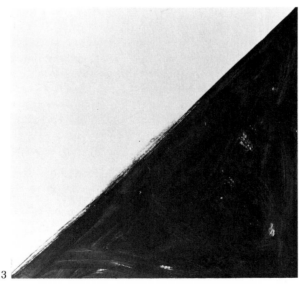

3

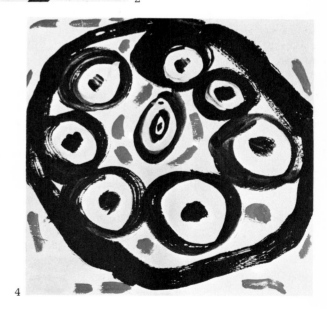

4

II: A three-dimensional kinetic construction

PURPOSE

To continue the exploration of motion as a factor in design.

MATERIALS

Cardboard discs, about 12" in diameter, with a ¼" hole in the center to fit the spindle of a turntable, at least one per child

Corrugated paper, assorted colors, cut in various lengths and 2" wide, at least two pieces per child

Construction paper, various colors, 1" x 9", at least six pieces per child

Swab sticks

Dowels, ⅛" in diameter by 10", 12", and 15" long, at least three per child

Ribbon and gelatin, scrap

Feathers

Paste

Masking tape

Staplers

Wire

Scissors

The teacher reviewed the previous experiment in which the class had painted lines and colors on squares that they had then spun, producing optical mixtures. She said that in this session, two important elements would be added. First, the design would be in three dimensions; it would be a construction built on a disc. Second, the motion would be supplied mechanically, by placing the disc bearing the construction on a turntable like that of a record player. She pointed out that the constructions would be like a carousel or merry-go-round but said the children should not try to imitate one but just express its spirit in color and motion. She told them they need not try to make horses, sledges, or any particular objects, because shapes of different sizes and colors would express the feeling of motion and gaiety even more effectively.

Each child took one of the cardboard discs with a hole pierced in its center (the hole can be started with an awl or nail and enlarged with a pencil until it is large enough to fit the spindle of a record player). The children selected their materials—corrugated paper, construction paper, swab sticks and dowels, and wire. They were advised to keep their constructions simple, because the turning motion would produce an effect

of more pieces than actually composed them, as the teacher demonstrated.

The children fastened pieces of corrugated board and construction paper to the disc bases with masking tape or a stapler. Stacey slipped swab sticks and dowels into slits cut in her corrugated paper and fixed them in place so that they suggested poles or staffs for banners or flags (fig. 5). Others mounted tissue, ribbons, and feathers on sticks which added to the effect of flying and visual excitement when the constructions rotated on the turntable (figs. 6, 7). The speed could be regulated to 78, 45, or 33 r.p.m. to produce the most effective design when the construction was rotated. The children all enjoyed looking at one another's constructions in motion on the turntable and each took his own home to try on his own record player.

APPLICATION TO OTHER AGE LEVELS

The project is too complex to be tried with children younger than six, but with older age levels it creates increased interest and satisfaction. At any level, it should be preceded by some experience in three-dimensional construction.

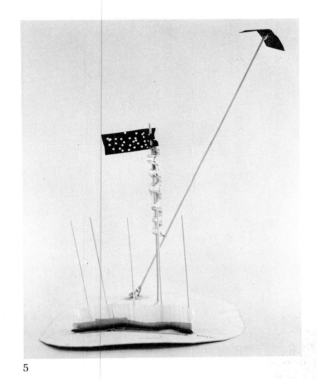

5

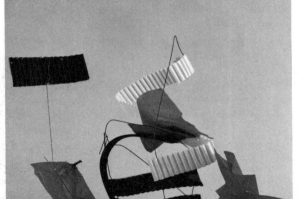

6

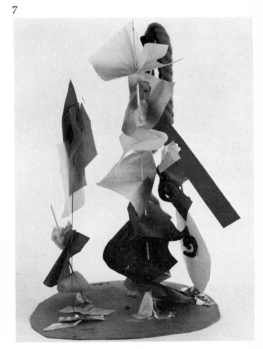

7

A theatrical group project in four stages

PURPOSE

To develop a project that sustains interest over a period of time and adds progressive experiences for the individual and the group, through painting, collage and verbal expression.

I: Puppet making

MATERIALS

Paper molds, such as those used to separate layers of fruit or pack other materials, pressed into square, rectangular, round, pear-shaped, lozenge-shaped, or triangular indentations, about 4" to 7" in their largest dimension; at least one per child (These can be obtained from a fruit store, or the children can be asked to bring them from home; small paper plates will do if no molds are available.)

Cotton batting, shredded paper, or shredded plastic excelsior

Yarn; beads; tongue depressors; paints, primary colors only; scissors; staplers; paste

The teacher began: "We are going to make simple puppets and then have a play. How many of you know what a puppet is?" All the children knew about puppets; some had made them in other classes; the majority had seen them on children's television programs.

> *Teacher:* We shall need to know what kind of characters we want for our play; any suggestions?
> *Stephen:* I'll make a crook.
> *Jonathan:* I'll make a clown.
> *Thomas:* Mine will be "Grandfather Bigmouth."
> *Andy:* I'm going to do "Strawberry Sam."

The teacher said that those who still didn't have any idea for a character should start making their puppets anyway and in the process ideas might occur to them. She proposed that they begin by making the faces and showed them the various shapes of the molds, which suggested faces; and said that in order to make the puppets very colorful, they should be painted in some primary color. The children set to work enthusiastically and after first painting the molds (or plates) for faces, some added features—eyes, nose, mouth—in other colors. While the paints were drying, there was further discussion of the characters the puppets might represent. These characters were then elaborated by adding hair, moustaches, and beards of various collage materials, pasted or stapled onto the faces. Some who had not painted features made them out of bits of collage materials (fig. 1). After a face was completed, a tongue depressor was stapled at the base to provide a handle (fig. 2). The teacher helped any child who needed assistance in stapling the tongue depressors securely in place.

1

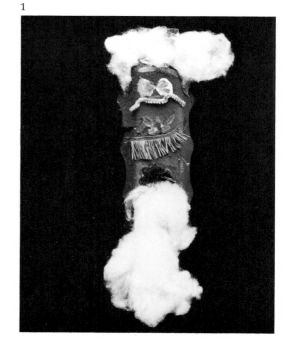

II: Scenery

MATERIALS

Paper, 18" x 24", six pieces

Paint

2

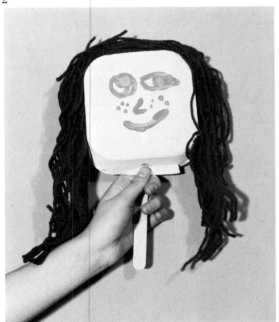

The children developed the story line for their play, the object being to have every child participate in the discussion. Three scenes were decided upon: a public park, a circus, and a village bank. The scenery for each was made up of two 18-by-24-inch sheets of white paper hung either vertically or horizontally, and mounted about two feet apart.

The action was to take place in the open space between them. The class was divided into teams of two, and each team collaborated on a scene, deciding on its subject matter, color, and position of the paper. They compared their work to achieve an effect of unity. When they had finished, they improvised the story for each of the scenes, ending in a bank robbery.

III: The play

MATERIALS

Completed puppets

Scenery made in previous session

The class planned the action of the play, in which each child's puppet had a role. A stage was improvised by placing two stools on a table, about three feet apart, and laying a board across them (fig. 3); for each scene, the two painted pieces of 18-by-24-inch paper were tacked to the front edge of the board, one at either side, leaving an opening two feet wide for the action.

The children held their puppets by the tongue depressors and moved them about for appropriate action while they improvised the dialogue for the story. Those not performing in a particular scene composed the audience.

3

4

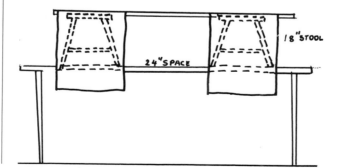

IV: A collage painting

MATERIALS

*Construction paper, various colors,
18″ x 24″, at least two sheets per
child*

*Cloth, in solid colors and in patterns,
cut into pieces about 8″ x 16″ and
smaller, at least two of the larger
pieces per child*

Patterned paper

Assorted collage materials

*Puppet heads made and used in pre-
ceding sessions*

Scissors

Paste

Staplers

Paint

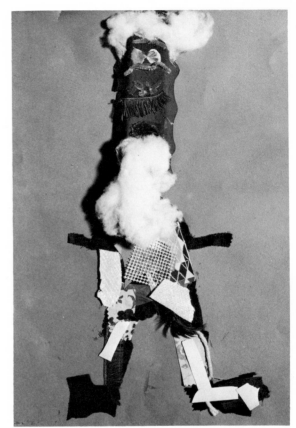

5

The teacher said that although the puppets had served
their original purpose of enacting a play, they might
be put to an additional use by making collage paintings
out of them. The children discussed how, after remov-
ing the tongue depressors that had served as handles,
they could add bodies and backgrounds to their puppet
heads.

Each child selected a sheet of colored construction
paper and glued or stapled his puppet face near its top.
The remainder of the figure was made in collage, using
fabric or other pieces of paper. Some children cut the
body out of one piece of cloth or paper, while others
built it up in sections—arms, legs, torso—which they
pasted or stapled in place. A few folded the arms or
bent the legs of their figures to suggest motion or action.
Some did not carry their collage further, but others
made a painted background suggesting an interior, a
palace, a house, or some other setting, as in Cathy's
Lady in the Street and Her Baby (fig. 5).

APPLICATION TO OTHER AGE LEVELS

This four-stage project may be used at any older level
by developing the techniques and concepts in a manner
appropriate to the age of the students.

Progressive projects
for young people thirteen
to fourteen years old

Exploring texture and pattern in three stages

I: A book of printed textures

PURPOSE

To develop increased awareness of pattern and texture, both in nature and in the man-made environment; to encourage the invention of patterns; to work with an informal process of printing from textured materials.

MATERIALS

Materials with a variety of textures: feathers, rug samples, pieces of burlap, wire screening of different meshes, nails with large heads, small pieces of sponge, bottle caps, skeins of yarn and string, corrugated board, nuts and bolts, etc.

Construction paper, black and white, 6″ x 9″, two black and six white sheets per student

Paint, black and white

Staplers

Paper punches

An assortment of objects—a snakeskin, smooth and rough seashells, small stones of various textures, and a woven basket—were provided for the students to handle or look at through a magnifying glass. The students first discussed the texture of these materials, touching them while their eyes were closed. They discovered that they could feel some textures which they could not see with the naked eye but which were visible under the magnifying glass. The teacher remarked that the microscope, too, often revealed textures and patterns that could not be otherwise seen. Several boys said they were familiar with microfilms; one boy mentioned that a piece of steel looks smooth but under a microscope can be seen to have a definite grain. A girl added that human skin, which also looks smooth, reveals a decided texture under magnification. These observations led to the conclusion that texture makes pattern. The class then turned its attention to photographs displayed on the wall—a wheatfield, a cross-section of a giant tree trunk, a closeup of the moon's surface, and pebbles on a beach.

The teacher said that the students should discover for themselves the textures of different kinds of material and use them to make a simple book in texture and pattern. The books were to be made of six white sheets of paper imprinted with different patterns, for the pages, and two black sheets for covers. The books could either be stapled or laced together with yarn run through holes punched in one corner or along one edge.

The procedure was for each student to select a different material for each of the pages, then pour a small puddle of paint of rather thick consistency into the mixing tray and apply the paint to the textured material with a brush—white paint being used for the black covers, and black paint for the white pages. The material was then pressed on the paper so as to imprint a pattern, which was repeated to cover the sheet. Patterns were made from burlap, sponge, nail heads, string, the tips or full lengths of feathers, and dry brushes (figs. 1, 2, 3). One girl made a pattern of fingerprints. Because the students chose different materials and used different means of imprinting them, the resulting designs were all personal and varied. The project proved absorbing and satisfying, both because the imprinting of designs by paint applied to textured materials seemed to involve a kind of magic and because young people enjoy making books. The 6-by-9-inch dimension of the page is essential for keeping up the pace and accelerating interest; larger paper might make the project tedious and too time-consuming.

APPLICATION TO OTHER AGE LEVELS

The project will prove interesting and fruitful for any of the older age levels, especially if the patterns are made more complex by overlapping them and printing in different colors, or if the work is carried out on a larger scale.

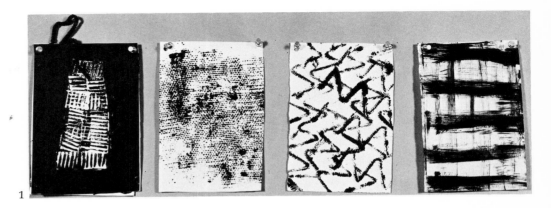

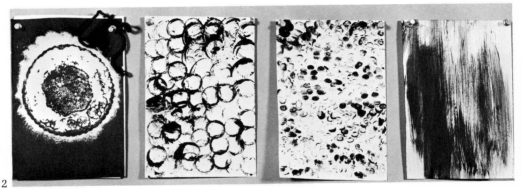

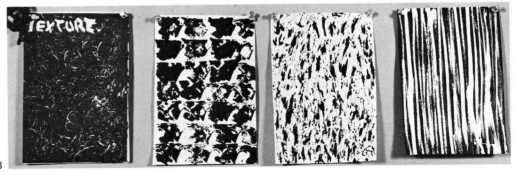

189

II: A textured clay plaque or column

PURPOSE

To explore texture in three dimensions by working with tools on clay.

MATERIALS

Moist clay, balls about 5″ in diameter, one per student

Wire clay tools, nails, straws, bottlecaps, wire netting with meshes of various gauges

Swab sticks, coffee stirrers, tongue depressors

Linoleum or asphalt tiles, 9″ square, as a base for the clay while working on it, one per student

The students examined the books they had made in the previous session by imprinting the texture of various materials—nail heads, sponges, feathers, fingers—in paint on paper. The teacher said that the object of this lesson would be to make texture three-dimensionally by using tools on clay. She formed a slab of clay and demonstrated how it could be given a textured design by poking or scratching its surface with a nail or the round end of a coffee stirrer, or by using a bottlecap to make impressions on the surface. The students could choose to make either a plaque, about 7 to 9 inches in the largest dimension and about ¾ inch thick, and in any shape—round, square, oval; or else a freestanding capital or column. To illustrate these, she showed reproductions of Byzantine capitals from the sixth-century basilica of San Vitale in Ravenna and a row of twisted and decorated columns in the cloister of a medieval Italian church.

The students who made plaques invented several textures for them, some using one tool (fig. 4), and others two or more. Some divided the surface into areas of different sizes and filled each with a different texture. Frank made a round plaque and used a variety of tools—a nail, a bottlecap, and a wooden stick—to texture its surface and surrounding edge (fig. 5). Those who made columns or capitals first shaped them as three-dimensional constructions and then applied texture to the surfaces with different tools. Jean used a nail head (fig. 6), Priscilla applied strips of clay (fig. 7), and Karina scratched the surface with a pointed stick (fig. 8).

APPLICATION TO OTHER AGE LEVELS

This project can also be done with ten- to twelve-year-olds as well as with older groups, for whom the three-dimensional columns or capitals are particularly interesting.

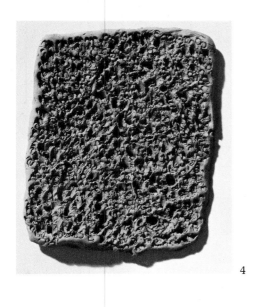

4

5

6

7

8

III: The transformed object—a gift box for a blind child

PURPOSE

To intensify the response to tactile sensations; to stimulate the imagination.

MATERIALS

Boxes of various shapes and sizes

Paper of different textures, smooth or embossed

Collage materials

Straws

Yarn

Rubber cement

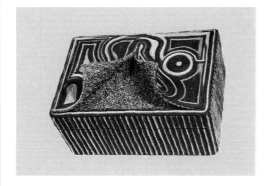

Samaras Box, No. 43

The teacher said that the class was going to undertake the solution to a special kind of problem, the making of a gift box for a blind child. She pointed out that most presents we receive are attractively wrapped, so that they appeal to us even before we know what the package contains. Holding up a sheet of decorative wrapping paper, she challenged the class to decide how a gift could be made attractive to a blind child. The class agreed that the outside wrapping or the surface of the box would have to appeal to the sense of touch by its texture. The teacher said that though the boxes they were to make should primarily have tactile interest, they could also make them pleasing visually. She showed a photograph of a box decorated by the artist Lucas Samaras, which had been made, not for a blind child, but as a personal expression, an object "transformed" into a work of art. As such, it not only appealed tactilely through its textured surfaces but also appealed to the mind through the free reign given to the imagination.

Each student selected a box and proceeded to trim it with paper and collage materials. Some students decorated both the inside and outside of the boxes. Since the decorations were to be both tactile and visual in their appeal, there was a wide range of possibilities. One student covered the entire surface with white cotton to make it soft and cuddly and added a wire animal sculpture. Another solved the problem in a unique way: she covered the box with a striped pattern and made it textural by gluing rows of drinking straws, dried peas, and yarn on top of the stripes. The top of Jose's box had squares of styrofoam mounted on textured paper, cut out and pasted over smooth, shiny paper; a row of fringe ran around the edges (fig. 9). Maria used strips of cork, lengths of yarn, and smooth beans to produce a repeat pattern that combined contrasting textures with gay, varied colors (fig. 10).

APPLICATION TO OTHER AGE LEVELS

The project is suitable either for ten- to twelve-year-olds or for older students.

10

9

A project based
on the human face
in six stages

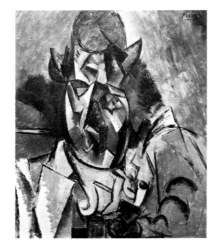

Picasso *Portrait of Georges Braque*

Braque *Man with a Guitar*

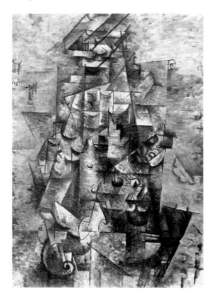

The six class sessions described below offer activities that are both independent and interconnected; that is, each activity has its own motivation and procedure and achieves some objective, yet it also anticipates a further step and involves long-range goals. Learning is intensified when experiences grow in meaning and acquisition of skills. Young adolescents like order and logical procedures; at the same time, each new project must have its particular emotional and mental challenge, or they may become bored. The stages must be different enough to seem new or at least represent an independent step.

I: Drawing a portrait

PURPOSE

To interpret the head in terms of planes and geometric shapes.

MATERIALS

Newsprint, 18" x 24", at least three sheets per student

White paper, 9" x 12", at least one sheet per student

Charcoal; pencils

In order to build up interest and anticipation, the teacher said that this session and the five to follow would all be based on the human face. She said, "We're going to start by drawing in line. Our subject is faces—the human face, your face, and the faces of your classmates. Look around the room and observe the faces. Look first for the general shapes; some are long, some round, some square, others triangular. With your pencil or charcoal, draw six different kinds of faces on sheets of newsprint. Then draw the features—noses, eyes, mouths. We aren't making portraits, so we will not be interested in likenesses but in shapes. Keep your drawings of the face and features flat at first; then you can indicate shapes for the planes or the places that you might want to shade. You can either adhere to the naturalistic shapes, simplifying them, or make them

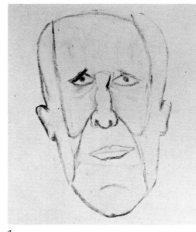

1

geometric as the Cubists did. I have put up on the board the reproductions of two Cubist paintings, one by Picasso and the other by Braque that may be of help to you. Who can tell us what a Cubist painting is?"

Elizabeth: It's dividing the object into planes to suggest the form.

Teacher: Is that the only reason?

George: No! It's because the artists liked the design that the planes made and added other planes for the sake of the design, not because they actually saw them in the object.

Teacher: Yes, that's correct; and that will be our purpose, too—to use the planes as a design; so you can add planes or change their positions, if you like.

Beverly: Shall we draw the hair?

Teacher: No hair or hairdos; but you can put in the neck, if you want to.

The group began by drawing faces in contour, starting with the main shape first. Most used the frontal view, but a few also did profiles. Next, they drew the shapes of noses, eyes, mouths, and ears, either separately or as parts of the faces. Some invented new shapes or varied those that they observed. Not everyone filled the three sheets of newsprint with sketches, but many did so. The search for the basic shapes of human faces and features and the possibility of inventing new ones served to direct the class away from either depending too much on realism or from falling into clichés. Finally, each made a selection from his different sketches from which he made a composite drawing on his 9-by-12-inch piece of white paper. This was to be used in the next stage as a pattern for making a collage.

II: Making a collage portrait

PURPOSE

Further to direct the students away from realistic or cliché images of the face by having them convert shapes of faces and features drawn in the preceding session into flat designs of abstractly conceived planes; to introduce the problem of using values and colors.

MATERIALS

Construction paper, black, white, brown, ochre, and gray, 9" x 12" sheets, at least three per student, and 12" x 18" sheets, at least one per student

Pencils

Rubber cement or paste

Scissors

The teacher asked the group to study the line drawings they had made in the previous session. Each student was to regard his drawing as a design and to think of the parts not as representing projecting planes or features of the face, but as flat, abstract shapes like the pieces in a jigsaw puzzle; each piece having its interest both independently as a design and also with relation to the whole. If a student felt it would add to his design, he could shift the parts about or change their shapes. The teacher referred again to the reproductions of Cubist paintings by Picasso and Braque; she also asked the students to feel their own faces to get a sense of the underlying planes of the bone structure.

Each student selected two or three sheets of 9-by-12-inch construction paper; the colors were limited to black, white, and earth colors to simplify the problem. They superimposed their drawings on the construction paper, using them as patterns from which to cut out the shapes of the faces and the features from sheets of different colors. The shapes could be simplified or changed in the cutting, if desired. Next, the cutout shapes were arranged on the background of a 12-by-18-inch sheet of a different color, the object being to use the shapes as freely as possible to create an original design, while still keeping some semblance of a face. The shapes were moved around freely until the desired result was obtained, generally after some consultation with the teacher; then each student pasted the pieces down as a collage. Some students, such as Brad, retained the natural shape and features of a face (compare his collage, fig. 2, with his drawing, fig. 1), but others altered them considerably (figs. 3, 4). A few students used more than one color for the background, which they integrated with the design of the face (fig. 5).

2

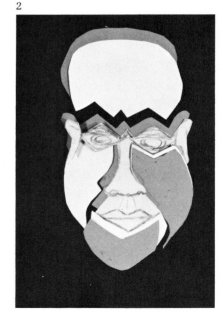

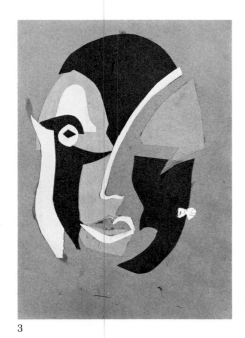

3

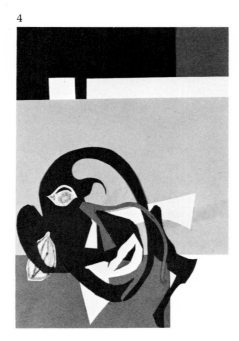

4

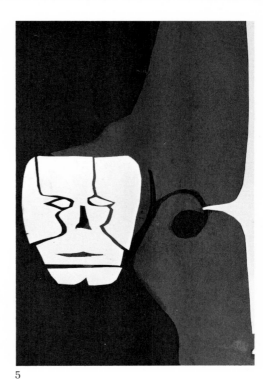

5

III: An abstract painting

PURPOSE

To invent an abstraction using the paper collage made in the previous project as a point of departure; to translate the colors of paper into those of paint.

MATERIALS

Paper, 18" x 24", at least one sheet per student

Paint, earth colors

A frame or finder with an opening of approximately 3" x 4", one per student

In this stage, a further step is taken toward the student's idea of an abstraction by having him select from the semi-abstract collage made in the previous session that portion of the design which will make the best abstraction. The teacher said, "I have placed the collages of faces that you made last time in front of you, because you're going to use them today. You are going to use your collage as a reminder or guide in making a painting; however, the idea is not just to copy your collage in paint, because that wouldn't be very interesting, nor would you learn enough from it. You're going to paint an abstraction; who can tell me what that is?" The students volunteered that it is a painting that does not represent a recognizable subject. One said that though the painting may show objects, their shapes have been so simplified or modified that one can no longer recognize them. The teacher said that definition came very close, but she added that an abstraction could either be based on recognizable objects or on geometric or imagined forms. For the purpose of what they were

about to do, the class would accept the idea that their paintings were to be made up of shapes that were interesting as designs in themselves, whether they suggested recognizable objects or not. She also pointed out that many artists translate from one medium to another—from collage to painting, or vice versa; and she referred specifically to Josef Albers as a well-known modern artist who makes collages out of colored paper as studies for his abstract paintings.

She told the class that they were to use only part of their collages for their paintings. "Imagine that you are going to photograph a section of your collage and are looking through the lens of your camera to find the best part. I have made these frames for you, so that you can slide them over your collages just as if you were passing your camera over the landscape to find the most interesting view. Artists in the past used such frames as 'finders' to help them find a good composition. Each of you should select the portion of your collage that you think will make the best abstraction."

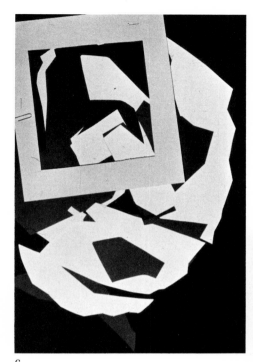

6

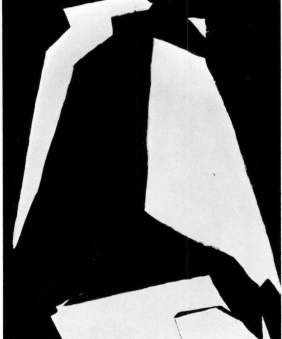

The students were fascinated by the idea and especially by using the frames to help them "find" a good composition. The teacher suggested that when a student decided on the area of his collage to be painted, he squint at it through the finder and imagine it blown up to the full size of the paper (figs. 6, 7). Although only a limited palette of earth colors—ochres, grays, browns, and black and white—were to be used in painting the abstractions, the students were encouraged to change the colors from those used in their collages for greater contrast or harmony, or in any way that suited their taste. The purpose was not to reproduce the colors of the paper but rather to discover what happens when pigments are mixed, and also to make subtle variations within a limited color range.

The students had the experience of creating their first abstractions. In general, the effect of the paintings was hard-edged, but some students were inclined by natural preference to paint more freely.

7

IV: A clay collage face or mask in bas-relief

PURPOSE

To have students conceive of the human head in terms of flat planes of different shapes and thicknesses and relate these as a design, using clay as a medium.

MATERIALS

Moist clay, balls about the size of a grapefruit, at least two per student (As the clay is not to be fired, it is not necessary to use firing clay nor wedge the clay to eliminate lumps and air bubbles.)

Clay tools, or tongue depressors cut to a slant at one end and to a point at the other, one per student

Linoleum or masonite, approximately 10″ x 12″, or any sturdy support for the clay

Sponge and pan of water, one per student

The problem is not to attain human likeness but to make a design that relates planes to each other, and to the whole; the head is taken as the point of departure because at this age it is more appealing than an abstract shape, either free-form or geometric. Slab construction in clay is used because of its similarity to making collages with other materials, a procedure already familiar to the students.

The teacher said: "You have made many collages of paper, cloth, and other materials, but this time you will make a collage of shapes of clay only. It will be a bas-relief. Who can tell me what that means?" Most of the class knew, but one boy accurately defined it as a form of sculpture in which the modeling is low and only slightly raised from a flat background. The teacher continued: "You each have two lumps of clay at your place. Flatten one to a thickness of about an inch, for your background, and make it into an interesting shape.

"With the second lump of clay, you will make the shape of a face, also only about one inch thick. Keep it flat. Do not model it. Trim the edge with the slanted edge of your tool, and use the pointed end to draw features on the face. Then divide the face into several parts by cutting it with the tool."

When the students had progressed to this point, they were ready to organize their reliefs. The pieces into which the face had been cut were arranged on the background slab in such a way that a face was suggested without being strictly represented; the spaces between the shapes were left as dividing lines as in the arrangement of the paper collage (Stage II). The planes were made higher or lower by changing the thickness of the clay. When a student attained a result that pleased him, he attached the pieces to the background; this was done by scratching the back of the piece and the corresponding area of the background with a tool, wetting the scratched areas with water, and pressing the piece into position on the background. If necessary, the edges were smoothed either with the wooden tool or with the fingers. Some students chose to give the backgrounds or some of the planes texture by pinching, scratching, cross-hatching, or stippling the surface.

V: Painting the bas-relief head

PURPOSE

To continue the concept of the bas-relief head as a design of flat planes and accentuate this flatness by painting.

MATERIALS

Paint

8

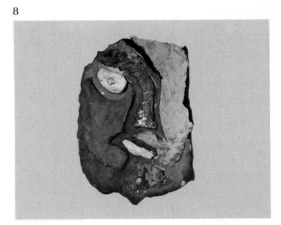

9

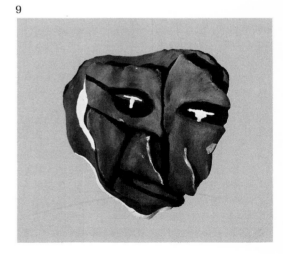

The teacher referred to the work the students had done in making their collage portraits (Stage II) and said that they were to continue with their clay collages to create an effect of flat surfaces, using different levels of depth in the clay to indicate the various planes, and using paint, not to suggest modeling but to accentuate the flatness. She suggested that the colors might indicate materials, such as stone, wood, plaster, or metal, rendered by means of such colors as gray, tan, brown, black, or white. She also said that a painted pattern could be applied, particularly by those students who had not textured their pieces. A number of reproductions of primitive masks, mostly African, were shown to the class as suggestive examples but were removed immediately so that there would be no temptation to copy them.

The clay pieces were now dry, but as they were not fired, they had to be carefully handled to prevent them from breaking while they were being painted. Colors also had to be mixed thoroughly in order to produce even surfaces free of streaks. The background colors were allowed to dry thoroughly before any paint was added for patterning.

VI: A painting based on the bas-relief head

PURPOSE

To go a step further in using the human head as the basis for a design by translating the bas-relief into a painting; to capitalize on the experience gained previously and provide a bridge between the three-dimensional experience of the clay collage and the two-dimensional one of painting.

MATERIALS

Paper, 18" x 24", at least one sheet per student

Paint, earth colors

Pencils and charcoal

The bas-relief heads that the students had made and painted in the two preceding sessions were available. The teacher commented: "You have learned a great deal in making your bas-reliefs by using the idea of a head as the basis for your designs. There were many good ideas, and everyone made an original design. I hope that you've seen through this experience that you can use any real or natural object as a starter and change it into a design of your own. The challenge I have for you today is for each of you to use your bas-relief as the starting point for a painting; of course, the object is not to copy the bas-relief but to make a new and different composition."

The same earth colors used in previous stages were employed. There was great freedom in the way the paint was used—thick or thin, flat, or in free brush strokes. Some students drew their heads in pencil or charcoal first, others painted directly. In some cases, the reliefs were followed quite closely (compare figs. 10 and 9, 11 and 5). Nina used the same subject in her collage (fig. 3), bas-relief (fig. 8), and painting (fig. 12). Others, however, departed markedly from their previous compositions (figs. 13, 14).

APPLICATION TO OTHER AGE LEVELS

This six-stage project may be developed further with groups of older students. It can be made more challenging by using different materials, such as metal, wood, or plaster.

10

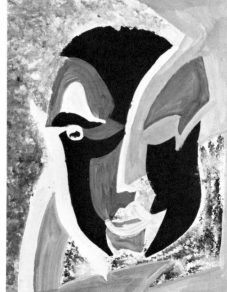

11

12

13

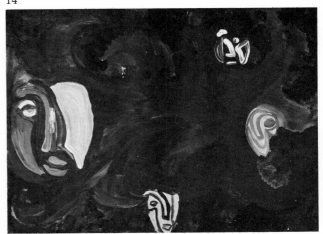

14

Group projects: an integrating activity

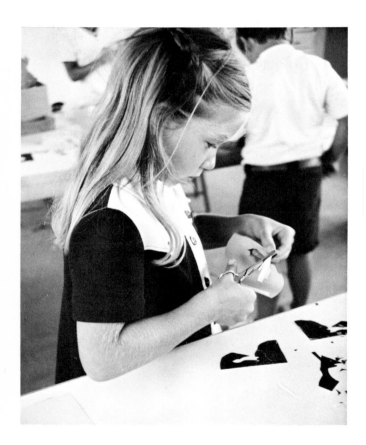

When the child's independent, individual development is highly important, it is also important for children to learn to work together. At times they need to learn how to share and to strive for the same goals, to give and take, and to be objective about the results. In the art class, working in teams or as a group can provide some of this necessary experience. Each child, when involved in a group project, learns to adjust his own idea to some common idea and to relate his own expression to an overall visual statement. He is able to see his effort in a wider context and recognize its relation to the creation of a harmonious work. In addition, the group project satisfies the child's social need to be part of a group, to identify with his peers, to be accepted and accepting.

Although the group project offers many advantages, it also has disadvantages which, unless they are averted and overcome, can destroy the group effort and injure the child, both psychologically and creatively. Many conscientious teachers have abandoned group projects completely because of an inability to offset the disadvantages; but awareness of the dangers can prevent their occurrence.

It is essential that only positive and creative methods be used. In making a group mural, the common practice—and one most injurious to a child's sensibilities—is to have the most "gifted" children plan the composition, and draw in and paint the more difficult parts, usually the human figure; while the less "talented" children paint the details, color and backgrounds, or even just mix the paints. This practice is based on the false notion that good drawing and facility in representation constitute creative ability. A somewhat different but equally injurious approach is that of a celebrated French teacher, who has all the children make sketches for the mural. The teacher then chooses the "best," cuts it into equal parts, and gives each child a part to render in full scale on the enlarged mural. The completed work is hailed as an outstanding work of child art, at least by the uninitiated. But the glory is won at the expense of the majority of the children, who are made to compete with each other and render their services at the expense of their pride and integrity.

Other group projects can involve similar harmful practices; for example, in the presentation of professional plays, or those written by children, the more able students may be entrusted with the designing and the important parts, while the others perform technical work or make props. New problems arise in relation to the making of

dioramas, models, and maps, usually undertaken as projects for social studies or other school work unrelated to art classes. Frequently, children simply copy the materials from books, charts, or other sources; they merely provide the labor of transferring material from the sources to the group product through copying or even by tracing. Most well-educated art teachers today are aware of the harmful effects that copying may have on the child and are opposed to its use. When a child copies, he is conscious that he is indulging in some form of deceit or stealing, especially if he has been guided to respect his own uniqueness and personal expression. Furthermore, he is required to adopt a style that is not his own, usually one that is more sophisticated or technically developed. Such confusion of goals tends to reduce the child's confidence in his own abilities and make him more dependent on adult values and performance.

Last, but not least, the kind of group projects described above may belong to the group but do not belong to any one individual. After the project has been finished and has had its share of attention or admiration, it must be discarded or destroyed.

In spite of the possible dangers, the group project can be a great asset to the creative growth of the child. The projects presented in this chapter are constructive experiences that offer the advantages of group activity while at the same time protecting the child's individuality. Every child has equal opportunity and an equal place in the joint endeavor. Unity is achieved because the children have a common motivation or theme; and although each expresses himself in his own inimitable style, the similar character of children's work at a specific age level gives a natural harmony to their creative work. The design concepts and the materials provided also tend to produce harmony in the completed product. The teacher does not decide who shall do the major parts, because there are no major parts; the units are all equal to each other and therefore interchangeable. Nor does the teacher decide where the various parts shall be placed; this is left to the students, who decide on the basis of their own judgment where the parts look best or produce the best aesthetic effect. Each child has a hand in the general organization and places the parts where he thinks they seem most effective. The final statement is agreed upon by the entire group, using their judgment as objectively as possible. Finally, because each project is composed of individual units, after it is finished and has fulfilled its object it can be dismantled, enabling each child to take his own unit home with him—a complete statement in itself.

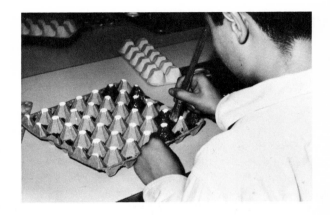

Group projects for children six to seven years old

A flower-garden centerpiece

PURPOSE

To use a seasonal or special subject in a constructive and creative way; to engage an entire class in a single objective, thus developing the habit of sharing and cooperating.

MATERIALS

Base for the centerpiece, about 18″ x 24″ x 4″ deep, filled with moist clay. (This can be made from a shallow box, corrugated board, or wood; the clay can be cleaned and reworked for future use. A somewhat deeper box, 5″ or 6″ deep, and filled with earth or sand, will serve the same purpose.)

Dowels and pieces of reed, ¼″ in diameter, 12″ to 15″ long, at least six per child

Pipe cleaners, various colors, at least two per child

Scissors

Staplers

Paper punches

Paste

Paint

The teacher said that the school was planning to give a party for parents just before the Christmas holidays, and that each class would participate by making some of the decorations. She said that she had volunteered to have her class make a centerpiece for the refreshment table. In the discussion about centerpieces that followed, it was observed that they were usually made with real flowers, often surrounded by lighted candles. The teacher proposed that the class invent its own centerpiece and the flowers for it. She showed them a boxlike shape of styrofoam, 18-by-24-by-4 inches, which had been discarded after having been used to ship some fragile equipment, and which she had filled with moist clay. She suggested that the styrofoam be used as a base for the centerpiece and painted an attractive color, and the flowers be "planted" in it.

The teacher showed the class the different kinds of materials from which they were to make flowers and demonstrated several possible methods of designing and constructing them. Holding up strips of colored paper, she asked, "What can you do with a piece of paper to invent a flower? You can curl it, bend it, punch holes in it." She produced pieces of reeds and dowels for the stems and showed how the paper could be attached to a single dowel, or how by using two reeds or dowels a plant with two stems could be made. She

also called attention to pipe cleaners in assorted colors, which could be bent to make single flowers or used in conjunction with other materials.

Three of the children volunteered to paint the base first so that it would be dry by the time the flowers were ready for planting. Each child selected three or four strips of paper in his favorite colors, two pipe cleaners that would go well with them, and reeds and/or dowels. In constructing their flowers, the children showed that they had benefited from the teacher's demonstration; however, they did not imitate what she had done, because she had challenged them to invent their own methods and designs. Neither did they copy each other's work but invented freely.

When the flowers were finished, the group gathered around the painted base to plant them. One at a time, the stems were inserted into the clay wherever each child thought his flowers looked best, while the rest of the class served as jury. The centerpiece was turned several times so that it could be viewed from all sides, and often one or two flowers were moved to more effective positions. The children attended the party, and afterward each took his flowers home.

APPLICATION TO OTHER AGE LEVELS

This project can serve as a seasonal or special-event activity for almost any age level above four, but for the younger children the concept and procedure should be simplified.

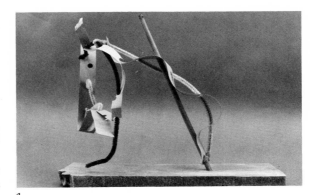

1

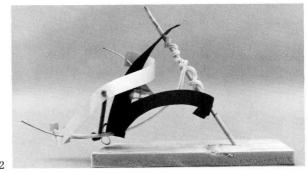

2

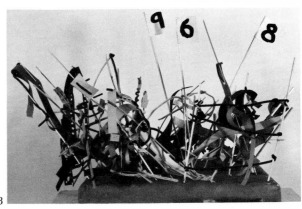

3

Animal families: a mural in two stages

PURPOSE

To involve all the class in a group undertaking, setting a common goal; to add the experience of painting to that of making a collage.

I: The group collage

MATERIALS

Construction paper, white, gray, and black, 18" x 24", at least one sheet per child

Construction paper, various colors and sizes ranging from 3" x 5" to 9" x 12", at least six pieces per child

Pencils

Scissors

Paste

The teacher said that the class was going to make something in which everyone would take part. It would be a mural. She asked the children whether they knew what that was, but the word was new to them. One boy ventured a guess that it was some kind of animal. The teacher explained that it was a picture painted on a wall; she said that most murals were painted right on the wall itself, but they were going to make theirs in a different way. Theirs would be made on paper— they would make a collage first and then they would paint it in the next session. After they had all seen and enjoyed the completed mural, it could be taken apart and each child could take his own part home. The theme was animal families. The animals were to be of three kinds—those that fly in the air, those that move on the ground, and those that swim in the water. The teacher tacked on the wall three rows of 18-by-24-inch paper, one above the other: the top row was white, for flying animals; the middle one, gray, was for animals on the ground; and the bottom row, black, was for water animals.

Each child decided what kind of animal family he was going to make. He took several pieces of colored paper and drew on each an animal, making it fill the sheet, and then cut it out with scissors. If he wanted to make twins, he laid one piece of paper over the other and cut both out together. After each child had made his family of animals, he took to his seat one of the large pieces of paper of the appropriate color. As it turned out, there were more flying animals than the other two kinds, so some had to be put on the ground or on rocks in the water. The completed papers were then reassembled on the wall and discussed.

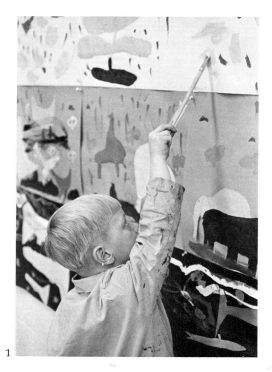

1

II: Painting the collage mural

MATERIALS

Paint

The teacher said that while the collage mural looked very interesting just as it was, it might be made even more so by adding some paint. She asked the class to look carefully at the mural and offer any suggestions for its improvement. A few children discovered that the colors they had used for their animals were the same as the colors of their paper backgrounds, so that the shapes were lost; but they learned that this could be corrected by painting a pattern on the animal or an outline around it. The teacher said that it might be fun if the children were to paint directly on the mural while it was tacked to the wall, instead of taking the separate pieces back to their seats. This required working on ladders, which they enjoyed. She suggested that they might paint falling leaves, or rain. Inspired by these ideas, the children added clouds, trees, rocks, a fence, ripples and bubbles in the water, and firecrackers bursting in the air.

Painting the collage as a group was a new and challenging discipline. The teacher had told the class that in a group project such as this, the quality and success of the whole were to be regarded as more important than individual preferences, so there were more advisers and critics than painters. A few children who became distracted or impatient were allowed to start individual paintings or finish an earlier work. When the mural was completed, it was tacked on the wall in the corridor for others to enjoy. After it was finally dismantled, each child took his own part of the collage painting home.

APPLICATION TO OTHER AGE LEVELS

This project is not suited to children younger than six. It can be used with success at any of the older age levels, for whom it should be made more challenging and complex in accordance with their interests and capacities.

2

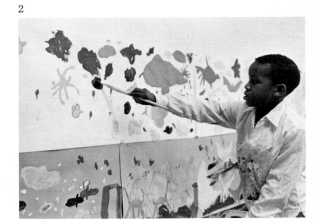

3

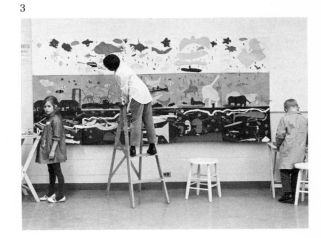

A pop-up collage mural based on the theme of the city skyline

PURPOSE

To engage in a common objective; to generate group spirit through related efforts and interests.

MATERIALS

A sheet of paper 3' high x 12' long (Kraft or wrapping paper will do), tacked to the wall as background for the mural

White paper, 9" x 12", 9" x 24", 12" x 18", at least two sheets per child

Construction paper, various colors, in the same sizes as the white paper, at least two per child

Straws and thin sticks

Pencils

Pointed scissors

Paste

Pushpins or thumbtacks

The teacher proposed that the group work together to design and construct a mural of a city skyline. Everyone would contribute his work to the whole mural, but when the mural was dismantled, he would receive his own work back intact and be able to take it home. She said that they were going to make paper pop-ups for their mural and demonstrated their construction. First, shapes such as spirals, triangles, or squares were drawn, each with a continuous line; then, by cutting along the lines, the shapes could be pulled out and made to stand up. She first drew, then cut, semicircles, squares, and triangles, and also some letter shapes like G, F, H, L, M, N, S, T, U, V, W, Y, and Z. Then she folded or bent them like flaps to suggest doors or windows.

She urged the class to invent shapes of their own.

The teacher went on to develop the idea of how an unusual city skyline for the mural could be made, composed of the façades of buildings with windows and doors made of spiral or flap pop-outs. Holding a sheet of colored paper behind one of the pop-outs she had made as a demonstration, she showed how the contrasting color heightened the effect of the design.

Each child was to make one or more buildings with pop-out doors and windows.

The children first made such buildings from sheets of the white paper, which they pasted onto pieces of colored construction paper of the same modular size, so that the color showed through the cutouts. Next, the group arranged the buildings in a row on the mural paper tacked to the wall, to suggest a city skyline. The pieces were tacked in place with pushpins so that they could be moved about to achieve the best effect; some buildings were put on top of others to give variety or added height. Finally, radio and television antennae made of drinking straws and thin sticks were fastened to the tops of the buildings to enliven the design. The children gave the completed mural (fig. 1) a name that one of them had suggested; they called it *Curly City*, because it was unlike any city they had ever seen. It remained for a time as part of the class environment, and when it was dismantled each child took his own buildings home.

APPLICATION TO OTHER AGE LEVELS

This project should not be attempted with children younger than six, but it will work at the older levels, particularly with eight- to ten-year-olds.

1

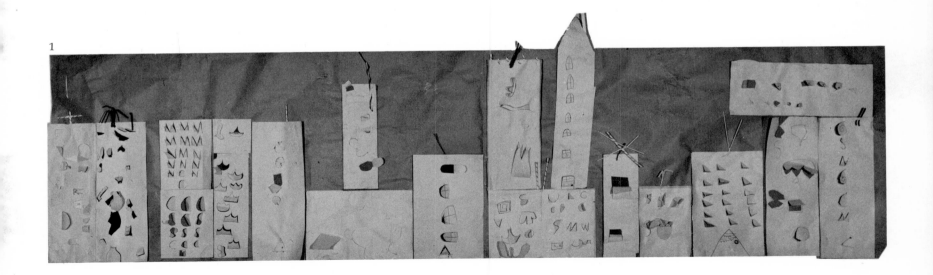

A family tree

PURPOSE

To use a familiar and appealing subject—the self-portrait; to involve the entire group in a project in which each child would maintain his own identity and yet also become part of a composite image.

MATERIALS

White cardboard, saved from scrap and varying in shape and size, approximately 6″ x 9″, at least one piece per child

Paint

Colored yarn

Staplers

A bare tree branch held upright in a bucket of sand, or otherwise secured

The teacher asked the class whether anyone knew what a family tree was. A few of the seven-year-olds said it referred to the members of the same family—parents, children, grandparents, aunts, uncles, and cousins. The teacher said that the idea of a tree suggested the close relationship within the family, whose various members were like the limbs and branches growing from the same trunk. She went on to explain that the class would adapt the idea in an imaginative way by creating a group tree—a real tree on which every member of the class would be represented by a self-portrait. She showed them the large branch with extending limbs that had been firmly fixed in a bucket of sand, and said each child would paint his own portrait and hang it on the tree in any place he wished. She also showed them the small pieces of cardboard of different sizes and shapes that had been saved from scrap. She suggested that the children paint on these directly, without making preliminary drawings. She did not limit the idea of a portrait, so that each child was free to paint only a

face, or include part or all of the figure. She suggested that the back of the cardboard should be painted with a gay or pleasing color, because when the portraits were hung on the tree, they might turn or sway so that at times only their backs could be seen, and also because the tree would be seen from all sides.

The resultant portraits varied greatly. They ranged from a painting of the features without any outline of the face, by a six-year-old boy, to torsos and full-length portraits by some of the older children. Some figures had arms and legs extending, others were shown seated or standing. One child created an interesting blurred effect by painting over still-wet paint. As each child finished his painting, he chose a brightly colored piece of yarn and stapled its ends to the top of the cardboard, making a loop with which to hang it on the tree. Each hung his portrait where he felt it looked best, but the teacher pointed out that since this was a group family tree, the placement of every part should be related to all the others. Accordingly, some children changed the

1

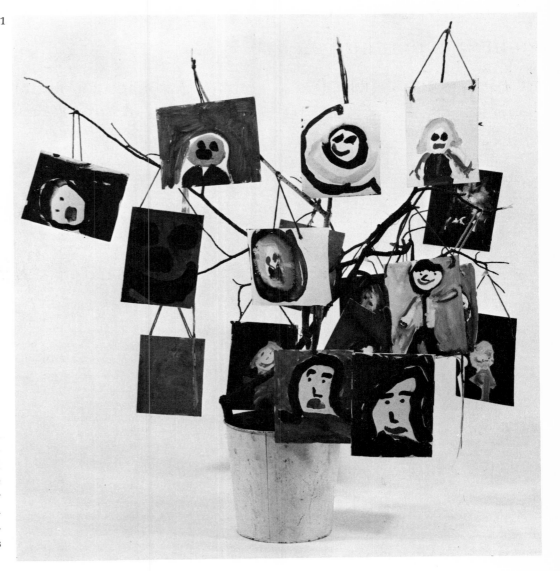

location of their portraits when they discovered that a monotonous effect resulted from placing side by side two paintings that were almost identical.

APPLICATION TO OTHER AGE LEVELS

The project of a freely interpreted family tree is particularly appropriate for this age level, because children of this age are interested both in depicting themselves and in participating in a group game in which everyone is represented. The subject of a family tree is not recommended for children younger than six, although hanging of decorations—simple collages or constructions—on a tree or similar support would appeal to, and be appropriate for, four- and five-year-olds. The project could also be adapted for older age levels by making both the idea and the structure more demanding in terms of the use of imagination and craftsmanship, for example perhaps entailing cardboard cutouts or marionettes.

Group projects for young people thirteen to fourteen years old

A collage zoo mural in three stages

PURPOSE

To provide an opportunity for both individual expression and group expression; to develop these in an extended project whose three related stages give a sense of continuity and encourage concentration toward a specified goal.

Although painted murals have been done in schools for many years as a means of involving an entire group, frequently everyone does not have an equal opportunity, since the more important parts are done by the more gifted student (usually identified as the best "drawer"), while the less gifted do the background or details. Sometimes in fact the least able do not get to work on the mural at all. The result of this may not only be the loss of a creative experience but also damage to the child's emotional and psychological growth.

The strategy underlying this project is that the collages are made individually; they are fastened to the master plan for the group mural and later removed, so that each student is able to take his own work home.

MATERIALS

A large piece of paper, approximately 3' high x 24' long, divided into 9" squares with pencil and straight-edge; Kraft or wrapping paper will do, and the length can vary according to the size of the room and the number of students. (If possible, the paper should be mounted on a tacking board so that pushpins or thumbtacks can be stuck into it, but if this is not available, the paper can be fastened to a blackboard or wall with masking tape.)

Construction paper, various colors, cut into four different shapes and sizes, one set of each per student

Note that the pieces have a 9" module so that they will all fit together.

Old newspapers; pencils or charcoal; paint, black or another selected color; scissors; rubber cement; thumbtacks or pushpins

I: Drawing the animals

Teacher: Today, we are going to begin making a mural in which everybody will take part. Who can tell us what a mural is?

Eric: A big picture.

Maria: It's a picture painted on the wall.

Teacher: How many have worked on a mural?

(Several hands went up.)

Amy: I was supposed to work on a mural, but my turn never came.

Teacher: That's not going to happen this time, because everybody will have an equal part. What do we have to think about when everyone works on the same mural?

Nadja: We must all do a good job.

Teacher: Yes, I hope we will all do our best; but I was thinking of something else.

Thomas: It's got to hang together.

Maggie: No parts must stick out more than the others.

Denise: Oh yes, it has to be balanced.

Teacher: Yes, that is the main object, but it won't be difficult, because we are going to do it in a special way. This is going to be a new kind of mural; instead of being painted, it's going to be a collage. Let's pretend that we have been asked by the Parks Commission or the City Zoo to make a mural. We could make it out of many different kinds of material—metal, stone, or wood—but we are going to make ours out of paper, because it's cheaper and easier. What will the subject be?

Sergio: If it's a zoo, it's got to be animals.

Teacher: Name a few animals that come to your mind.

Class: Bears, giraffes, lions, monkeys.

Teacher: Good. Now, I have a few photographs of animals to refresh your memory, but if you want to use others, please do. It won't matter if they aren't exact, or if there are some imaginary animals in the mural; they will add interest.

Each student took one piece of each of the four shapes that had been cut out of construction paper, and some newspaper. The teacher said, "Everyone has four pieces of paper of different shapes and sizes. Choose one animal with a simple or bulky shape, for example an elephant or a hippopotamus. You are going to draw that animal on newspaper in different positions— standing, sitting, lying down, or crouching, so that he will fit into each of the four shapes. You can cut the newspaper, if you want, so that it will fit the sizes and shapes of the pieces of colored construction paper. Before we begin, let's make sure everybody has chosen a different animal, so that there will be an interesting variety in our mural."

The students drew the animals they had chosen on their pieces of newspaper, and cut or tore them out. As newspaper is cheap, each student could do several more than were needed, exploring different possibilities within each shape (figs. 1, 2). Each student pasted his final four onto the pieces of colored construction paper with rubber cement. Figs. 3, 4, 5, and 6 show how Peter interpreted a cat.

217

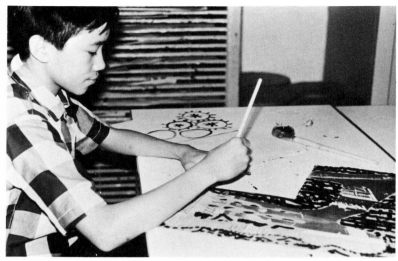

1

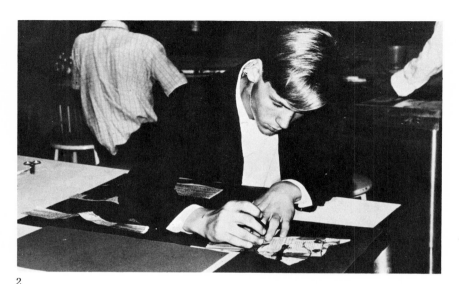

2

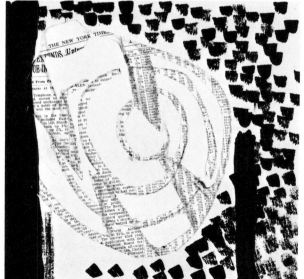

3

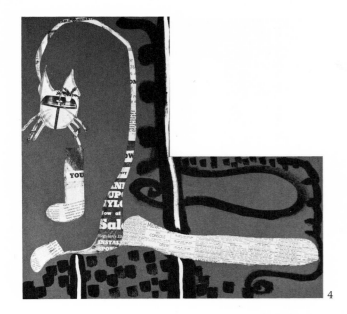

4

5

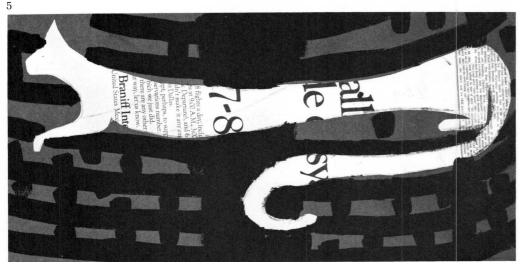

6

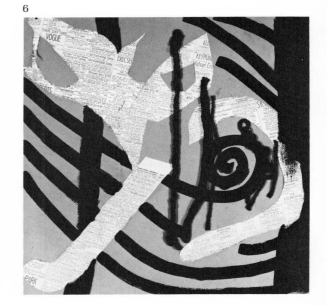

II: Assembling the mural

At the following class session, the teacher said: "Now that we have finished our collages of animals, let's try making a mural. Everybody go up and pin one animal onto the brown paper; place it anywhere you want, but keep it within the ruled squares." When everyone had put up one animal, a second, third, and fourth were added in turn, until the entire paper was covered. (If it is not possible to use thumbtacks or pushpins, double-faced masking tape or a touch of rubber cement can be put on the back of each piece.) Some of the animals had to be rearranged several times to fit into the space (fig. 7). The class and the teacher evaluated the mural for balance and interest, and changes were made as a result of their discussion, with a few of the students doing the actual moving about of the pieces to achieve the new arrangement. When a satisfactory result was arrived at, the mural was ready for the next stage.

III: Painting and finishing the mural

Teacher: Now that the mural has been put together, let's examine it to see whether it holds together or needs anything.
Leslie: The colors stand out too much.
Thomas: They're too blank.
Teacher: What can you do about it?
Maggie: Paint stripes in the background.
Kimberly: I'd use dots.
Teacher: Those are both good suggestions. Adding a pattern with paint would help, but what color would you use?

Black was finally decided upon to accentuate the unity of the whole. The mural was completed as a group project; but each student's contribution remained a separate, individual work, which he could take home after the mural had served its purpose.

APPLICATION TO OTHER AGE LEVELS

This project may be used in secondary-school classes but is not suitable for younger age levels.

7

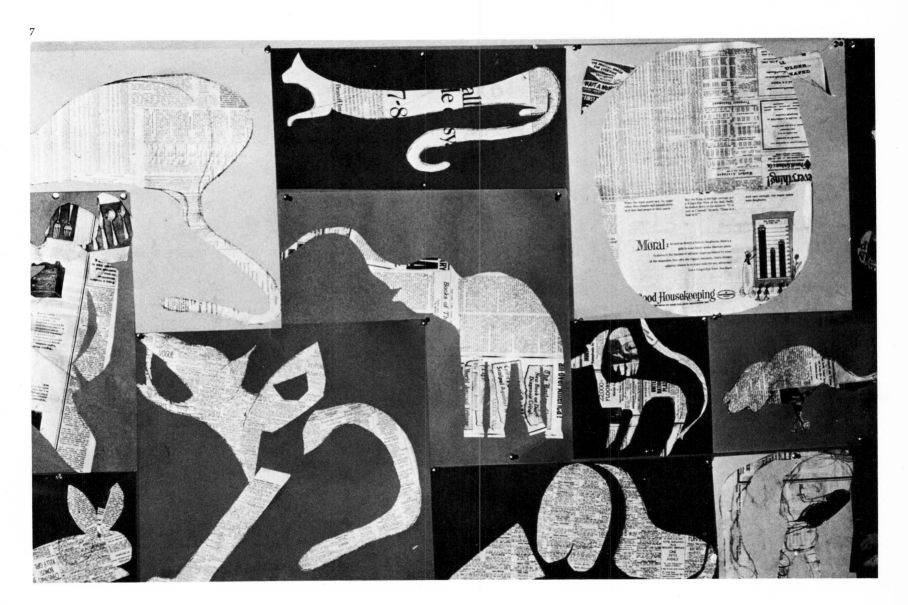

A sculptural mural

PURPOSE

To provide an experience that is valuable from both an aesthetic and a social standpoint; to allow each student to make a unique statement and at the same time be part of a group enterprise; to develop group associations and habits.

MATERIALS

Molded sheets such as those used for packing fruit, vegetables, etc., two per student. (Each student should be asked to obtain two such sheets from a supermarket, grocery store, fruit market, or bakery.)

Paint

Hammer

Nails or brads

This project of making a mural together was devised in order to meet certain needs characteristic of early adolescents. At this age, there is a particular desire to fraternize and participate in group activities, especially between opposite sexes, although these aims may be confused by attitudes of aggression or even hostility. There is considerable ambivalence: the desire to gang up in groups of all boys or all girls, the desire to be part of a mixed group, and the desire to be a "loner" can all coexist. There is also the tendency to compete for attention and to show one's superiority. Doing a mural together produced a challenging social situation and also made for a dynamic art experience. The mural was made up of individual units, so that each student could make a personal expression and eventually take home his own work as a finished product; at the same time, the assembling of these units into a whole that produced a unified mural allowed each student also to be part of a group enterprise.

Interest was developed at the outset, because the students had been asked to search for and bring to class molded cardboard forms such as those used for packing eggs, fruits, vegetables, and baked goods. These are familiar objects, as every family is likely to acquire some of them on any shopping trip; usually they are discarded as rubbish, but to the artistic eye they are interesting, well-designed shapes that offer excellent opportunities for creative work. The students had been told to seek out forms that could be used for making a class mural, so their interest was aroused both through an appeal to their curiosity and through the anticipation of participating in a group effort.

The teacher called attention to the different shapes of the molded cardboards and to their fascinating surfaces. Most were gray, but some were green, purple, or other colors. She arranged a few on the board, to show how they could be put together to make more interesting and varied shapes, and called for reactions. Chris said, "It's a mural." Maggie said, "It's a whole thing." Several names were proposed, but the group liked Debbie's title, *A Sculptured Mural*. The group then discussed how to tackle the design. Charles thought that the molded cardboards looked good just as they were; but Ellen disagreed, because she felt more color was needed than the few colored ones alone would supply, and therefore some design on the gray molds would improve the effect of the whole. Debbie said, "If we don't do anything to them, it won't be our mural, and when you get close it will look just like a lot of egg and fruit boxes, and everybody will recognize them for what they are."

The class was asked to consider the overall design.

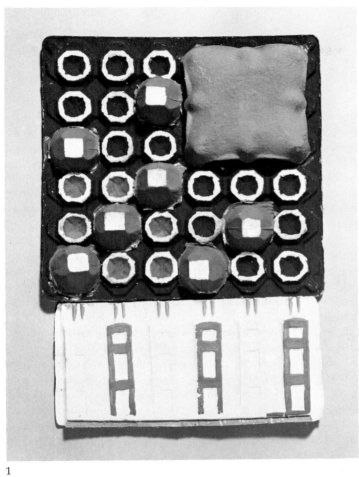

1

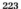

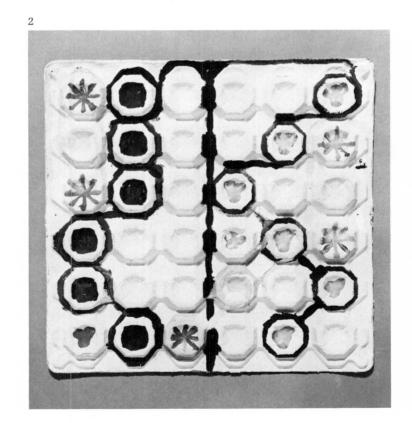

The students observed that the general character of the sheets, like the molded shapes themselves, was geometric—circles, squares, and polygons. This made a kind of common denominator. Some of the molds were simple and shallow, while others were made up of many small shapes in high relief. The students decided to accentuate these various qualities by painting certain parts in color; they decided that black or white should be used in the large areas, and colors in the small areas.

Each student took one large and one small box. The largest size was about one foot square, and the others ranged from about 4 by 8 to 6 by 12 inches. The raised or recessed embossed shapes were filled in with colors or surrounded with outlines (figs. 1, 2, 3). Although it was painstaking work, which the teacher had thought might prove tedious or boring, none of the students seemed to find it so, in spite of the numerous minute areas involved and the careful technique required. She took this opportunity to discuss "paint-by-numbers" sets and the damage they can do in undermining creative expression, and she asked the students whether filling in the shapes of the cardboard molds seemed to them like working with such sets. Maggie said, "Definitely not, because a paint-by-numbers set is not your own, and you have no chance to choose the colors or shapes." Kim said, "A numbers set is easy. You don't have to think. It's all done for you." Eric added, "I don't know about numbers painting, because I never did one; but it doesn't sound very interesting."

When each student had finished, or nearly finished, one unit, the teacher asked that the units be put together to see how the mural might look as a whole. The tables and chairs were pushed back to provide a large space on the floor, where the mural could be laid for the class to examine. At first, pieces were placed at random; then the group discussed changes, and pieces were moved and shifted about to conform with their ideas for the whole design. Some of the colors seemed out of harmony, and changes were proposed; other molds needed more color accents or strong contrast to bring them up to the level of the mural. The students made the necessary changes and finished their second units; some were so enthusiastic that they made three or four, doing the extra work at home. Paul experimented by putting units on top of one another, which increased the three-dimensional quality.

A second session was held in which the mural was put together. This was done on the floor. When time ran out, two students were delegated to finish the arrangement by carrying out suggestions made by the group. Finally, the mural was tacked on the wall with brads or thin nails (fig. 4), and the group decided it was rich and colorful. It was so striking that students from other classes came to see it on display. When the exhibition was over, each student took his work home intact.

APPLICATION TO OTHER AGE LEVELS

This project in only slightly simplified form is applicable to a group of eleven- to twelve-year-olds, with each child doing only one molded piece for the mural.

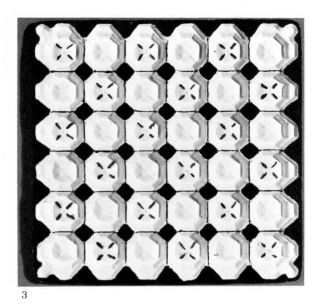

3

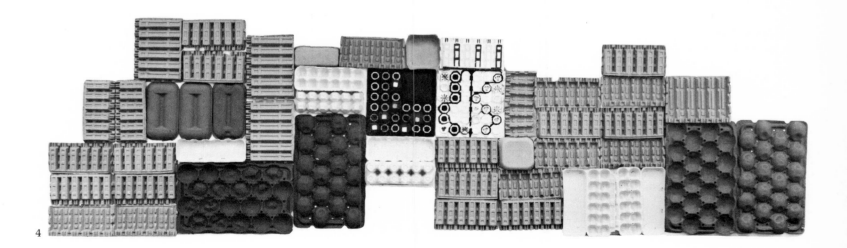

4

A sculptural assemblage in two stages

PURPOSE

To explore further the discipline of a group project; to continue the experiences of achieving harmonious results in group behavior and aesthetic effect, as initiated in two projects previously undertaken by the class, "A Collage Zoo Mural" (page 216) and "A Sculptural Mural" (page 222).

MATERIALS

An assortment of shoe boxes of approximately the same size, at least one per student. (These can be supplied by the students.)

Wood scraps, a large variety: turned pieces, finials, balusters, wood balls or half-spheres, blocks of different sizes and shapes, squares, rectangles, triangles, knobs, etc., at least eight pieces per student, including some flat and some turned. (These can be gathered from the school carpentry shop or from local carpenters.)

Water soluble paint (rubber base or acrylic), white or black, one quart for a class of fourteen students

Paint brushes, 2" wide, six to be shared by the class; pushpins; Elmer's glue, a medium-sized dispenser for each student or to be shared.

Nevelson *Royal Tide, I*

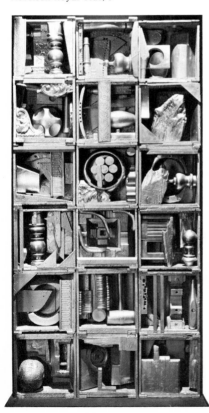

I: The individual assemblage

The teacher displayed photographs of assemblages by Louise Nevelson, one of a horizontal arrangement called *Homage to 6,000,000 II* and the other a vertical arrangement called *Royal Tide I*. She gave the artist's titles for these works but then asked the class to give them their own titles. One boy said the assemblages reminded him of a workshop in which all the tools were neatly arranged. A girl said she thought they looked like bookcases. Some of the other suggestions were crowns, cities, walls for a modern kitchen, souvenir shops, and fabricated forests. The teacher said that she believed these titles would have pleased the artist. She went on to discuss the works, pointing out that the numerous pieces that composed them were set at various depths from front to back in order to establish space and distance. She indicated that positive shapes made by the pieces of wood, and the negative shapes created between them. She also called attention to the way in which certain shapes had been placed in the

corners of the box-frame to give the design elements of transition. The class noted how the placement of the shapes at different levels and different distances produced a sculptural effect and observed the way in which light, projected from different angles, changed or accented the forms. One girl noticed that even though a work might be painted all in one color, such as black or white, the light reflections greatly emphasized the sense of form.

The teacher pointed out the collection of pieces of wood in different shapes, from which each student was to make a selection for creating an arrangement within his shoe box. The boxes would finally be put together to compose a single large group assemblage. The boxes could be designed to be used either vertically or horizontally in the mural. The teacher proposed that before starting work, the class choose either black or white for the construction. They chose white.

After each student had selected the wooden pieces he wanted and arranged them to his satisfaction within his shoe box, he made a rough sketch of the arrangement before taking it apart to cover the inside and outside of the box and the individual pieces with paint. (The tables were covered with newspaper for protection, which is important because rubber-base or acrylic paint does not wash off after it has dried.) When the boxes and pieces were dry, the pieces were glued in place by applying glue to the surfaces that were to be affixed to the boxes. In cases in which some pieces were to hang from the top and others rest on the bottom, like stalactites and stalagmites, the latter were first glued to the bottom of the box; when the glue was set, the box was reversed and the top pieces glued in place. The glue was allowed to become tacky before a piece was positioned and held in place for a time until it could support itself. When the arrangement made it possible, it was found most convenient to begin at the back of the box and work forward. Attention was called to the advantage of using a block or several blocks at the corners of the boxes to provide a transitional motif in the design (fig. 1). When the boxes were finished, they were put away to dry thoroughly.

1

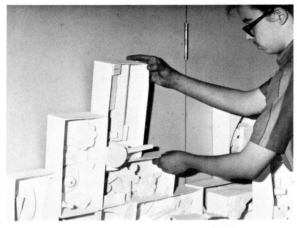

2

II: Organizing the individual assemblages into a composition

The teacher said that in organizing the individual assemblages into a composite assemblage, the object was to give a unified and harmonious composition and produce the most effective design. The class discussed the way in which Nevelson organized her compositions and its implications for their own problem.

The shoe boxes containing the students' individual assemblages were all gathered on a long table set against the wall. Several students assembled them into arrangements, while the rest of the class offered suggestions and criticisms. If a box needed securing in place, this was done by driving a pushpin through the back into the tackboard wall behind. One student arranged all the boxes vertically, standing one on top of another; a second made an all-horizontal arrangement; and a third combined horizontal and vertical boxes. The class thought that all the combinations had been exhausted, but the teacher prodded them to invent others, and a number of different arrangements were tried: staggering the boxes, spacing them in pyramids with transitional elements, turning them at angles from the wall, and setting them at different distances from the wall. When everyone had had a chance to arrange the boxes in a new way, or alter an arrangement, the group decided on which organization they preferred. They chose a team to fix it to the wall as a permanent design, placing pushpins to anchor it wherever necessary. The rest of the class acted as a jury and made suggestions or, if the class approved, changes. When the assemblage was eventually dismantled, each student took home his individual shoe-box assemblage.

APPLICATION TO OTHER AGE LEVELS

On a simpler basis and with smaller boxes, this project can be done at the eleven- to twelve-year-old level. For older levels, it offers unlimited possibilities of design and craftsmanship; the boxes can be larger, and of different shapes and proportions, and the units can be more varied and complex.

List of illustrations

(*Works by modern masters*)

Page 50
Georges Rouault. *We Think of Ourselves as Kings.* 1922–27. Aquatint and roulette over heliogravure, 25⅝ x 19¹³⁄₁₆″ (sheet size). The Museum of Modern Art, New York. Gift of Samuel A. Berger.

Pablo Picasso: *Head of a Jester.* 1905. Bronze, 15 x 14⅜ x 9″. Collection Mrs. Bertram Smith, New York.

Page 52
Odilon Redon. *Vase of Flowers.* 1914. Pastel, 28¾ x 21⅛″. The Museum of Modern Art, New York. Gift of William S. Paley.

Page 82
Vincent van Gogh. *Irises.* 1890. Oil on canvas, 29 x 36¼″. The Metropolitan Museum of Art, New York. Gift of Mrs. David M. Levy, 1958.

Page 84
Naum Gabo. *Column.* 1922–23. Glass, metal, plastic, wood, 41″ high. The Solomon R. Guggenheim Museum, New York.

Page 108
Henry Moore. *Family Group.* 1948–49. Bronze, 59¼ x 46½″. The Museum of Modern Art, New York. A. Conger Goodyear Fund.

Page 110
Isamu Noguchi. *Bird C (Mu).* 1952–58. Greek marble, 22¾ x 8⅛″. The Museum of Modern Art, New York. Given anonymously in memory of Robert Carson, architect.

Eduardo Chillida. *Place of Silences.* 1958. Forged iron, 15⅝ x 17¾″. Collection D. and J. de Menil, Houston.

Page 112
Alexander Calder. *Lobster Trap and Fish Tail.* 1939. Mobile: painted steel wire and sheet aluminum, ca. 8′6″ x 9′6″. The Museum of Modern Art, New York. Commissioned by the Advisory Committee for the stairwell of the Museum.

Page 116
René Magritte. *The False Mirror.* 1928. Oil on canvas, 21¼ x 31⅞″. The Museum of Modern Art, New York. Purchase.

René Magritte. *The Castle of the Pyrenees.* 1959. Oil on canvas, 78⅝ x 50⅝″. Collection Harry Torczyner, New York.

René Magritte. *The Ladder of Fire, I.* 1933. Oil on canvas, 21¼ x 28¾″. Private collection, London.

Page 120
Joan Miró. *Catalan Landscape (The Hunter).* 1923–24. Oil on canvas, 25½ x 39½″. The Museum of Modern Art, New York. Purchase.

Wassily Kandinsky. *Composition 8, No. 260.* 1923. Oil on canvas, 55½ x 79⅛″. The Solomon R. Guggenheim Museum, New York.

Page 122
Ancestral Figure. Gabon: Kota. Wood, paint, and iron sheeting, 20¼″ high. The Museum of Primitive Art, New York.

Standing Female Figure and Child. Upper Volta or Mali: Lobi or Dogon. Wood, 30½″ high. The Museum of Primitive Art, New York.

Page 128
Stuart Davis. *Visa.* 1951. Oil on canvas, 40 x 52″. The Museum of Modern Art, New York. Gift of Mrs. Gertrud A. Mellon.

Page 142
Arthur Dove. *Grandmother.* 1925. Collage of shingles, needlepoint, page from the Concordance, pressed flowers, 20 x 21¼″. The Museum of Modern Art, New York. Gift of Philip L. Goodwin (by exchange).

Page 150
Pablo Picasso. *Head of a Woman.* 1960. Metal cutout, folded and painted, 13¾ x 9⅞″. Owned by the artist.

Pablo Picasso. *Jacqueline with a Green Ribbon.* 1962. Metal cutout, folded and painted, 20½ x 11½″. Owned by the artist.

Pablo Picasso. *Head of a Bearded Man.* 1961. Metal cutout, folded and painted, 31½ x 24⅜″. Owned by the artist.

Page 152
Pablo Picasso. *Girl Before a Mirror.* 1932. Oil on canvas, 64 x 51¼″. The Museum of Modern Art, New York. Gift of Mrs. Simon Guggenheim.

Page 158
Alberto Giacometti. *The Palace at 4 A.M.* 1932–33. Construction in wood, glass, wire, string, 25 x 28¼ x 15¾″. The Museum of Modern Art, New York. Purchase.

R. Buckminster Fuller. Dome for U.S. Pavilion, Expo '67, Montreal.

Page 192
Lucas Samaras. *Box, No. 43.* 1966. Mixed media. Private collection.

Page 194
Pablo Picasso. *Portrait of Georges Braque.* 1909. Oil on canvas, 24¼ x 19¾″. Collection Edward A. Bragaline, New York.

Georges Braque. *Man with a Guitar.* 1911. Oil on canvas, 45¾ x 31⅞″. The Museum of Modern Art, New York. Acquired through the Lillie P. Bliss Bequest.

Page 226
Louise Nevelson. *Royal Tide, I.* 1960. Gilded wood, 8′ x 40″ x 8″. Collection Howard and Jean Lipman, New York.

DATE DUE